WAKEFIELD
IN
50
BUILDINGS

PETER THORNBORROW &
PAUL GWILLIAM

AMBERLEY

This book is dedicated to the memory of Mary Oddie OBE, who, with her husband Muir Oddie, saved and restored Heath Hall in the early 1960s, together with several other buildings in the village of Heath, which she ensured was designated a Conservation Area of Outstanding Importance. She was particularly kind to me in the mid-1980s when I was listing the outer Wakefield area.

Wakefield is a clean, large, well-built town, very populous and very rich; here is a very large church, and well filled it is, for here are very few Dissenters; the steeple is a very fine spire, and by far the highest in all this part of the country … They tell us, there are here more people also than in the City of York.

Daniel Defoe, *A Tour Through the Whole Island of Great Britain* (1734)

First published 2018

Amberley Publishing, The Hill, Stroud
Gloucestershire GL5 4EP

www.amberley-books.com

British Library Cataloguing in Publication Data.
A catalogue record for this book is available from the British Library.

ISBN 978 1 4456 5906 0 (print)
ISBN 978 1 4456 5907 7 (ebook)

Origination by Amberley Publishing.
Printed in Great Britain.

Contents

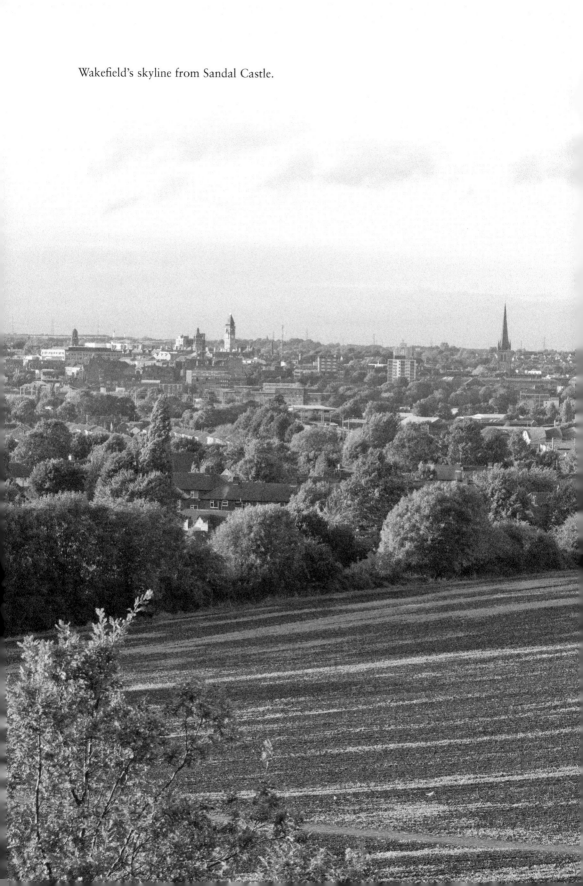

Wakefield's skyline from Sandal Castle.

Acknowledgements

Without the photographic skills and computer expertise of my photographer Paul Gwilliam this book would have been the poorer. We rediscovered Wakefield together, visiting many fine buildings in the process, discussing and taking photos of many more than fifty buildings. Whereever we asked to inspect inside a building we were warmly welcomed by private owners and the management of commercial properties alike, for which we were truly grateful.

In particular we are indebted to several owners for granting permission to photograph the interiors of their properties and the rear of buildings from private gardens. These include: Sharlston Hall; Frieston Almshouses, Kirkthorpe; Lupset Hall, near Wakefield Golf Club; Clarke Hall, Stanley; the Normanton Golf Club, Hatfeild Hall; Vivienne Hodges MD of AHC, Heath Hall; Marcus Dyson MD of Eleventeenth; both the owners Ossett Brewery and the landlady of the King's Arms, Heath; the manager of the York House Hotel, Nina Rassouli; The Cow Shed; Qubana; the Waterton Park Hotel; the Theatre Royal Wakefield, Kealey Woodward and Jess Rooney; Liv Bennet at Unity House; the headmaster and archivist Elaine Mercx, Queen Elizabeth Grammar School (QEGS); the headmistress of Wakefield Girls' High School and Junior School; the trustees of the Gissing House Museum; Groundwork, Kirkgate Station; Tracy Holyer of Sense, Pemberton House; the valued assistance of the clergy and church wardens at Wakefield Cathedral, with a special thanks to Malcolm Warburton (author of the guidebook) for his personal guided tour; the Church of St Helen, Sandal; Church of St John the Baptist, St John's Square; the Church of St Peter & St Leonard, Horbury; Keith Aisbett, the Church of St James, Thornes; Revd Fr David Bulmer, St Austin's RC Church, Wentworth Terrace; the trustees of Westgate Unitarian Chapel; and the Friends of the Chantry Chapel of St Mary, Kirkgate. Finally to the various members of Wakefield MDC for providing access to the Town Hall, County Hall, Wakefield One, The Art House and former Library, and and the management of the Hepworth Wakefield.

Wakefield is fortunate in having a dynamic Civic Society ably led by their President Kevin Trickett, who is greatly thanked for his time. In addition Wakefield Historical Society is similarly led by President Pam Judkins and her husband and secretary Phil Judkins. They organise helpful events and lectures, and we found the Wakefield Waterfront and Wood Street: Heart of Wakefield (jointly with the Civic Society) projects of particular interest and assistance. I particularly acknowledge the helpful information gained from the publications of the late Kate Taylor, a local historian par excellence. Also thanks go to the archivists of the WYJS Archive Service, at the West Yorkshire History Centre on Kirkgate, for their helpful assistance and for permission to use a copy of an historic map and plan.

Introduction

The finely carved replica of the original Market Cross standing outside the west door of Wakefield Cathedral bears witness to over a thousand years of Christian worship within the city. The cross, which lies on land once owned by King Edward the Confessor, acts as a signpost to Wakefield's Saxon past. After the Norman Conquest in 1066 King William's clerics came to document and value the land, recording in the Domesday Book of 1086, among other things, '3 priests and two churches'. The large manor of Wakefield was eventually gifted by the Crown to the Earl Warenne, a powerful knight from Normandy who built a motte-and-bailey

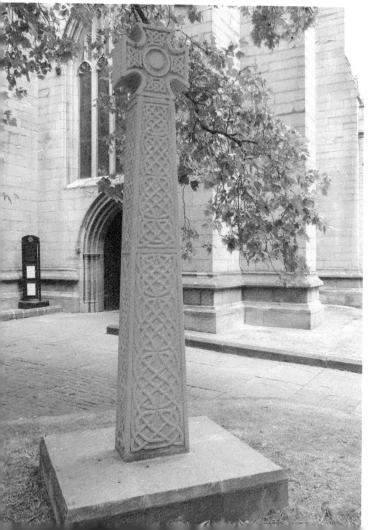

The modern Saxon cross at Wakefield Cathedral by Celia Kilner.

castle at Sandal. The castle, though ruinous today, still has impressive earthworks and from here there is a fine view of present-day Wakefield with its striking skyline of towers and its surrounding farmlands that in 1460 bore witness to the famous Battle of Wakefield where 'Richard Duke of York gave battle in vain'.

We begin our exploration of Wakefield's special buildings by looking at its two fine medieval churches: the cathedral in the centre of the town, and St Helen's in Sandal where the north transept of the church was once reserved for the earl's retainers. From St Helen's the southern route to the city continues on the A61, crossing the River Calder over the medieval Chantry Bridge with its ornate chapel, one of only four bridge chapels left in the country. Opposite the bridge is the elegant boardroom of the Aire & Calder Navigation Company established in 1699, which was built after the River Calder was made navigable. Upstream from this, and fronting the river, stands one of the finest examples of a riverside warehouse in the country, which symbolises the increase in trade generated from Wakefield's early markets. By 1630 a weekly corn market had been established in the town, followed by a cloth market in 1656, and a leather market in 1675. The cattle market established in 1765 eventually grew to be one of the largest and most important in the country, surviving into the twentieth century. The many fine examples of eighteenth- and nineteenth-century buildings bear testimony to the increased prosperity of the town from trade. From Chantry Bridge, Kirkgate leads northwards into the heart of the town, running in front of the former parish church, which is situated on a triangular plot of land that is depicted on Walker's map of 1823.

Northgate leads out of the town where medieval Haselden Hall once stood (its square courtyard plan shown on Walker's map). There is a fine display of carved

The Georgian boardroom of the Aire & Calder Navigation Company.

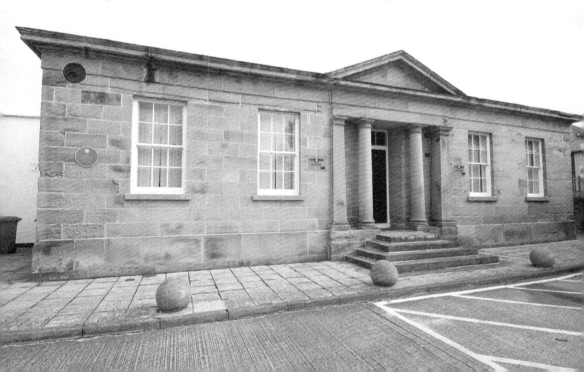

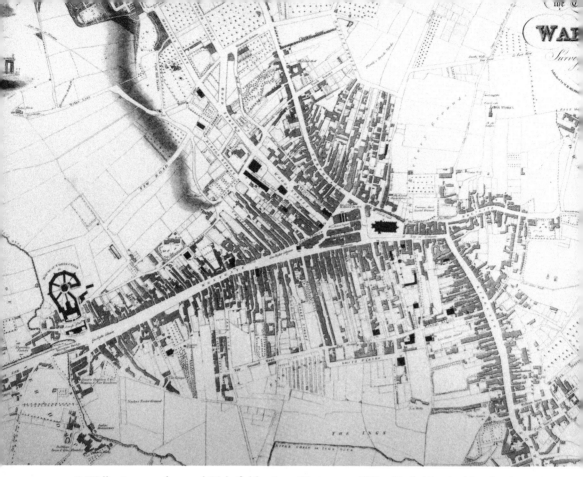

J. Walker's map of central Wakefield, 1823. (Courtesy of West Yorkshire Archive Service, Wakefield: E_WAK RN895)

timbers in Wakefield's new museum. To appreciate buildings from this early period we visit two fifteenth-century timber-framed halls on the outskirts of Wakefield, at Sharlston and Horbury. The late Elizabethan period saw much building activity when the town was said to be 'thick with timber buildings'. The Black Swan in the centre of the town is the only three-storey jettied timber-framed building to survive from this period, although on Northgate a restored two-storey timber-framed building retains an outstanding Elizabethan plaster ceiling. At Stanley, Hatfeild Hall is an ancient house with a Regency stone façade retaining a plaster frieze dated 1608, and an elaborate Regency Gothic plaster ceiling. Close by, Clarke Hall is a picturesque E-shaped mansion from 1680 that also preserves a richly decorated contemporary plaster ceiling – it is an early example of the use of brick with stone detailing. By the late seventeenth century brick became the dominant building material throughout the town, except for public buildings and churches where stone was mostly used. On the outskirts of Wakefield, Heath village has much to delight the enquiring visitor: Heath Hall is a magnificent stone-built mansion by local architect John Carr (1754–80) containing exceptionally fine Rococo plasterwork. We also visit the stunning church Carr built in Horbury (on the opposite side of Wakefield) where he is laid to rest.

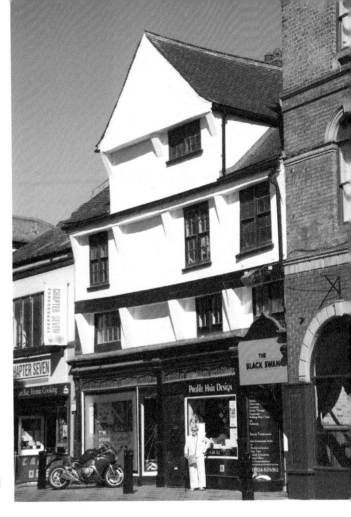

The Black Swan, a jettied
seventeenth-century timber-framed
building.

Walker's map of Wakefield shows Westgate, the main road into the town from
the west, lined with buildings, once a tree-lined boulevard with many fine houses
described by an American visitor in the 1770s as the finest street he had seen outside
of London. Built on earlier long and narrow burgage plots, back lanes provided
separate access to yards and gardens. These yards remain a significant feature of
Wakefield's street scene. We take a closer look at some of the surviving elegant
Georgian buildings on our journey. On Westgate these include a former hotel of
1772, which provided accommodation when Wakefield was the county town with
its own season and Assembly Rooms. Old Bank on the corner of Northgate and
Bank Street lays claim to be the first bank built outside of London in 1790.

The railway first arrived in Wakefield in 1840 with a station built on Kirkgate
in 1854. By 1856, a second railway station was built on Westgate linked to the first
by a long viaduct carrying the line, with a bridge crossing Westgate that effectively
ruined the street. This caused the demolition of the largest of the mansion houses,
after which the gentry mostly moved out, although one or two fine Georgian
houses (listed Grade II*) still survive below the bridge and are worth seeking out.

The nineteenth century was a period of growing civic pride after the town was
first made a Municipal Borough in 1848, and then granted city status in 1888

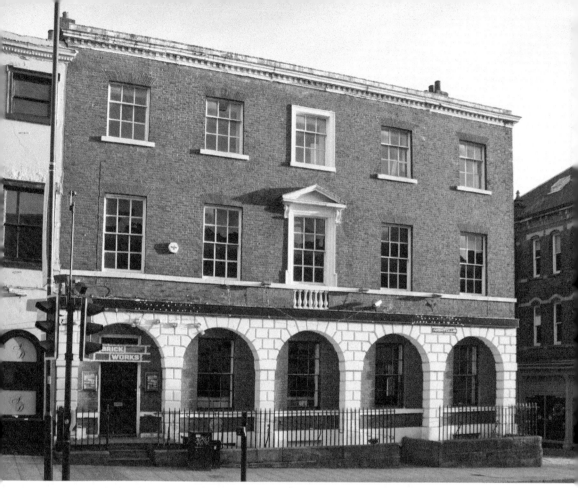

Old bank, Westgate, *c.* 1790.

when the parish church was elevated to a cathedral. This civic pride is reflected in the public buildings built on Wood Street, a new street of 1805 that links through to the St John's 'new town' area then nearing completion – Wakefield's only planned Georgian development. We pass the Mechanics' Institute of 1822, the Town Hall of 1880, the Courthouse of 1810 and County Hall of 1898, all representing different phases of Wakefield's transformation from a market town to an enfranchised city with its own Member of Parliament. Daniel Gaskell was Wakefield's first (Liberal) MP (from 1832 to 1837) and lived at Lupset Hall, which we will visit, where his portrait still hangs above the stairs.

In recent years the city has been revitalised. New initiatives have seen both stations rebuilt and restored, and a centralisation of council services into Wakefield One, an award-winning contemporary building. On the river, The Hepworth Wakefield is the city's exciting new art gallery. Built in 2011, it celebrates the life and works of Wakefield's famous sculptor Barbara Hepworth. I hope you enjoy this tour of Wakefield and its environs, which has much of interest to offer the visitor.

Peter H. Thornborrow

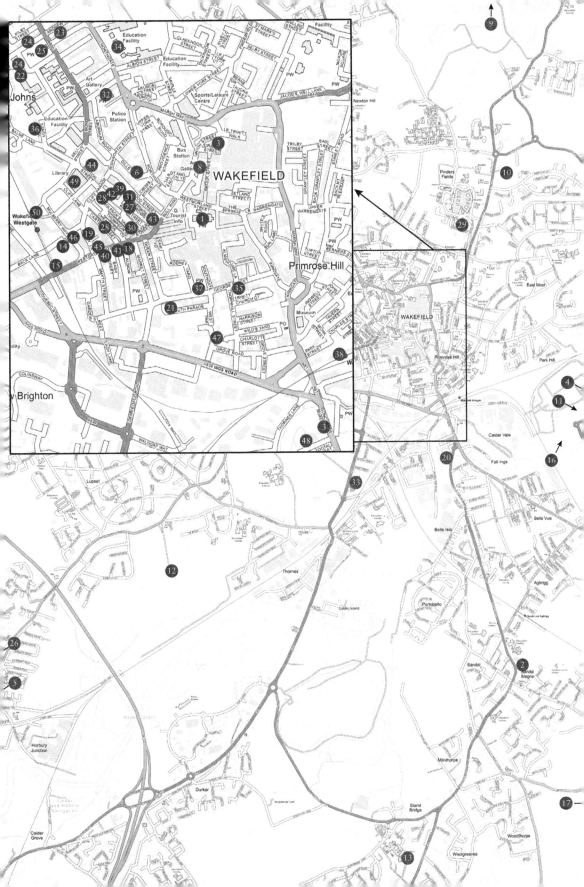

Key

31. The Waterton Building and Mechanics' Theatre, Wood Street (1822)
32. St Austin's RC Church, Wentworth Terrace (1828–80)
33. Church of St James with Christ, Denby Dale Road, Thornes (1831–44)
34. Queen Elizabeth Grammar School, Northgate, (1834)
35. Crowther's Almshouses, Nos 11–25 George Street (1838–63)
36. Cliff Hill House, Sandy Walk (1840)
37. The former Zion United Reformed Church, George Street (1844)
38. Kirkgate Railway Station, Monk Street (1854)
39. Town Hall, Wood Street, (1877–80)
40. Unity House, Nos 79–83 Westgate (1878–1908)
41. Nos 57–59 Westgate, former Wakefield Building Society (1878)
42. Old Police Station and Fire Station, Cliff Parade (1879)
43. Qubana (former Barclays Bank), Nos 1–3 Wood Street (1881)
44. County Hall, Bond Street, (1894–98)
45. Theatre Royal Wakefield, Nos 92–100 Westgate (1894 and 1905)
46. The former Wakefield Library, Drury Lane (1906)
47. No. 3 West Parade, (1995)
48. The Hepworth Wakefield, off Doncaster Road (2011)
49. Wakefield One (2011)
50. Wakefield Westgate and Multistorey Car Park (2013)

The 50 Buildings

1. Cathedral Church of All Saints, Kirkgate (Twelfth Century)

The setting of the cathedral has undergone dramatic change over the last 120 years. In 1900 it was separated off from Kirkgate by iron railings on low walls, which have since been removed and replaced by a pedestrianised scheme (1994), including new steps and paving featuring a distinctive cross design that has weathered well over the past twenty-five years. So too has the early twentieth-century massive scholarly Perpendicular-style extension built onto the east end of the church, giving it cathedral-like proportions. Its stonework now blends in well with the rest of the stone-cleaned building (done thirty years ago). As we see it from the south it is almost entirely a Victorian rebuild of 1858–74 by Sir George Gilbert Scott. Following the original late medieval design of the church, he replaced all the tracery windows in the five bays of the nave aisles in a Perpendicular style, each bay articulated by buttresses with gabled offsets, and commissioned twenty-nine

The long south front of the cathedral.

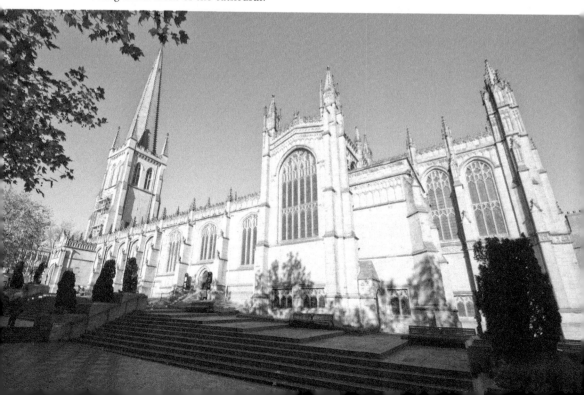

new stained-glass windows. Most of these windows were by Charles E. Kempe, who over a period of thirty-five years (1872–1907) designed some twenty-one windows – his finest set in the country. The church of Saxon origins had a Norman cruciform plan originally, to which was added a north aisle in 1150 and a south aisle around 1220. The central crossing tower tragically collapsed in the 1320s, destroying a substantial part of the church, and was reconsecrated in 1329 after it had been largely rebuilt with a new chancel arch. The nave is unusual in having seven bays of arches on the north side and eight on the south (the arches being slightly smaller). The columns on the south side are a mix of thirteenth-century octagonal columns and reused circular Norman drum piers. Those on the north side have seven slightly wider arches carried on an odd mix of decorated quatrefoil columns with bull-nosed (ovolo) moulding and capitals, but with three earlier circular columns; the clerestory windows have similar ovolo-moulded column divisions. A new freestanding tower was built around 1409–20 at the west end, and the nave was extended to meet it. The top of the spire blew off in 1714 and was poorly repaired. Scott began his restoration of the church with the tower, refacing it in two stages (1858–59) and rebuilding the spire (1860), the tallest – 247 feet – in Yorkshire.

Its crockets form a distinctive profile, and its peel of fourteen bells were recast after the Second World War. During the second half of the fifteenth century another major building programme began, raising the nave aisles with a new panelled-oak roof (replaced in around 1919–30 due to deathwatch beetle but reusing the carved bosses) and adding a clerestory with another added to the chancel. This was completed by 1475 when money for glazing the east window was gifted by John Savile. The window was removed in around 1900 when the church was extended further to the east. The five-bay Perpendicular arcades, with hollow chamfered arches on octagonal piers, date from this period. The fine oak furnishings of the quire – the stalls with misericords – was the gift of Sir Thomas Savile of Lupset Hall in celebration of his marriage to Margaret Bosworth in 1482. The delightful end bench is carved with his coat of arms quartered with that of his wife, the poppy head featuring his owl crest. The decoratively painted panelled ceiling has finely carved and gilded bosses, with the blue of the ceiling and the magnificent Gothic Revival altar reredos drawing the eye down the nave to the sanctuary. The upper section of the finely carved rood screen was added in around 1635 above the original fifteenth-century screen, the work of Francis Gunby (he was paid £17 15s). He also did the fine Jacobean woodwork in St John's Church, Leeds (1634). The restoration font dated 1661 at the rear of the nave has an octagonal bowl. The panelled sides were carved with the initials of the churchwardens and the king. In 1888 the church became the cathedral for the new diocese of Wakefield and Frank Pearson was awarded the commission to extend the east end of the church in an appropriate manner. The climax was St Mark's Chapel, which was dedicated in 1905. Its slender columns soar to the superb Lierne stone vaulted ceiling, the hidden treasure of the church. In 1950 the rood screen was restored with figures and a scene of the Crucifixion, flanked either side by beautiful six-winged angels with

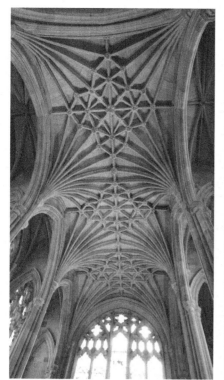
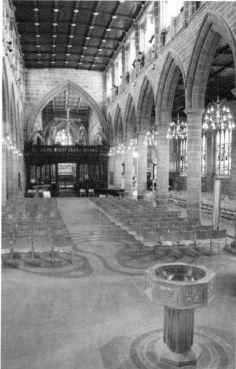

Above left: The vaulted roof of St Mark's Chapel. (Courtesy of Chapter of Wakefield Cathedral)

Above right: View down the nave to the chancel. (Courtesy of Chapter of Wakefield Cathedral)

gilded wings, an extraordinary piece of theatre – the finest and last such work by Ninian Comper. In more recent times the church has been reordered and its interior cleaned (2013). The nave pews were removed in favour of flexible seating, which were lovingly restored with a new stone floor inset with a bold labyrinth, complemented by a new lighting and sound system. The cathedral with its stunning interiors should be firmly on the tourist's map.

2. Church of St Helen, Barnsley Road, Sandal (Twelfth Century)

Just 2 miles south of Wakefield stands the ancient parish church of Sandal Magna. Its tall tower is crowned by pinnacles and it is something of an architectural puzzle of at least six different periods. The church is almost twice as long as most parish churches (take a step back into the churchyard to take it all in). Its dedication to St Helen suggests Anglo-Saxon origins and its cruciform plan is Norman, but with earlier remains in the base of the central crossing tower.

This was built in four phases. The lower stages have small arched windows and decorated belfry openings of around 1330, when much of the church was rebuilt. The upper stage has large fifteenth-century Perpendicular belfry openings, and a peel of six bells were installed in 1812. The battlements and crocketed pinnacles are replacements from 1888. The gabled south transept has a large Gothic arched window containing important fragments of medieval stained glass, including the arms of the Earl Warrene. The south (Waterton) chapel was added against the chancel in a general rebuilding of the early 1500s. It retains a superb parclose linenfold panelled screen decorated with a finely carved vine scroll, which, along with the font dated 1662 and two medieval carved pew ends in the north aisle, are the church's treasures. The east end of the chancel has an odd grouping of three fourteenth-century windows (probably reused) rather than one east window. The nave was reroofed twice, in the 1690s and 1872, as indicated by the rooflines on the tower, when the nave was extended two bays to the west. The long sloping roof over the aisles creates a barn-like effect. Its impressive interior is dominated by the tall stone columns of the Gothic arched thirteenth-century nave arcade, which is carried on by alternating circular and octagonal piers (as at Wakefield Cathedral, which it resembles), one with a water-leaf capital. The striking crossing has tall intersecting pointed arches, and the central arch was glazed in a reordering scheme (2004–05) to introduce modern facilities within the chancel area.

South front of St Helen's Church with its central tower.

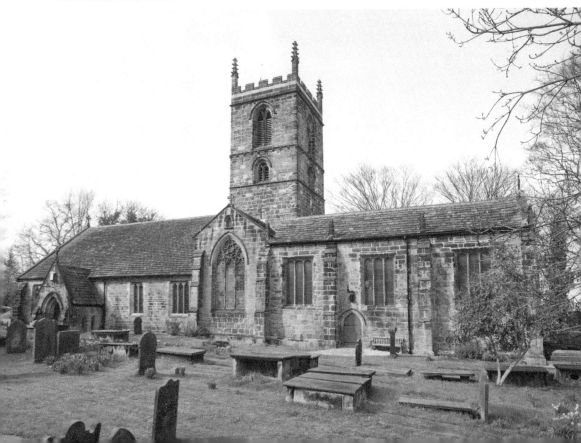

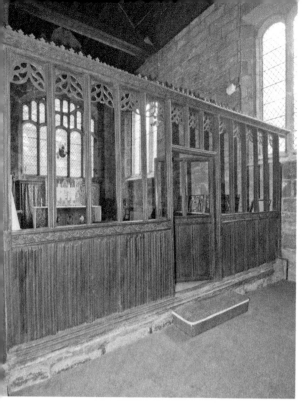

The Waterton Chapel parclose screen.

3. Wakefield Bridge and Chantry Chapel of St Mary, Kirkgate (c. 1350)

Wakefield can not only lay claim to having the longest medieval bridge in England, but also has the finest surviving bridge chapel. Its exceptional width of 320 feet is carried on nine Gothic pointed arches. It replaced an earlier timber bridge that was damaged by floods in the 1330s. It was built in two phases: the first with ribbed

East side of the medieval Chantry Bridge and chapel.

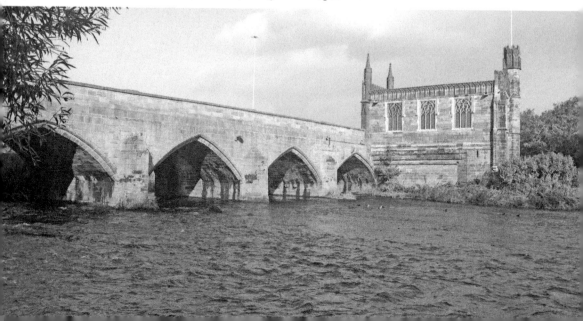

under arches began in 1342 from the north bank to a small island in the middle of the stream, where they built a chapel (licensed in 1356) buttressed against the bridge; the second phase to the south bank appears to have been constructed without ribs, having smooth undersides to the arches. The stonework was integral with the recessed moulding, as illustrated by Turner in 1797 when the bridge was widened for a second time with semicircular arches, probably by Bernard Hartley to John Carr's design, who he succeeded as county surveyor of bridges.

The chapel was built partly as a shrine but also as a means of collecting money for the upkeep of the bridge itself. The original design is clear enough despite Sir G. G. Scott's doomed but scholarly reconstruction of 1847. The replica front in Caen and Bath stone suffered badly from industrial pollution and was totally replaced in Derbyshire stone in 1939. Nevertheless, the building is a small jewel of the Decorated Gothic style, with its elaborate façade of five bays under steep pointed gables – a delicate design. Set below the embattled parapet are five reliefs of scenes from the Life of Christ and the Virgin, to whom the chapel is dedicated. To either side tall pinnacles are decorated with carved figures, and an octagonal spiral stair turret rises above the roof. On the sides there are three tracery windows, the hood moulds of which have carved head terminations, and a similar east window with stained glass. A friends group, formed in 1991, put together a funding package to bring the building into the twenty-first century. Work in June 2018 partly cleared the island, revealing well-dressed stone foundations under the medieval footings of the chapel and the bridge piers. The aesthetically beautiful interior of the chapel is open most public holidays.

Interior of the chapel, which is used for services and meetings.

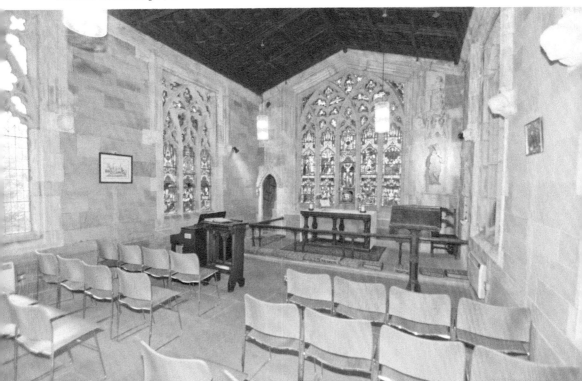

4. Sharlston Hall and Dovecote, Sharlston Common (1450)

Tucked away on Sharlston Common and a mile from Heath is an ancient manor house (listed Grade II*). Its setting is much enhanced by its approach through tall stone gate piers with ball finials and the stone-walled drive to the hall, a working farm with a large stone dovecote amid the ploughed fields. This large and complex building with many gables of different dates evolved from an early fifteenth-century timber-framed open hall with a cross passage. The solar west wing with a crown post roof, rare in West Yorkshire, was added by 1450, the framing of which is visible on the west side with long curved down struts. A matching east wing was added shortly after, completing its E-plan. In the early 1500s a narrow wing was added to the west wing, its position suggesting its use as a chapel. On its west side a small twin-gabled accommodation block was added, and at the east end a new gabled kitchen wing with large chimney stacks was added. The render covering the building hides a stone-walled ground floor with timber framing above. An upper floor was inserted into the hall, lit by stone attic dormers at the front and rear where the wall had to be taken down and rebuilt due to mining subsidence. Romanesque carved stonework found in the foundations suggest the finely dressed stonework was reused, probably from nearby Nostell Priory shortly after the Reformation. The final phase of development is the stunning timber-framed porch that features quadrant framing – the only example in Yorkshire. A long-eroded inscription once recorded, 'This house was begun … finished and done by John Fleming, Cuthbert and Dorothy his wife … in 1574.' In 1584 a double marriage between the Flemings and the Stringers brought the hall into the ownership of the Stringer family for the next 100 years, after which another marriage brought it into the Earl of Westmoreland's hands around 1710. He paid for the superb funeral monument to his wife's parents Thomas (d. 1681) and Katherine Stringer (d. 1707), which were erected in Kirkthorpe Church in 1731 and designed by William Kent, with two busts by the Italian sculptor Guelfi.

The gated approach to Sharlston Hall.

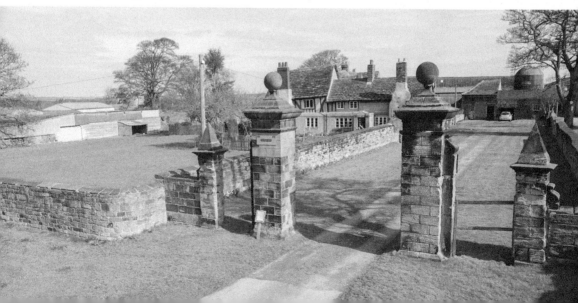

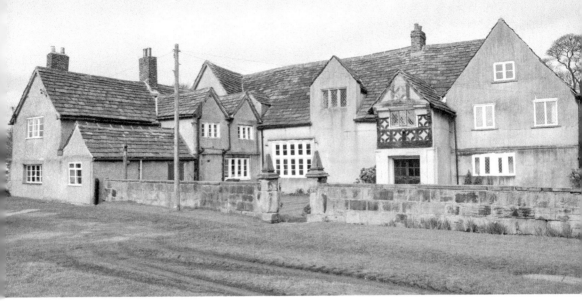

Above: The south front of this large, complex medieval building.

Right: The timber-framed porch, dated 1574.

5. Horbury Hall, Church Street, Horbury (1490s)

At first glance this somewhat dilapidated building, which is half-built of stone and rendered brick, does not appear to be of particular interest, as only its steeply pitched stone slate roof hints of its older origins. Local postman and building enthusiast Ken Bartlet persuaded the residents to let him investigate the roof space of this former row of cottages in the early 1970s. He was amazed to discover a fine medieval roof of a former open hall, which has decorative king post trusses with intermediate arched-braced collar beam trusses still in situ. A rare survival was the head beam of a dais canopy carved on its outer face with seven shields variously decorated with foliage and the Yorkist rose, and in the centre is the coat of arms of the Amyas family. With the help of Jack Sugden he produced an analytical, measured drawing of this late fifteenth-century former gentry house (published in 1976). Following the sale of the house to a knowledgeable historian, the attic ceiling was removed to reveal the roof timbers, which featured cusped wind braces and a spere truss next to the original door position – the only examples known in Yorkshire. The timber posts and roof timbers were repaired with plaster board set between the rafters, using skilled craftsmen. The work ground to a halt and the right-hand part of the building still needs to be restored. This has a framed opening in the middle of the floor for a timber spiral staircase leading from the buttery to the first-floor solar, with a close-studded timber-framed internal wall to

Horbury Hall opposite the church.

The Amyas coat of arms on the head-beam of the dais canopy.

the hall. Originally the front brick wall had close studding but this was removed, probably when a floor and a chimney stack was inserted into the hall to provide two heated ground-floor rooms and chambers, with a lobby entry against the chimney, sometime around 1700. The window openings have been restored with timber transom-mullioned windows with leaded lights and metal casements at the front, but cross-mullioned at the rear – typical of this period. Sadly the owner abandoned his project over thirty years ago to work abroad. This unique and important medieval building remains unfinished and unloved, but not forgotten!

6. Nos 53 and 55 Northgate (The Cow Shed), Nos 2–14 Gills Yard (c. 1500)

This replica timber-framed building, now a restaurant, replaced a modern shopfront in c. 1991. When it was put up for sale, the historic buildings officer of the West Yorkshire Archaeology Service talked his way in, photographing a well-preserved but damaged plaster ceiling dated 1596 in a rear upstairs room, a rare survival and one of only two such Elizabethan town house decorative ceilings to survive in Yorkshire, the other being in York. They submitted a spot list request to the DOE and the building was Grade II listed in February 1990. Following an application by a new owner for consent to convert the building and its neighbour into shops and offices, it was stripped out under archaeological supervision when false partitions, suspended ceilings and cladding from the walls were removed. This revealed a timber-framed house over 500 years old. Its medieval king post roof was mostly intact, together with close studding on the side walls and original beamed ceilings, one of which was painted with a rare chevron pattern, which is still discernible today. An original stone fireplace was discovered in an upstairs room where a cross wall had been removed to form a single great chamber. On closer inspection the cladding from the walls proved of interest: hessian sheets were covered by over a dozen layers of block-printed Georgian wallpaper pasted one on top of the other, some with excise duty marks. This was brought to the attention of Wakefield Museum, who commissioned their

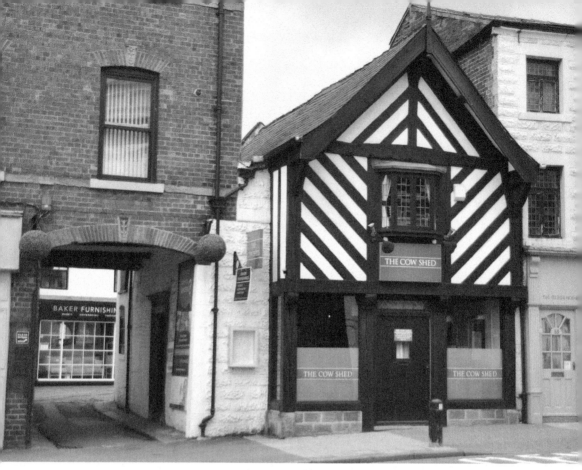

No. 53 Northgate, a restored medieval timber-framed house.

conservation, displaying them in an exhibition in 1991. Documentary research revealed that the building had been used as a showroom for the interior decorators and furnishers Wright & Elwick from *c*. 1750 to the 1800s. They were the premier cabinetmakers and upholsters to the Yorkshire gentry and also occupied the long building attached to the rear fronting Gills Yard, described as their 'Glass and Cabinet Ware House'. After these discoveries both buildings were upgraded to Grade II*. Its current use as a restaurant allows diners to inspect the restored ceiling and medieval timbers up close where the first floor is open to the roof.

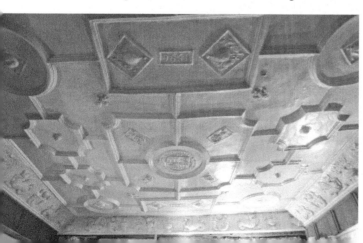

The fine Elizabethan plaster ceiling dated 1596.

The medieval Great Chamber with original fireplace.

7. Frieston's Hospital, Kirkthorpe Lane (1595)

Standing close to Kirkthorpe Church is one of the most remarkable buildings in Wakefield. Visible from the road, the building sits downhill and is approached by a curving road laid with stone setts. Its pyramidal roof covers single-storey aisles on three sides, and the top of its steeply pitched roof is penetrated by tall stone dormer gables with mullioned and transomed windows that light an inner hall. Small two-light mullioned windows illuminated nine individual small unheated rooms. These were accessed from the central hall and separated by oak plank-and-muntin

Frieston's almshouses, Kirkthorpe.

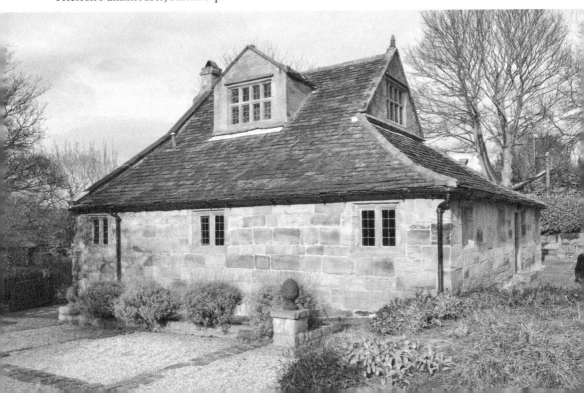

The plank wall divisions between the rooms.

walls with close studding above, which were fixed to oak posts with braces. The tall open hall has a large stone fireplace. Its Tudor arch was formed by regularly cut voussoirs with a wedge-shaped central keystone, which provided the only heat for the residents who shared communal living. The rear is gabled with a massive external stone chimney stack and an entrance door, above which a copper plaque records that 'John Friestone of Altofts Esq. Founded and Endowed this Hospital An Dom 1595. He that hath mercy on the poor happy is he. Prov 14 21'. In 1592 John Frieston conveyed a portion of his lands by a trust deed 'to the Master and Fellows of University College, Oxford' for the maintenance of 'a schoolmaster at his free school in Normanton and the poor people in his intended almshouse at Kirkthorpe'. His will of 1594 confirmed sufficient funds and fuel to sustain seven aged brethren and a matron, who lived rent-free in a small cottage next to it. Originally they were all paid 12*d* per week, but later benefactors added to the charity and by 1865 they were paid 4*s*. However, there was no provision made for repairs to the building, and in 1893 the Charity Commission required University College to pay £150 for repairs to the almshouses. In 1971 the Charity Commission authorised the trustees to sell land and the hospital to fund four new almshouses close by. The building was then restored and converted to a dwelling. More recently the external stonework has been carefully cleaned using the Doff steam-cleaning system.

8. The Elizabethan Gallery, the Old Cathedral Grammar School, Brook Street (1598)

Wakefield's oldest public building, the Grade II*-listed former Queen Elizabeth Grammar School (QEGS) still holds its own next to one of Wakefield's latest buildings, the Trinity Walk Shopping Centre of 2008. It's fairly incongruous setting is saved by its curtilage of lawns and forecourt laid with stone flags and setts in front of its restored entrance door. This impressive Elizabethan stone school was built in the 1590s, and its stone-slate roof was supported by sturdy king post roof trusses. A chamfered plinth runs around the building below large five-light double-transomed chamfered mullioned windows glazed with diamond-paned leaded lights – five on its east entrance front, three at the rear, and an even larger window in the north gable. All were designed to light the large single classroom within, appropriate for its present use as the Elizabethan Gallery, which is used for art exhibitions and events, and as a wedding venue. The Savile family were instrumental in establishing a grammar school at Wakefield. Sir Henry Savile, a distinguished scholar and former Greek tutor to Queen Elizabeth, Warden of Merton College Oxford and Provost of Eaton, presented the request to the queen, who granted its royal charter on 19 November 1591. The fundraising to build a new school was slow so the Saviles provided further assistance. In 1593 George Savile gave a close of land for the school in the Goodybower, together with stone from an adjoining quarry. William Savile 'procured twenty trees to build the schole, the seats and flores therof'. The building, completed by 1598, was described as 'very fayre builded at the proper costs and charges of Mr. George Savile deceased and two of his sonnes', as commemorated by a recut inscription above the door

The Elizabethan Grammar School.

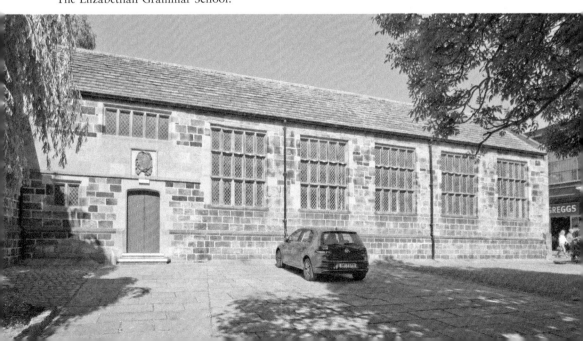

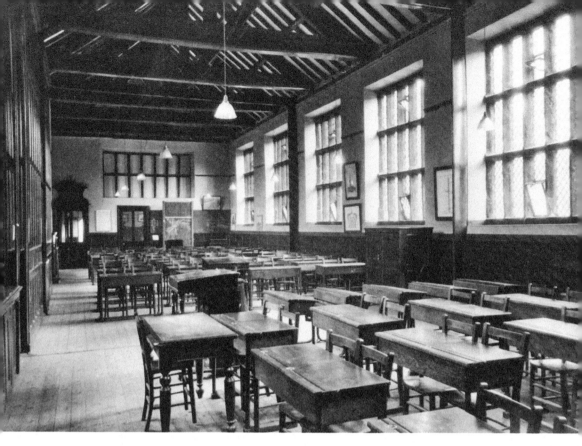

Above: The historic interior schoolroom. (Courtesy of QEGS Archives)

Below: The Savile inscription and royal arms.

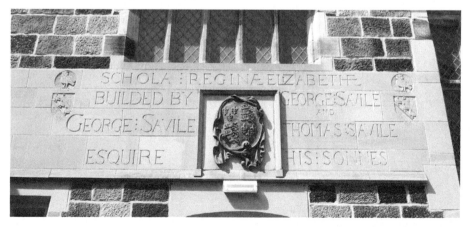

featuring the Savile coat of arms and an owl crest. The royal coat of arms are above the door. The five-light window originally lit the master's dwelling, who lived 'above-the-shop'. Attached to the left, the gabled wing in matching style is an addition of 1898 for the Cathedral School. QEGS moved out to larger premises in 1854.

9. Hatfeild Hall, off Aberford Road, Stanley (1608)

Hatfeild Hall is approached down a long sweeping tree-lined driveway that cuts through the green landscape of the 145-acre Normanton Gold Course. Its pleasing symmetrical east front (A, B, A) faces an ancient mulberry tree as old as the house – one of the earliest in England. It is built from sandstone ashlar featuring a run of nine twelve-paned sash windows at the first floor. Carried above the central three bays is a pedimented gable, flanked by full-height projecting canted bay windows unified by a plain ashlar parapet dating from a restoration of the early 1980s. The ground-floor windows and central door have pointed Gothic arched heads infilled with Y-tracery glazing bars. Originally its Regency Gothic façade was more elaborate, and the parapet and gable ends were decorated with crenelated battlements. In the tympanum of the pedimented gable is John Hatfield Kaye's coat of arms with the inscription '*SE QUOS AUDES*'. Following his marriage in 1772 he rebuilt an earlier Jacobean house in the new fashionable 'Strawberry Hill' Gothic style. Sadly the house was largely destroyed by fire in the early hours of New Year's Day 1987 and remained roofless and derelict until it was rebuilt in 2010 with a new golf club house on the back. The original house is now used for meetings and functions. Amazingly, it retains two rooms decorated with historic plasterwork, which survived the fire. While the former Oak Room has lost its Jacobean oak panelling, it still retains the original decorative plaster frieze with the initials 'GH' (for Gervaise Hatfeild) and the date 1608, recording when he rebuilt the earlier hall. It also features a repeated design of Neptune flanked by mermaids holding mirrors with wyvern supporters. On the opposite side of the entrance hall the former drawing room is decorated in the

Hatfeild Hall with new front of 1777 with Gothic arched windows.

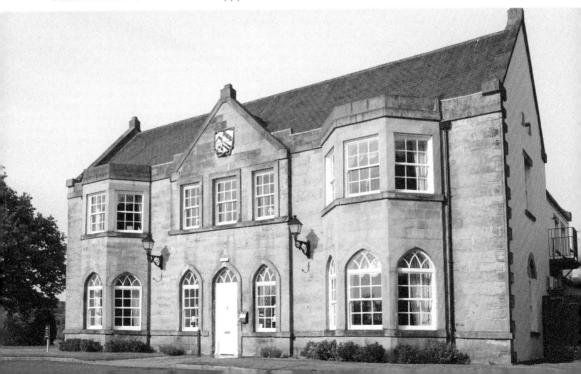

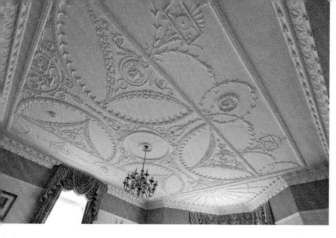

The fine Regency Gothic ceiling.

Gothic taste with arched niches in the wall and a superb decorative plaster ceiling; this has an intricate design that incorporates figurative roundels. In the grounds beyond the car park are the attractive ruins of the former Georgian coach house, featuring brick-lined stone walls with circular windows and cross-shaped ventilators.

1c. Clarke Hall, Aberford Road, Stanley (1680)

On the outskirts of Wakefield a glimpse of the north front of this picturesque small brick mansion can be had. Grade II* listed, its forecourt is laid with river cobbles. Its seven-bay symmetrical E-shaped façade has projecting outer bays and a central gable-fronted porch with golden sandstone quoins and a Tudor arched doorway with a richly moulded surround that may have been reused from the Tudor Bradford Hall by the owner Benjamin Clarke, who rebuilt it in a more

The north entrance of Clarke Hall.

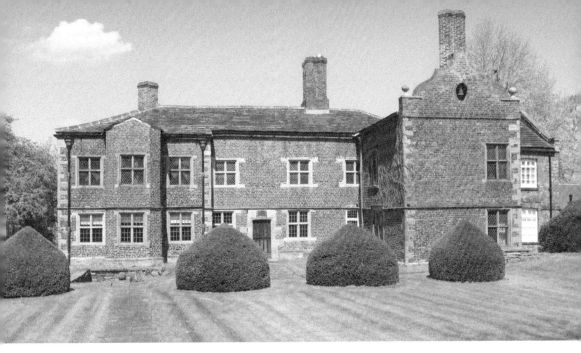

The south garden front of Clarke Hall.

fashionable style in 1680. All windows are cross-mullioned with diamond-paned leaded lights. The ground-floor windows at the rear have square panes with metal casements, replacements from the 1970s when the building was restored following its sale from the estate of Mr H. C. Haldane to the West Riding County Council in a far-sighted move to create a Children's Museum, for a class of schoolchildren to attend in period-style costume to experience a day living in the seventeenth century. Period furniture was acquired to furnish the hall and authentic replicas for use by the children, who attended in their hundreds each week. Increasing financial pressures on local authorities led to the demise of the scheme and almost inevitably the building was sold to be a private house once again.

The house demonstrates a transitional three-room plan with a single-depth central reception room and a flat baluster stair, with a kitchen to the left and a large dining room to the right. This is a fine oak-panelled room with a superb plaster ceiling featuring an oval design decorated with foliage and flower heads in

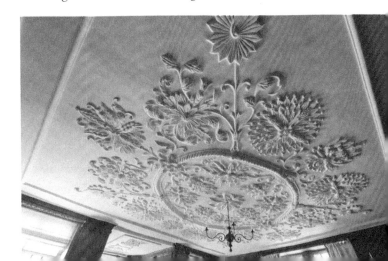

The plaster ceiling of the dining room, dated 1680.

bold relief, and a bay window bearing the date 1680. A wing was added in around 1700 to the east to provide more accommodation, as the first floor is largely open without subdivisions. The house is set within attractive grounds with lawns and mature topiary bushes and features a parterre and a circular maze with a mount from which to view it, a creation of the 1970s. The fake moat beyond them was a creation of the 1930s to suggest medieval origins.

11. The King's Arms Public House, Heath Common (1690–1841)

This attractive old inn at the southern entrance to Heath village has the impressive royal coat of arms of the Stuart kings over its entrance door, finely carved by the former owner David Kerr. He enhanced the interior of the building in the 1970s, creating a new enlarged oak-panelled 'Best Room' from smaller cottage rooms. The period panelling was acquired from various sources, said to include Irnham Hall, Lincolnshire. He installed the pair of finely moulded stone Elizabethan arched fireplaces (creatively made from doorways) salvaged from the ruined Heath Old Hall, while preserving the original taproom, with its bench seating to the left of the entrance and the former kitchen behind it. The kitchen is now a cosy snug with a working Yorkist range, retaining the gas lighting to reflect a bygone age. The building originated as a late seventeenth century three-room brick-built farmhouse. The ceilings have chamfered oak spine-beams and square-cut joists. The are stone quoins at the corners of the original hand-made brick rear wall and the stone doorway has a basket-arched lintel and quoined jambs of *c.* 1690. The stone-flagged cross passage leads back to the front door, which has a flat basket-arched lintel dating from the early eighteenth century, when it was altered to a pair of stone built cottages. One door is now blocked between the stone-framed sash windows. The attached hip-roofed three-bay barn or coach house is an addition from around 1841, when the earlier cottages were converted to a public house. Its gable-fronted central bay has a tall segmental-arched doorway with voussoirs, above which a stone-framed circular

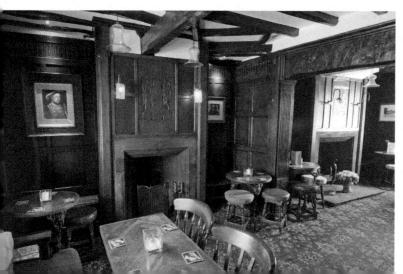

The oak-panelled main bar of the King's Arms, Heath.

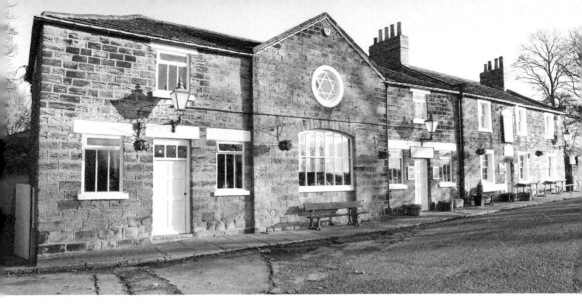

Above: The former coach house and the inn.

Right: The former kitchen makes a cosy snug.

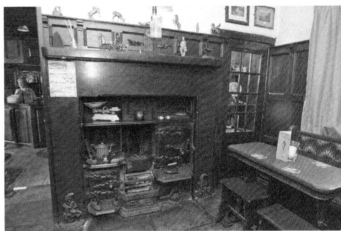

window glazed with the six-pointed Star of David forms a distinctive feature. The barn, incorporating two single-bay cottages, was converted to The Gaslight Restaurant in the mid-1980s. The unusual rosewood panelling of the cocktail bar is an impressive labour of love. It is to the credit of the present owners, Ossett Brewery, that its unique character has been retained.

12. Lupset Hall, Horbury Road (1716)

Just a mile from the centre of Wakefield, down Westgate on the road to Horbury, stands Lupset Hall (Grade II* listed), which was originally in open country on the edge of the town, but is now screened by urban housing. Its rural setting and open parkland survives as the town's municipal golf course, for which it was the clubhouse from its creation in 1936 to 2013 when it was sold as a private house. They moved to the adjacent purpose-built Gaskell Sports Pavilion. This is a restrained classical gentlemen's residence dating from the early years of the

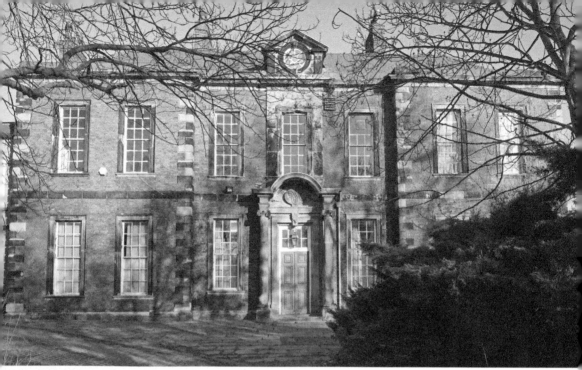

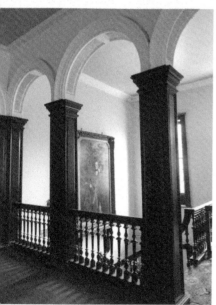

Above: The symmetrical front of Lupset Hall.

Left: The arcade of arches to the stair hall.

reign of George I. It is built of a pink-coloured brick in Flemish bond with raised ashlar stone dressings, quoined angles, a deep plinth, platband, eaves cornice and surrounds, and the eighteen-paned sash windows under a hipped slated roof. It has a seven-bay symmetrical façade. The central three bays are recessed and articulated by the finely dressed and regularly cut quoins, and the central ashlar bay contrasts with the surrounding brickwork. This features a Queen Anne-style hooded semicircular doorcase supported on Ionic columns with carved volutes, which frame a six-panel double door with a tall fanlight set within a moulded

architrave with a dropped keystone (carved with the date 1716) and a finely carved oval medallion above bearing the conjoined initials 'WR', standing for Richard Witton. He was the brother-in-law of Theophilus Shelton, a gentleman architect who probably designed this house. He lived in the original part of Heath Hall, and was the first recorder (of property deeds) for the West Riding. The disposition of its façade is similar to that of Tong Hall (1702), which is ascribed to Shelton. It has a plain five-bay return with sash windows that light the two main parlours, which face south across landscaped grounds to the River Calder. The entrance leads into a square hall, leading through to the cantilevered stair that is open strung with finely carved balusters – perhaps the finest in West Yorkshire. Once owned by Daniel Gaskell, Wakefield's first (Liberal) MP (1832–37), his portrait still hangs here, framed by the arcade of arches on the landing.

13. Kettlethorpe Hall, Kettlethorpe Hall Drive (1727)

On the outskirts of Wakefield is a unique early Georgian house of great charm and interest. It is easily visible from a public footpath that continues around a small fishing lake, enhancing the setting of the house. Two storeys high, it has a five-bay symmetrical façade, but with single-storey bays added to each side. These extend the internal length of long parlours that have fireplaces backing onto the entrance hall above, the flues of which come together to share the unusually designed central chimney stack. It has a double-pile plan, being two rooms deep, and the rear rooms are separated by an open-well stair hall with dado panelling. The stair has carved tread ends and a ramped handrail that is lit by a domed roof light. Constructed of watermarked stone, each block is carefully laid to contrast with the one next to it, creating a shimmering effect like Shantung silk. The eighteen-paned sash windows have raised surrounds with unusual carved ears and open segmental pediments filled with lively carvings: a bird and a squirrel in the outer bays, and delicately carved swags hung with fruit in relief to either side of the door. This has a decorated architrave, overlight and dropped keystone carved with the initials 'ANA', with the coat of arms of the Nortons under the curved pediment. The conjoined initials celebrate Gervais Nortons second marriage to Ann Smith (of Bolsover) following the death of his first wife in 1721. The window above has a portrait bust of a female bearing the date 1727, which presumably represents Ann, though the head appears to have been replaced. To either side the windows have keystones with strange carved grotesque mask-like faces of bald men. The house has regular raised quoins to its angles and a platband uniting the ground-floor pediments, with a roll-moulded band uniting the tops of the keystones. A bold projecting enriched cornice on modillions runs around the deep parapet and is articulated by large urn finials in the corner angles. A tall central chimney stack rises above the parapet and is surrounded by small Doric column shafts linked by the cornice – an unprecedented design.

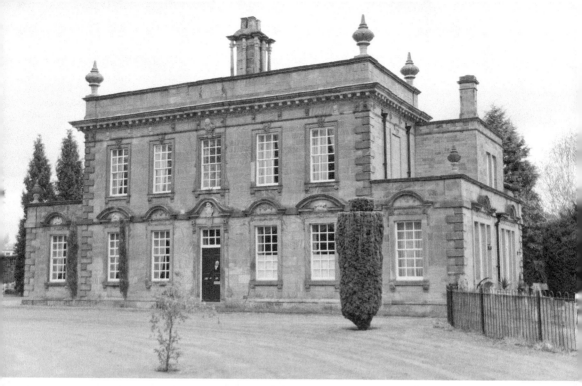

Above: The south front of Kettlethorpe Hall.

Left: One of the windows with a carved pediment.

14. Westgate Chapel (Unitarian), Westgate (1751–52)

Set back from the street off Westgate is the best of Wakefield's chapels. Grade II* listed, its setting is compromised by the County Court (2008), which blocks its previously open view. This fine brick building, constructed in 1751–52, is gable fronted, its wide gable treated as a triangular pediment. The stone door and window dressings are painted white, which helps define its three-bay symmetrical façade against the warm orange-coloured brickwork. Stone pedimented doorcases with Doric pilasters

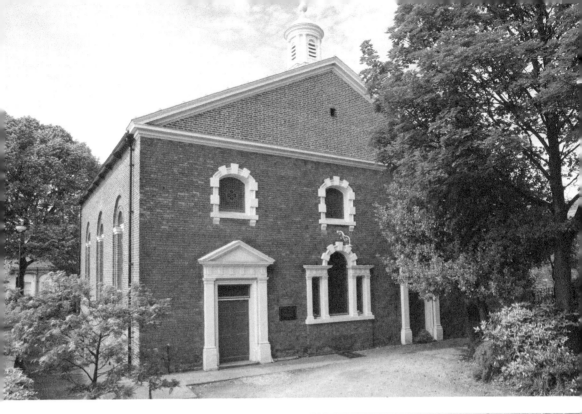

Above: The fine symmetrical front of Westgate Chapel.

Right: The interior of the chapel from under the gallery.

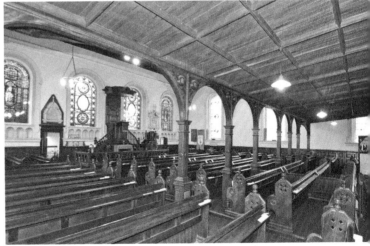

and frieze are placed to either side of a central Venetian window, the arched head of which has raised block keystones. This lights a small vestibule with staircases to each side, leading to a south gallery lit by the three segmental-arched first-floor windows with Gibb's surround. The small drum bell-cote has Doric columns framing arched openings, crowned by a ball finial. Its side elevations have three brick-arched recessed windows with stone imposts and sills; the rear has four similar windows that help define the symmetry of the superb north-facing interior. It focuses on the high canopied oak pulpit of *c.* 1737, which was brought from an earlier chapel. This sophisticated

design has all the hallmarks of John Carr, the preferred architect of the Milnes family, who were important patrons and benefactors of the chapel. They were cloth merchants who traded with Russia, taking a return cargo of timber, probably supplying the Baltic pine beams for the coffered ceiling. The box pews were swept away in the 1880s when walnut pews with raked seating and attractive carved ends were installed. The gallery, with its fine organ, was underdrawn with pitch pine, and a vestry was added on the north side. All have attractive stained-glass windows, most of which are memorials to local families. There is a striking small Gothic-style wall monument to Benjamin Gaskell, who is buried in the catacombs below the chapel. Originally funds were raised to help build the chapel by subscriptions for burial rights in the catacombs, an unusual feature of the building that is well preserved. A tunnel (blocked) leads under the road to the Orangery, which the children used for their Sunday school.

15. Pemberton House, No. 122 Westgate, and the Orangery, Back Lane (1753 and 1780)

Fronting Westgate, this three-storey detached Georgian brick house with a hipped roof and five bays of sashed windows with cambered heads, once the home of a Georgian gentleman who had a four-horse carriage, is now used as offices. It has an interesting story to tell. The rear is similarly fenestrated but with

Pemberton House fronting Westgate.

a two-storey canted bay window with stone Doric columns originally lighting the principal rooms. Its east-side elevation is irregular and maybe partly rebuilt; at the south end there are just three window bays and pedimented doorcase on curving consoles. Its entrance hall has a modillion plaster cornice, lit by windows with eared architraves, and a fine open-well stair with two turned and carved balusters with enrichments to each step. It has some nineteenth-century modifications, and several of the rooms retain casement-moulded cornices. It was built in 1752–53 for Pemberton Milnes (1729–59), the twenty-five-year-old son of Richard Milnes, a cloth merchant, shortly before his marriage in 1754. It is the smallest of the several Milnes brothers' town houses built on Westgate, constructed using their own bricks and imported timber – they owned one of the largest export houses in the Yorkshire textile trade. In 1770 Pemberton became a West Riding magistrate and then deputy lieutenant of the county (1776). In 1779 he purchased Bawtry Hall, rebuilding it to the designs of William Lindley, but Pemberton House still remained his town house. It takes on added significance because it survived the coming of the railway in 1864 and a public inquiry for its demolition in 1975. It was isolated by the railway goods yard built in its grounds and lost its outbuildings, save for the Orangery on Back Lane, which is a delightful *c.* 1780 single-storey building in a walled garden with an entrance lodge. Built in the Adam style, probably by Carr, the tall five-bay arcaded centre with arches and a swaged frieze of husks are separated by columns under a hipped roof. There are attached lower pavilions to each side with pilasters defining the bays, which were used by Westgate Chapel as a Sunday school in the mid-nineteenth century.

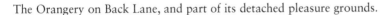

The Orangery on Back Lane, and part of its detached pleasure grounds.

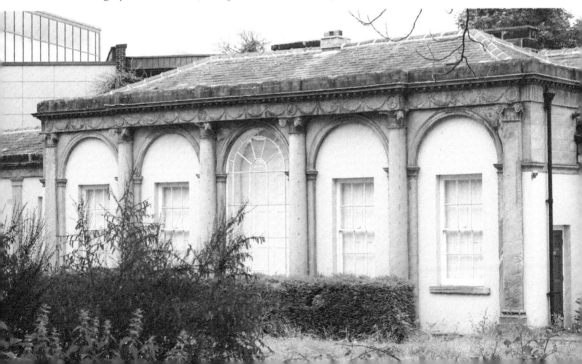

Just a mile from Chantry Bridge along the Doncaster Road, Heath Common is a large open area of rough grazing land, usually with a few ponies on it. At its heart is a large village green where the Duke of Wellington's regiment came to drill on this unenclosed common before sailing to France to fight Napoleon, where they were victorious at the famous Battle of Waterloo. The roughly square village green, where famous cricketer W. G. Grace once scored 175 for Heath as a guest player, is surrounded on two sides by large Grade I-listed mansions built close to its edge: Heath House, a Palladian villa designed by architect James Paine in around 1744, to the west; Heath Hall, designed by architect John Carr in around 1754, to the north; and the Dower House of *c.* 1740. These impressive mansions, linked by beech hedges and curving ha-has, contrast with the smaller houses and cottages on the opposite sides. This gives it a unique character with a haphazard mix of larger houses, smaller cottages and short terraced rows, some clustered together on island sites amid the common. An extension to the east retains older seventeenth-century dwellings, and another large house, Beech Lawn, of *c.* 1770. Few such commons of a similar size exist in the country, except for Hampstead Heath. Within its conservation area are some thirty listed buildings and structures of special interest. They are easily visible when following a circular walk around the common.

16. Heath Hall, Heath Common, north side (1754–80)

Heath Hall is that rare object: not just an imposing Georgian mansion but, with its flanking large E-shaped pavilions, an impressive architectural composition. They have striking clock towers crowned by an open rotunda. Begun in 1754, over the next twenty-five years John Carr enlarged an earlier Queen Anne house, a three-bay cube built in around 1700 by Theophilus Shelton to his own design. In 1709 he sold it to John Smyth, a successful and ambitious wool-stapler from Wakefield, whose son married into the gentry in 1746. He wanted a larger house more appropriate to his social standing, eventually engaging John Carr in the 1750s. For economy the original house and its basement were retained, but a bay and wings with canted ends to either side were added, containing the best rooms with curved apses internally. The join between new and old was disguised by adding four giant Ionic columns between the windows that supported a pediment, transforming it into a Palladian palace. The original house can be seen at the rear, where it projects; the corners are articulated by ashlar quoins. Internally, the oak stair with barley-sugar twist balusters was retained, but improved by Carr. One of the bedchambers still retains its Queen Anne panelling and corner fireplace. The saloon, occupying the east wing

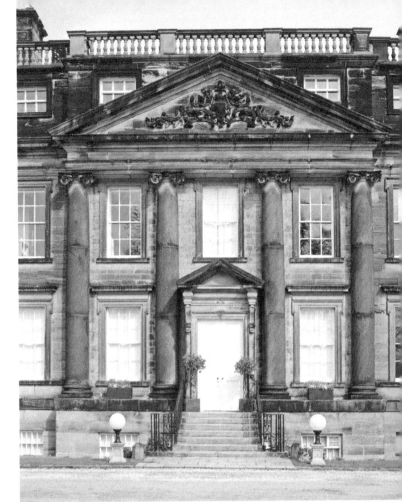

Right: The central three bays of Eshald House were retained but disguised.

Below: The original Heath Hall with Carr's extensions to either side.

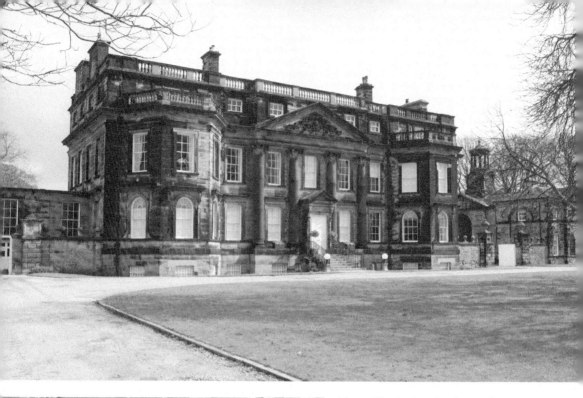

Above: The impressive front of Heath Hall after three extensions.

Left: The fine plaster ceiling of the saloon.

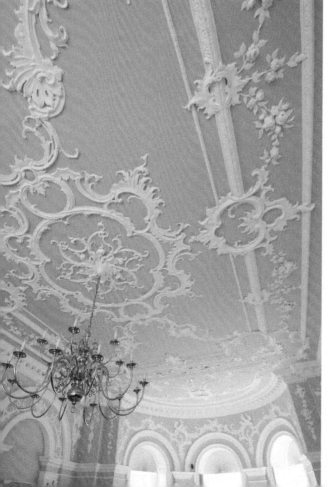

from front to back, is a well-proportioned room with very fine plasterwork decorating the walls and ceiling in a swirling Rocco style, which was the work of the York School of Plasters (Thomas Perritt and Joseph Rose), with fine doors and woodwork by Daniel Shillito. It is considered one of Carr's finest reception rooms, which could also serve as both a drawing room and occasional ballroom. His only son, John, rose in society, first becoming MP for Pontefract and then Lord of the Admiralty, the Treasury and Master of the Mint. After he inherited the hall in 1771, he eloped with Lady Georgiana Fitzroy, one of the beauties of the day, godchild of George III and daughter of the Duke of Grafton. The couple moved to Heath in 1778, commencing another programme of building work over the next two years, including a library decorated in the then fashionable Adam style, similar to Carr's work at Harewood House. In 1834 an attic storey was added to the designs of Salvin, who created twelve bedrooms off a central corridor. The fortunes of the house declined after the Second World War and it was only the timely purchase by Muir and Mary Oddie (OBE) in 1958 that saved the house from dereliction. It was restored by Francis Johnson, supervising architect, together with the pavilions and stables, which were eventually converted into dwellings. The future of the hall appears assured by its present use as prestigious offices.

17. Waterton Park Hotel at Walton Hall (1768)

Just 4 miles from Wakefield, Walton Hall is in a picturesque setting on its island surrounded by a large lake. The ancient home of the Watertons (1435–1876), the medieval building once boasted a 90-foot-long oak-panelled hall. Damaged in the Civil War in 1644, only the Watergate survives, with bullets in its door. The present three-storey classical mansion, with its unusual eight-bay symmetrical façade in figured sandstone, was built by Thomas Waterton in around 1768. In the nineteenth century a porch with Tuscan columns was added to the central double door – which has an amusing pair of door knockers that strike faces, one smiling (as it's fixed)and the other grimacing in pain. The façade has giant pilaster strips supporting a pediment over the central four bays, and the windows have raised eared architraves. The tympanum features a carved coat of arms with the strange motto 'BETTER KYNDE FREMB THAN FREMB KYEN'. It is two rooms deep, has a five-bay return and a cantilevered open-well stair with turned balusters. The splendid oak-panelled entrance hall of this country house hotel has an elaborate Jacobean carved oak overmantel, and many of the rooms retain their original Georgian doors and woodwork. The hall is approached over one of the earliest iron bridges in the country, dating to *c.* 1800, which has an elegant shallow arch. It is hard to believe, given its location, that the hall was once Wakefield's maternity hospital for a period of twenty years until the 1960s. Its real claim to fame is it was the home of the famous explorer, pioneering naturalist and taxidermist

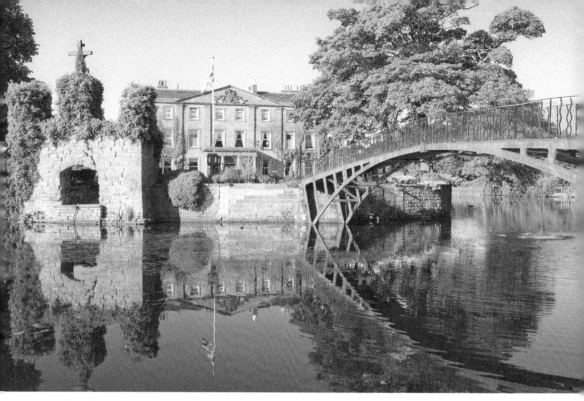

Above: Walton Hall is approached by an iron footbridge over a lake.

Below: The eight-bay front with giant pilaster strips.

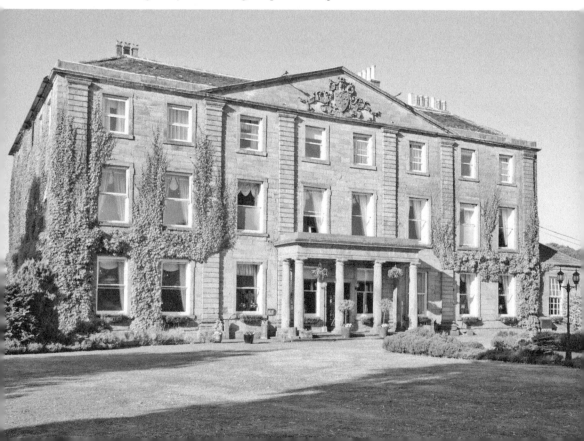

Above: The humorous doorknockers.

Right: The unusual twenty-sided sundial.

Charles Waterton (1782–1865), who created the lake and the world's first nature reserve. His collection is celebrated in the new museum Wakefield One. The family had a plantation in Guyana that took him to South and North America, which he travelled widely. He built a high wall (reputedly costing £10,000) around his estate to keep his wildlife in and poachers out. At the rear is a unique twenty-sided sundial (1813) that tells the time in different parts of the world.

18. Nos 51–55 Westgate, formerly The Great Bull Hotel (1772)

This remains one of the finest Georgian buildings in Wakefield. Grade II* listed, it was built as a hotel in 1772 on the site of the seventeenth-century Bull Inn by a wool-stapler called Hargrave, who used over a million bricks in its construction, reputedly having stabling for 100 horses. It was renamed The Great Bull in 1837 and The Great Bull Hotel in 1865. Sold in 1875, it was occupied first by the Prudential Assurance Company and then Barclays Bank. Its magnificent four-storey nine-bay symmetrical neoclassical façade is subtly articulated, with each storey treated differently. The centre five bays project under a tall pedimented gable. The façade is covered in stucco except for the brick tympanum with a modillion cornice and a roundel on carved leaves. The narrow central bay has a recessed arch with a Venetian window. The first floor has channelled rustication and the outer canted bays have domed lead roofs. The brick rear has a similar pedimented gable with a Diocletian window and a large – possibly contemporary – wing identified as 'Assembly Rooms' in plans of 1947. The central rusticated doorway, which is framed by Doric columns, is signed 'Westgate Studios', signifying the use of the upper floors for artist studios.

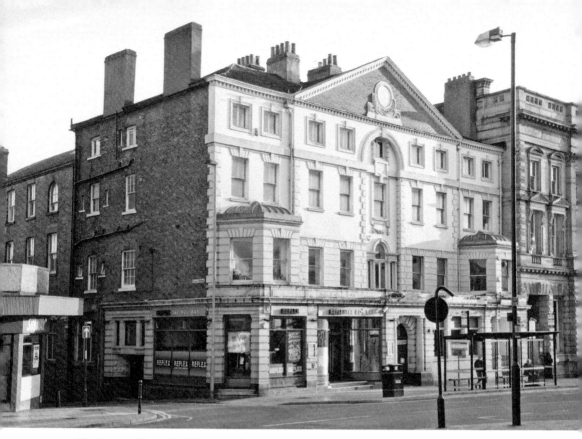

The former Great Bull Hotel at the top of Westgate.

19. York House Hotel, No. 12 Drury Lane (1775)

This fine Georgian house, Grade II* listed, is representative of merchant's houses built during the second half of the eighteenth century on the edge of the town, close to the Westgate Bar. It was built in the mid-1770s by James Banks, the ambitious son of a successful wool-stapler, who owned property on Westgate. Following his father's death in 1766, he enlarged his estate to five houses, warehouses and stables, eventually mortgaging them for £2,000 to build a new house to reflect his status as a gentleman. It is unusual in being an almost square three-storey cube, five-bays by five-bays of twelve-paned sash windows, with two symmetrical façades above an ashlar plinth built in hand-made brick in Flemish bond. The windows have finely cut 'soldiers', triple keystones and thin sills, with sill bands on the ground floor. The two pedimented doorcases differ: the south door has an impressive Gibb's surround with a triple keystone, its moulded architrave has projecting quoins and it opens into a transverse corridor to the stairs; the more modest north door, with architrave and console brackets, originally faced a large garden (mostly lost to 1980s road improvements) and opens into a long entrance hall with a casement-moulded cornice. An arched doorway leads to a stair hall where the dog-leg stair that rises through the house is lit by a tall stair window.

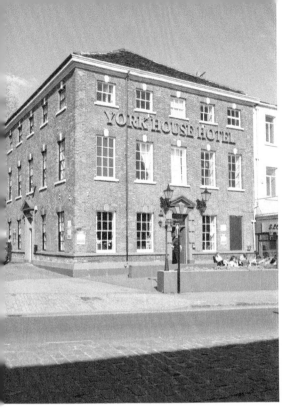
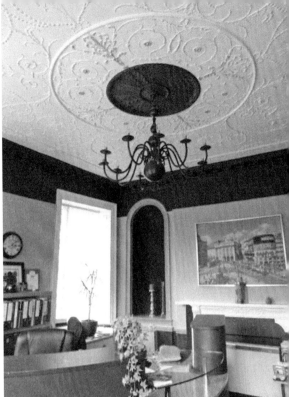

Above left: York House with two symmetrical façades.

Above right: The hotel reception with its fine plaster ceiling.

More arched doorcases with fanlights survive on each floor. Its Georgian character is preserved, with the rooms and corridors retaining thier plaster cornices and dado rails, windows with shutters and seats. The best room on the south-west corner (hotel reception) is dual aspect, having a modillion cornice around its attractive Adamesque plaster ceiling, which has arched niches to each side of the fireplace. In the 1950s it became the Wakefield and County Club, emulating London clubs. Alterations were made to the first floor, creating a suite of licensed rooms now used for wedding receptions. Shortly after building his house Banks built Wakefield's first theatre, the Theatre Royal, close by on the site of the present theatre. John Gay's *Beggar's Opera* was performed on the first night, 7 September 1776.

20. Calder & Hebble Navigation Warehouse, Bridge Street (1790)

Fronting the River Calder, upstream from The Hepworth, is one of the finest and earliest canal warehouses in the country, and is Grade II* listed. Built as a pair of warehouses in around 1790, they shared a central wet dock for unloading undercover. They were converted into a single warehouse in 1816 for the Calder & Hebble Navigation Company, when the top two floors were added. Its impressive river frontage of four storeys and an attic has a seven-bay symmetrical

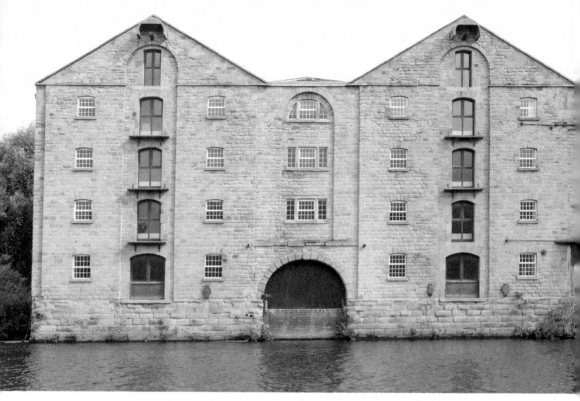

One of the earliest canal warehouses in the country.

façade with a five-bay return built above a base plinth of large roughly dressed stone, contrasting with the smooth golden sandstone walling above. This is subtly articulated with shallow projections to each alternate bay. The twin gable-fronted three-bay ranges have twenty-paned timber windows (originally with iron glazing bars) in the outer bays, with thin projecting sills and segmental-arched heads with voussoirs. The central loading bays, originally with double doors, are set within a tall arch-headed recess that rises into the gable with a projecting cat head hoist in the apex and a queen-post roof structure. The massive wooden floor frame is supported by square wooden piers. This is the flagship office development and has a new apartment block built next to it.

21. Nos 1–4 South Parade (1790s–1820)

This long Grade II-listed terrace of three-storey brick houses with sash windows is easily missed. Tucked away below George Street, this single street, laid out by William Lindley in the early 1790s on a sloping site overlooking open country on the edge of the town, was Wakefield's first attempt at a fashionable Georgian terrace. It was completed slowly over at least three decades in a piecemeal fashion at a similar time to the St John's development. Unlike the St John's terraces, there was no prescribed design. Careful observation reveals the terrace

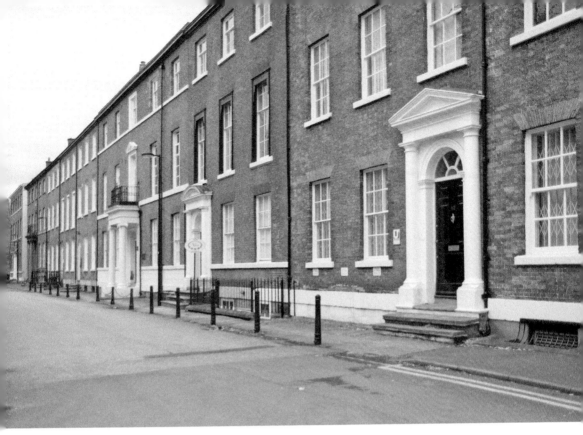

South Parade looking towards No. 10 with its projecting porch.

evolved around four substantial detached villas, Nos 1, 5, 6 and 10, all similarly treated. Each has a symmetrical five-bay façade with ashlar bands to the basement and steps to their entrance, some with sill bands to the windows, and porches with Doric columns and fanlights. No. 5 has a triangular pediment that remained a separate dwelling. The other three had short terraced rows of three three-bay houses added on to their east sides, eventually linking up to form a mostly continuous terrace, providing the manse for the Zion Congregational Church and the vicarage for Holy Trinity (demolished). It was also home to various clergy including Wakefield's first bishop. No. 6 is the most elaborate of the villas. Its Doric porch has tall stone columns with a Regency wrought-iron balcony on top, the windows having triple keystones, and the entrance hall has plasterwork decorated with oak wreaths. From 1874 until 1890 it was the home of Thomas Sanderson, Wakefield's MP and a maltster. Benjamin Watson, the mayor of Wakefield, lived at No. 8 in the 1890s. The terrace attracted the professional classes including doctors and a surgeon-dentist in the last house, No. 14a. No. 1 was the home of Frederick Thompson in 1863, a successful Wakefield corn merchant. His family lived here until 1925 when it was sold to the Wakefield DCO, who still occupy Church House. Part of South Parade's charm are the large private walled gardens to the south, where servants in the past carried trays of tea across the road to the summerhouses.

The St John's Area

The mastermind behind the impressive Georgian St John's development on the edge of the town was John Lee, a local solicitor and attorney. After setting up his own practice in 1780, he became something of a building speculator in partnership with Francis Maude, a local wool merchant. Maude was his financial backer, buying land in a piecemeal fashion in the Cliffe Field, one of the town's open fields. Their secret aim was to consolidate sufficient land to create a new town, half a mile from the old town, separated by open country, aimed from the outset at the middle classes. The development was designed for prosperous merchants, churchmen, lawyers, doctors and other professionals. As the plots fell into place they purchased a vital piece of land in 1788 entailed with a condition that it should be the site for a new church, which accorded with their plans to form a centrepiece for their development. Parliamentary approval was granted by an Act of 1791 (opening in 1795) largely instigated by Lee, who was one of the trustees. The site of the church agreed Lee needed to construct a new street to access it off Northgate. Building work began on the church in 1791 at the far end of St John's Street (later St John's North), carefully placing the east end of the church to face down the street, thereby acting as a focus for his new development.

St John's North, with the church as its focus.

22. St John's House and No. 2 St John's Square (1791–92)

In 1792 John Lee moved into St John's House shortly after his marriage to his second wife. Then isolated on its own, it faced south over a large garden as big as the square, where the building of the church and St John's North had just begun, presumably to be able to oversee his ongoing developments. This large elegant three-storey mansion has a seven-bay symmetrical façade with a plat band and a low-pitched triangular pediment carried over the central three bays. The central bay has a Doric pedimented porch, above which there is a tripartite window with turned balusters under a segmental arch. Its impressive entrance hall has fine Cuban mahogany six-panelled doors with applied astragal mouldings to the principal rooms on either side. Double doors with a glazed fanlight lead to a transverse corridor with a side door on the right opening onto the terrace (No. 2). The stair hall has an outstanding fully cantilevered stone staircase that rises to the attic storey, which is now top-lit. The two circular spoked-wheel windows in its north gable formerly lit the upper flight, which were later blocked when the adjacent terrace was built. It has an open tread with a single rod and a wrought-iron baluster of unusual design – much like a Christmas cracker in shape. The mahogany ramped

The symmetrical front of St John's House.

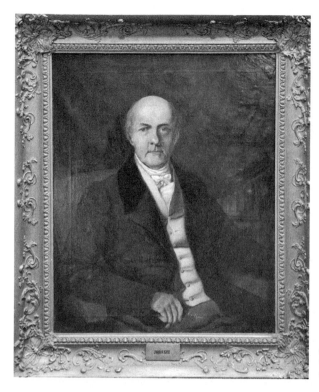

John Lee's portrait.
(Courtesy of
QEGS Archives)

handrail is balanced by the moulded dado rail on the wall. Backing against its west side wall is the more modest dog-leg back stair that goes from basement to attic. In 1964 the south end of the terrace was derelict and threatened with demolition. It was only saved by the Wakefield Charities, who purchased the end two houses for £6,500, spending another £20,500 renovating the building under the supervision of architect W. Eustace Watson (of Bairstow Square), who sympathetically converted the building for use by the Junior School of Wakefield Girls' High School (opening in 1967). Years Three and Four occupy the ground and first floors. The former garden is enclosed by its original boundary walls – now with school buildings – and an ancient mulberry tree planted in Lee's time is zealously preserved. His enigmatic portrait no doubt once hung in pride of place in his house.

23. Nos 2–24 St John's North (1791–96)

This exceptionally long terrace of twelve generously sized three-storey brick houses (in Flemish bond), listed Grade II*, originally faced open fields to the south. Lee and Maude only financed half the houses at the west end nearest the church, leasing the ground at the east end to local builders funded by an early building society, the Union Society (established in 1790), 'for the purchasing of Plots and Parcels of land'. This group of artisan craftsmen included local builder William Puckerin, joiner Robert Lee, and painter and decorator George Bennet, who were all involved in its

construction. Their financial part of the development stopped beyond the central five-bay house set under a pedimented gable, which projects slightly. To either side there are twenty-two bays, and twenty bays, of twelve-paned sash windows, with nine panes to the smaller windows on the top floor, following Georgian proportions to the design of John Thompson (d. 1792), a Wakefield architect, who stipulated that the south front should have 'good sashed windows, Stone door Cases and Stone window Sills'. This imposed a basic uniformity to the design. The terrace remained unfinished at the sale of Lee's property in 1837, completed by others with an interesting mix of doorcases. Some have pedimented porches with steps set between Doric columns, some over two doors, but some with just a large fanlight. An ashlar plinth forms a base to the uniformly matching brickwork. The windows have a ground-floor sill band painted white that, like the modillion cornice, runs across the façade, tying the elements together. The treatment of the larger central house is more elaborate, giving it a symmetrical five-bay façade with a first-floor

The sale plan, *c.* 1837, of John Lee's estate shows the unfinished terrace. (Courtesy of West Yorkshire Archive Service, Wakefield: E_WAK RN895)

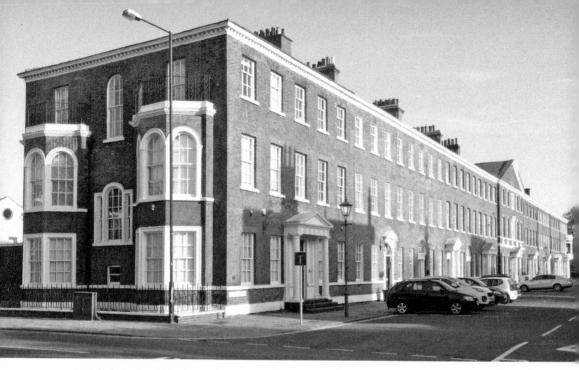

St John's Lodge. The vicar's house is at the end of the terrace.

plat band and white-painted turned balusters set below the windows, all with triple keystones. Across both ends of the terrace there are larger three-bay houses, both with two-storey projecting canted bays. One facing the church has a Venetian window at a mezzanine level, with an arched window above to light the stair. Called St John's Lodge, this was reserved as the parsonage for the vicar of St John's (located opposite) to live in, which was only completed after the church in 1796.

24. Nos 2–23 St John's Square, North and West Sides (1801–02)

Lee delayed his planned development by a couple of years, raising sufficient capital to buy out his partner Maude for £4,818. As Thompson died in 1792, he engaged Watson & Lindley to complete his L-shaped scheme for two terraces surrounding the north and west sides of the church, similar to the design for St John's North. The thirteen houses on the north side came first, built in 1799–1803, some just as shells with roofs and floors for others to complete. They have wrought-iron railings enclosing accessible front basements (to separate dwellings) similar to London terraces. Some doors have triangular or segmental pediments. Only the larger central house (No. 18) has engaged Doric columns, retaining its original six-panelled door and fanlight. A low-pitched pedimented gable is carried over the central five bays, featuring a spoked circular window in the apex identical to those in St John's House. The warm-coloured brickwork is built in garden wall bond. The façade is subtly articulated with slight projections to either side of the central bay, and to the end pavilions where No. 23 is given added emphasis by double consoles under its segmental pedimented doorcase, with urns on the corners of its

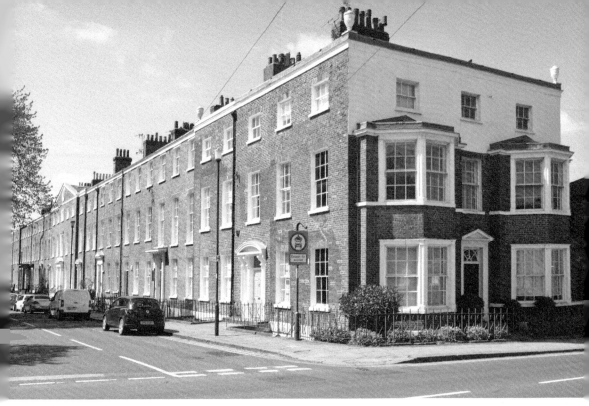

Above: The west side of St John's Square.

Right: A typical open-well stair with ramped handrail.

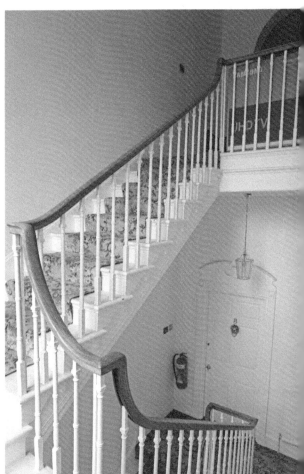

roof matching those on the church. The end house has a three-bay symmetrical façade with two-storey projecting bays to either side of its pedimented doorcase. The larger eight houses on the west side (facing north), built in 1801–02, are similar but the doors mostly lack pediments, though have fanlights. A white-painted sill band links the first-floor windows, which have attractive small semicircular wrought-iron balconies. The wider central five-bay house has a pedimented doorcase, which is approached up a flight of stone steps with alternating wavy and rod railings. A tall arched stair window at the rear lights a dog-leg stair with simple stick balusters and a ramped handrail. Other properties have similar stairs with long windows at the rear. The terrace is built on to and integrated with the back of the earlier St John's House, and No. 2 leads into its transverse stair hall.

25. Church of St John the Baptist (1791–95)

The east end of the church has a narrow chancel, which is blind except for a niche for a statue of St John the Evangelist. This extension to the original church, designed by J. T. Micklethwaite (1881), replaced a shallow sanctuary, completed in 1905. The present entrance at the west end, in the base of the tower, leads into a round

Elegant Church of St John is the focus of the square.

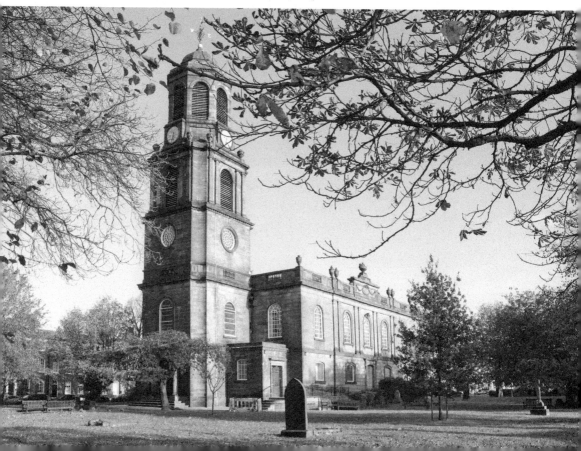

stairwell with two cantilevered stone staircases to the gallery. It was designed and built in 1791–95 by Charles Watson and William Lindley as the focus of the new square. Lindley's influence is apparent in its clean neoclassical lines, built in the Carr tradition, whose office he had worked in. Both this church and Carr's masterpiece at Horbury (1791–93) are contemporary with each other and feature the main entrance on the south side. This has a five-bay façade and the central three bays have rusticated stonework. Doric pilasters cut from figured stone (as at Horbury) frame arch-headed windows that originally lit galleries on the north and south sides. The square tower (rebuilt in 1895) unusually has cut-back corners rising in four stages, featuring circular windows, arched belfry openings, and clock faces below the octagonal belfry with a domed cap. The light airiness of the impressive interior is reminiscent of collegiate churches and the work of Wren. However, the truth is surprising, in that this was only achieved around 1900 after the removal of the galleries and the insertion of new stone columns supporting round arches, matching the tunnel vault in the chancel dated 1905, with new plaster ceilings decorated with circles and rectangles. The west gallery survived but was given a new oak front to match the oak choir stalls and panelling in the chancel, where the high altar has a superbly carved reredos with segmental pediment above an Italianate large painting of the Crucifixion, which is framed by carved swags in the style of Grinling Gibbons (made by J. E. Knox (London, 1900–12). Its setting is enhanced by the black-and-white-tiled floor. Set below the nave are catacombs not dissimilar to those under Westgate Unitarian Chapel built earlier.

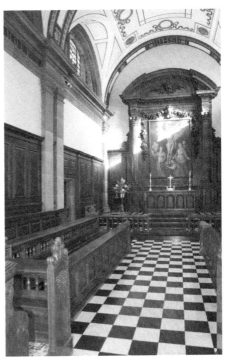

The barrel-vaulted chancel of 1905 and altar reredos.

Horbury

Horbury, a few miles to the west of Wakefield, contains two Grade I-listed buildings of outstanding interest. They stand opposite each other on Church Street at the heart of this small town's conservation area. It is surprising to find the medieval Horbury Hall and the fine Georgian church in this modest town, and they are well worth seeking out.

26. Church of St Peter & St Leonard, Church Street (1791–94)

This is the finest late eighteenth-century church in West Yorkshire, built by John Carr (1723–1807) at a cost of £8,000 and opened in 1794, replacing an earlier Norman chapel of ease in the ancient parish of Wakefield. The son of Robert Carr, a stonemason, John was to rise above his humble origins to become a distinguished

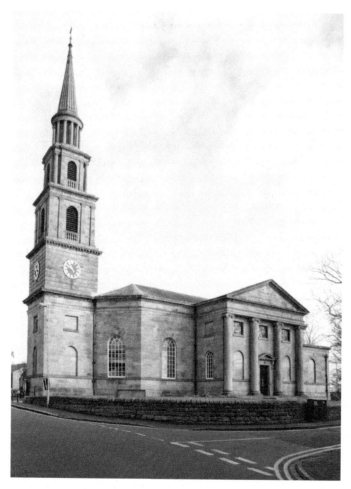

The church dominates the old village of Horbury. Its tower is a landmark.

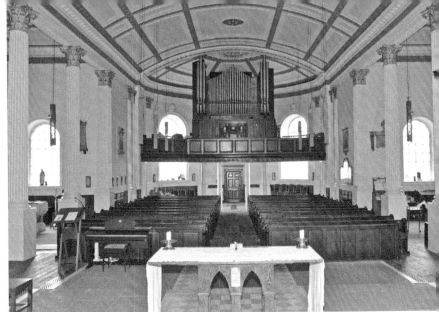

Looking towards the gallery from the sanctuary.

architect much favoured by the Yorkshire gentry, a magistrate, and twice Lord Mayor of York. Constrained by the tight elevated site, Carr designed a church of great originality more like a London church by Wren. The tall slender tapering tower of four stages is an eye-catcher, crowned by a circular colonnaded rotunda with a fluted conical spire. The church has canted ends under a hipped roof with a symmetrical south elevation, and the central three-bay projecting portico faces the street. Its pedimented temple front has giant engaged Ionic columns with figured stonework like draped fabric, the tympanum bearing a Latin inscription recording Carr's gift to his birthplace in 1791. The gabled pediment rises above the roofline, throwing it into prominence and creating a strong north–south axis, which is emphasised by the stepped approach to its central entrance. Today the church is entered on the north side, which leads into the transept. The door is framed by giant fluted Corinthian columns, which continue as pilasters around the church. Internally the church is in essence a basilica, housing two curved apses. Tuscan columns support a west gallery with a wooden-panelled front and an impressive-looking organ by Harrison & Harrison (1921, Durham). To either side of the altar there are memorials to Carr and his parents in similar classical frames. The small Lady Chapel (1921) has good contemporary stained-glass windows, a poignant war memorial.

Wakefield Town Centre

27. No. 5 Crown Court (Old Town Hall) and Lock-up, No. 16 Kings Street (1798 and c. 1850)

Built in 1798, originally this was the Assembly Rooms, with a music hall on the first floor opening in 1801, and from 1803 a printing press in the basement publishing *The Wakefield Star*. Spiked railings protect the light well for the

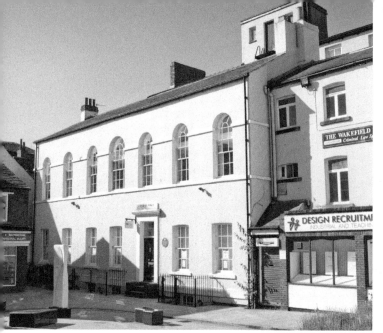

Above left: The elegant former Georgian Assembly Rooms in Crown Court.

Above right: The iron-bound door of the lock-up.

basement windows. This elegant brick building is rendered with smooth-faced painted stucco and has seven bays of sash windows, with cambered heads on the ground floor but with taller semicircular arched windows with an impost band above to light the generously sized hall. The off-centre door has 'TOWN HALL' carved above and dates from around 1848 when it became the Corporation's public offices until 1880. In 1893 the lofty hall became Alfred Kirkland's organ factory for nearly twenty-five years, and after this it was used for offices. The contemporary police station (Nos 14a and 16 King Street) was attached against the south gable, which has an impressive iron-bound door for the lock-up. The Assembly Rooms was replaced by the new and larger music room on Wood Street in 1820. When the new Town Hall opened the police moved to larger premises at Tammy Hall, sharing the building with the fire service.

28. Cheapside Warehouses and Terrace of Houses (1802–20)

Cheapside is considered the longest continuous street of surviving wool-staplers' warehouses in England. It was built on a new street following the line of the medieval burgage plot shortly after 1801, when the sale of property and land released the area behind Westgate for development, initially by wool-staplers Harper and John Soulby. Three warehouses were added on its west side in 1806, with more built opposite by 1812. Gradually, by the time of Walker's map of 1823, the street filled with a dozen or more warehouses. The south end of the street is narrow and crowded between the tall three-storey buildings. Most have canted brick window

Above left: A typical loading bay and hoist on Cheapside.

Above right: Looking down Cheapside towards Westgate.

heads, some with small-paned sashes, and all with the ubiquitous central loading bay with a projecting timber hoist head. Some also retain their man-driven wheels on the top floor, used for raising and lowering sacks of wool to each floor. No. 19 is four storeys high with a seven-bay symmetrical façade retaining four-paned sashes. Its loading doors are now windows, and it is the only one to be listed. It is now used as offices. Cheapside represents a significant survival of Wakefield's industrial past from a time when it was the principal market for wool in the county.

29. Stanley Royd Hospital, now Parklands Manor, off Aberford Road (1818)

This large classical-style Georgian building, built in a white brick and roofed with Welsh blue slates, is a 2005 residential conversion of Stanley Royd Hospital (closed in 1995), which was originally the West Riding Pauper Lunatic Asylum (1816–18), into apartments. The asylum was designed by Watson and Pritchett, who won the competition for a 150-bed asylum. Built in a H-plan, it has three-storey cross wings containing single rooms along galleries with low octagonal towers at their intersections. These rise a storey higher and look like pillboxes above the roofline. These were integral to the design as they contained spiral stairs and openings overlooking wards, corridors and exercise yards so that patients and staff could be kept under close but discreet scrutiny – a variation of the 'panopticon' layout. Its E-shaped entrance front has a central pedimented three-bay wing flanked by long wings with twelve-paned sash window. An octagonal stone tower with an open

The former Stanley Royd Hospital, now apartments.

circular cupola with a domed cap rises above the roof. Not merely an architectural device, this was part of the ventilation and heating system for the building. This asylum represented the most advanced thought on the design of such buildings, and was part of the contemporary belief that patients should be treated humanely and attempts made to cure them. Further matching wings were added in 1828 and 1833, and recovery rates gradually rose to as much as 41 per cent in the 1840s, attracting distinguished psychiatrists such as Dr Henry Maudsley and Dr (Sir) James Crichton-Browne, director from 1866 to 1876.

30. The Gissing House, Nos 2–4 Thompson's Yard, off Westgate (c. 1820–30)

An open carriage archway on Westgate leads to Thompson's Yard where Nos 2 and 4 are set at an oblique angle to the street frontage following the alignment of the medieval burgage plot. This elegant former Regency home of the Gissing's, purchased in 1865 for £2,940, has a good door with architrave surround to the left of a large two-storey three-light canted-bay window with pilasters. An old plaque states: 'This tablet was erected to commemorate the birthplace of George Robert Gissing (1857–1903) Novelist and Man of Letters.' A trust was formed to preserve the house as a museum (open on Saturday afternoons from May to September). The door opens into an attractive stair hall, which include internal doors with applied astragal mouldings, a typical Regency detail. The museum on the first floor has a well-preserved sitting room, with Gissing's portrait hanging above the fireplace and his parents' portraits to either side. The room contains a scale model of the house and a comprehensive library of his books and pamphlets, some of

Above left: Thompson's Yard and entrance to the Gissing Museum.

Above right: The museum in the first-floor sitting room.

which are for sale. An interesting audio-visual display tells of the life and work of this fascinating late Victorian novelist and literary critic, who died in France.

31. The Waterton Building and Mechanics' Theatre, Wood Street (1822)

This was originally built as the Public Library, Newsroom and Music Saloon (1820–21) to Watson & Pritchett's winning design. Its five-bay symmetrical façade of sash windows with a central entrance has survived well due to the quality of its ashlar stone, the basement plinth with channelled rustication. Its severe Greek style is relieved by the recessed upper storey. The windows are framed by engaged Ionic columns with coupled pilasters at the corners, and the sides have tripartite windows. At the rear a projecting full-height semicircular bay lights the stair. Its central entrance hall divides the ground floor into two halves to suit its multiple uses, which even included a savings bank, with an apothecary and dispensary housed in the basement. The imperial stairs lead to the Music Saloon (opened 1822). In 1841 it was leased by the Mechanics'

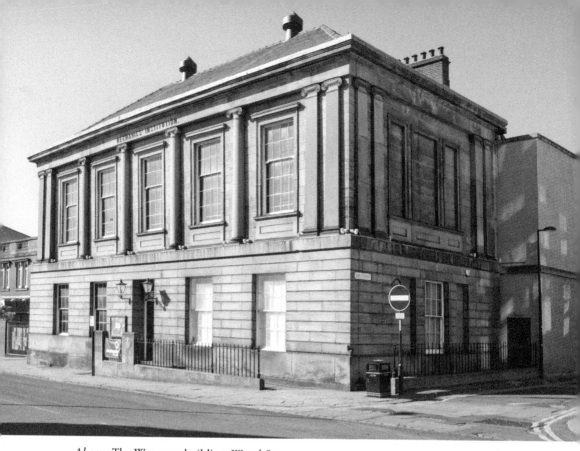

Above: The Waterton building, Wood Street.

Below: Engraving of Wood Street, *c*. 1823, taken from Walker's map. (Courtesy of West Yorkshire Archive Service, Wakefield: E_WAK RN895)

Institution, who purchased it in 1855. In 1936 Wakefield Council purchased the building, using it for the city's museum from 1955 to 2013, when it moved to Wakefield One. Now a performing arts centre for Wakefield College and renamed the Waterton Building, it provides drama and dance studios, and has the 160-seat Mechanics' Theatre on the first floor.

32. St Austin's RC Church, Wentworth Terrace (1828–80)

The plans for St Austin's, the first Roman Catholic Church in Wakefield since the Reformation, were prepared by Joseph Ireland in 1824, when fundraising began. Squire Waterton of Walton Hall and his brother were the largest benefactors. Built by William Puckrin, who added a basement below the chapel, it opened in 1828. It has a complex development with various alterations and additions made over the years and stands as Wakefield's Roman Catholic cathedral. In 1850 the entrance was moved to the north side, and the interior was embellished with plasterwork, a gallery was added and the windows were altered with Romanesque-style inner frames under the supervision of Andrews & Delaney (Bradford). In 1878–80 Joseph Hansom further altered the building, linking the church to the adjacent presbytery and adding a baptistery, sacristy and sanctuary, which is the focus of the church at the opposite end. All the projecting elements on the north side (except the Parish Room of 1930), are additions made in 1878–80. The church was reordered 100 years later in 1990, when the seating was altered with a central nave and side

St Austin's RC Church on Wentworth Street.

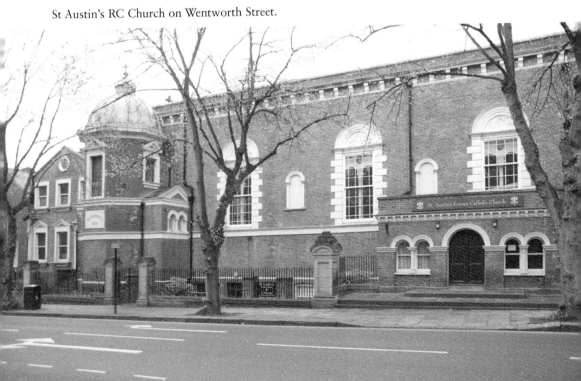

The rich plaster decoration of the interior is confined to the sanctuary.

aisles. The south side from the presbytery's garden gives a good impression of how the church looked – it originally had plain brick walls. The straight joint in the brickwork at the west end marks an addition, as do the tall square-headed sash windows. This discrete architecture was used to fit in with the street scene before greater religious tolerance. On the north side the classical decoration is cosmetic, and the windows have been 'improved' with added quoins and arched heads. The semi-octagonal tower with a lead dome bears the misleading date 1828, the original date of the chapel, even though the tower was added fifty years later. It contains an interior of great quality and refinement. The Roman decoration of the lofty chancel features six giant Corinthian columns framing the altar sanctuary and an attractive coved ceiling with exquisite plaster decoration. At the rear a modern narthex under the elegant gallery on the slenderest of cast-iron columns supports a striking original organ case. The church was listed Grade II in 1989 following a spot list request prepared by the author when working for the West Yorkshire Archaeology Service.

33. Church of St James with Christ, Denby Dale Road, Thornes (1831–44)

The Church of St James was built (1829–31) on the southern approach to Wakefield to a simple classical design by Samuel Sharp (1808–74) and was funded by the Million Pound Act and the Gaskell family of nearby Thornes House. Built of golden-coloured sandstone, it has three-by-five bays of tall small-paned sash windows in architrave surrounds with boldly projecting casement-moulded cornices; the doorways to the sides are similarly treated. The principal door in the base of the projecting square west tower has an architrave cut from diagonally veined watermarked stone. The tower has a blind circular window below the octagonal bell turret with a lead-covered dome. The east end has a square extension, added in 1844, containing the chancel, which is framed by Corinthian pilasters, and has a stunning altarpiece, a copy of Guido Reni's poignant *Crucifisso*

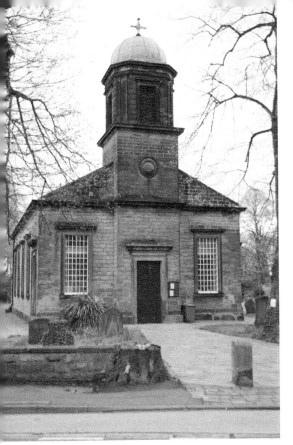

Above left: Church of St James, Thorne. The tower entrance fronts the main road.

Above right: The added chancel with stunning altarpiece.

of 1619, a gift from Mrs Milnes Gaskell. The light interior is like a collegiate chapel without the stained-glass windows, and has a west gallery with a panelled front carried on thin cast-iron columns. The simplicity of the oak pews and limed choir stalls to either side of the central parquet-wood floor throws a focus on the chancel, which adds a richness that the church otherwise lacks.

34. Queen Elizabeth Grammar School, Northgate (1834)

It is perhaps no coincidence that the West Riding Proprietary School was founded in the same year as the passing of the Great Reform Bill of 1832. This gave the middle classes the right to vote for the first time. They wished for their sons to have a liberal education (at an affordable price) to rival the grammar schools, but with a curriculum that included mathematics and modern languages, considered more use to the sons of merchants and industrialists than classics and Latin. Supported by the Earl Fitzwilliam, the Earl of Mexborough (Savile family) and Charles Winn of Nostell, the competition design of Richard Lane (Manchester) was chosen. Funded in part by shareholders (who bought £25 shares), the school opened in

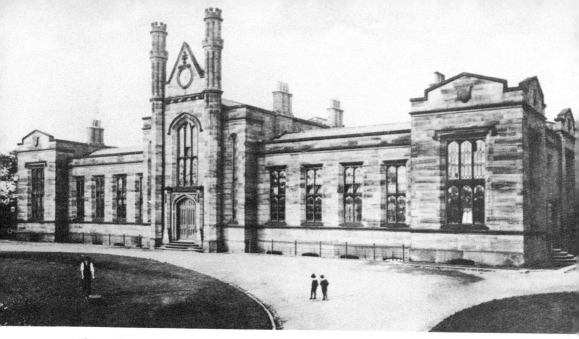

Above: Nineteenth-century photograph of the school. (Courtesy of QEGS Archives)

Below left: The Gothic arched top-lit corridor.

Below right: The war memorial for QEGS to the side of the school.

1834 with ninety pupils. It was widely copied in other towns, causing its numbers to suffer, until after twenty years the building was offered for sale in 1853. This coincided with a desire by the head of the Elizabethan Grammar School in Brook Street to seek new premises. It was too good an opportunity to miss and the Revd P. Yorke Savile, the son of the earl who had laid the foundation stone, secured it at auction for £4,050. QEGS have occupied the building ever since and have a growing national reputation and alumni. It is an impressive E-shaped mock-Tudor Revival ashlar-faced stone building with an eleven-bay symmetrical façade. It has clean classical lines to the long four-bay ranges of transom windows, which has a parapet and sill band, to either side of the taller central Tudor-style porch. The towering octagonal corner turrets soar like embattled minarets and frame a steep gable with a clock. The double doors and tall window above are set in Tudor arches and have Gothic-style tracery and glazing. The outer pavilions have similar large windows. Internally the central hall and transverse corridors have vaulted plaster-and-wood ceilings. There are good stone staircases in the end pavilions with cast-iron balusters, which, like the boundary railings, imitate Gothic tracery. The school's own war memorial (1921) by W. H. Watson features a lone bronze bugler.

35. Crowther's Almshouses, Nos 11–25 George Street (1838–63)

In an urban context, original stone boundary walls and railings help to define a building's curtilage when it's built close to the street. This is the case with this interesting row of almshouses on the south side of George Street. This is a good example of Victorian paternalism, an attractive 'Tudorbethan' style of architecture. The Tudor-style pointed-arched doorways alternate with two light mullioned windows with arched heads, which is all framed by hood moulds with straight returns. This produced a symmetrical arrangement of seven individual cottages. The central two-storey tower has windows to either side of a door with a moulded architrave. This originally led to the trustees' first-floor boardroom.

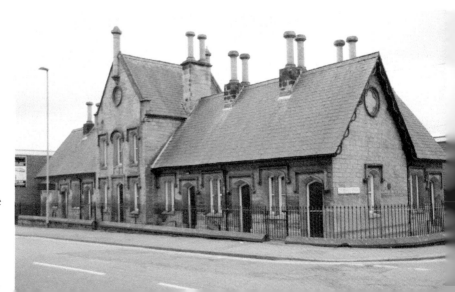

Crowther's Almshouses fronting George Street.

A roundel in the apex is inscribed 'Alms Houses/FOUNDED BY/Caleb Crowther M.D./A.D. 1838'. Each cottage has a pair of tall circular stone pots on the steeply pitched blue-slate roof, which oversails the eaves. The gable ends have Gothic-style decorated timber barge boards and a blind quatrefoil in the apex. The rear is similarly fenestrated now with ramps to the partly glazed rear doors, which were added when the cottages were modernised. In the burial ground at the rear is Caleb Crowther's gravestone. He died in 1849, ten years after his foundation memorial, which records: 'he attended the Public dispensary regularly for 54 years and the West Riding Pauper Lunatic Asylum for more than 8 years.' Crowther was a member of the Zion Congregational Chapel, endowing these almshouses 'for the benefit of Christian dissenters from the Church of England of any denomination' (except for Catholicism). They were built as shells and only completed later, not opening until 1863. The blue plaque on its tower records that the building was designed by William Shaw, 'railway contractor and fellow worshipper at Zion Chapel nearby'. The building is still used for its original purpose, providing the residents with rent-and rate-free accommodation.

36. Cliff Hill House, Sandy Walk (1840)

This is one of a pair of stylish Italianate villas built in brick (in English garden wall bond) with ashlar dressings. It is just off Balne Lane, close to where an ancient wych elm once grew. Cliff Hill House was built in 1839–40 in the early years of Queen Victoria – but designed resolutely in Regency style – on land sold in the 1837 auction of John Lee's St John's estate. The most striking feature of its three-bay façade is the depth of the oversailing eaves of its hipped roof, which is boldly carried on timber modillion brackets. It has an ashlar plinth and lintels to the windows. A platband runs across the façade with a recessed

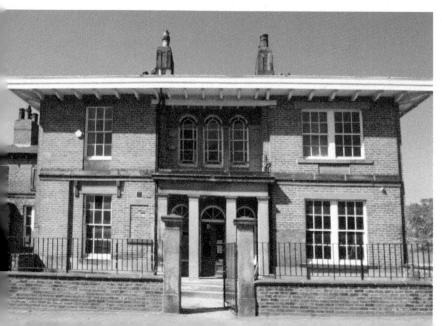

Cliffe Hill House with Regency detail.

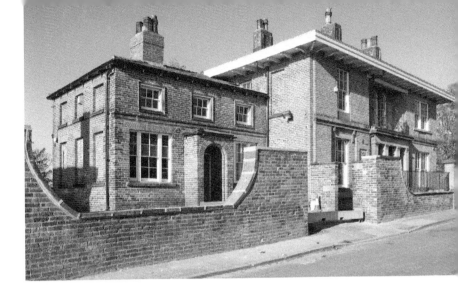

Oblique view showing the cottage to the side.

centre, and its entrance door and side windows with arched fanlights are set behind a screen of stone pilasters (like square columns), which support an entablature with a projecting cornice. The three-light window above retains the original margin-glazed lights and a railed balcony. Originally symmetrical with twelve-paned sashes and an ashlar apron, the right-hand bay was altered to two windows. Set back is a smaller three-bay cottage with an open porch and tripartite windows to either side. These have finely rubbed brick 'soldiers' contrasting with the stone surrounds of the square windows above. A moulded ashlar platband runs across its façade. It was built for John Bennington, a Quaker and prosperous draper with a shop in the Market Place. After his death it passed through various hands before it was eventually sold in 1879 for £3,500 to Miss Eliza H. Mackie, sister of Bownas Mackie, Wakefield's MP, who lived at St John's House close by. She was a friend to the Gissing children, who had lost their father when they were quite young. After her death in 1898 the building was leased to Margaret and Ellen Gissing, who ran a private boys' preparatory school here in 1906, a few years after the death of their illustrious brother, the novelist George Gissing. There were two classrooms, one on each floor. The boarders were probably accommodated in the attached cottage. Its setting is much enhanced by the boundary walls, which have a ramped coping at the front.

37. The Former Zion United Reformed Church, George Street (1844)

This prominently sited Grade II-listed corner building at the junction with Rodney Yard, a former Nonconformist chapel of 1844, was converted to apartments in 2005. It has a striking if not unique design of tall semicircular arched windows set between ashlar pilasters, which has a continuous impost band and hood mould. This is carried around the three sides of its five-by-seven-bay façades, which retains its original small-pane glazing with continuous circles in its margin lights. The wide central doorway of its south-facing five-bay symmetrical entrance front retains

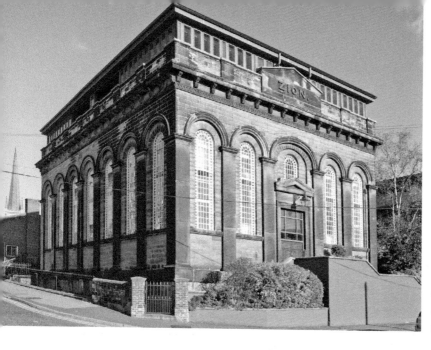

The former Zion Chapel, now apartments.

double doors and a grid glazed overlight. A deep parapet has ashlar panels, the central one carved with 'ZION' in bold relief, and a bracketed cornice carved with guilloche decorated frieze. The penthouse extension has a continuous run of small rectangular windows. Its shallow-pitched pyramidal roof oversails the windows, acting as a cornice. While the interior gallery has been removed, it has an internal atrium. The inserted floors of this sensitive conversion are set back from the original windows, which have been retained. The building remains an externally unaltered landmark and has a sustainable future as residential apartments.

38. Kirkgate Railway Station, Monk Street (1854)

Kirkgate station was named as 'one of the worst in Britain' in 2009 by Labour Transport Secretary Lord Adonis. It was semi-derelict and unmanned then with a threatening underpass to reach the down platform, and lacked even basic facilities following major demolition work in the 1970s. The main station building was just saved by its listing in 1979. After several hard years of construction work to upgrade this station, the transformative vision of the regeneration charity Groundwork is bearing fruit. The former booking hall is transformed with a new roof and glazing at balcony level, which has small individual shops or meetings rooms for hire. The new coffee shop with its first-class lounge is a welcome addition. The greatest surprise is the underpass, which is decorated with paintings by Holmfirth artist Ashley Jackson, including his life-size cut-out and the truism 'Many people look but only a few see'. Brass band music brings a smile to weary commuters on their return home. The station forecourt has been resurfaced and new landscaping includes a turning circle and car park. Long, sweeping graduated and curving stone steps greatly enhance the main entrance. The station has been restored back to some semblance of its original state, as constructed by George

Right: The former booking hall.

Below: Westgate railway station with new landscaping.

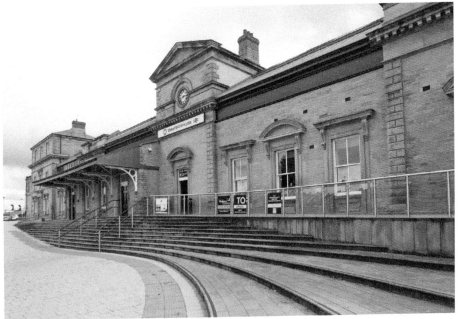

Thompson & Co. (Manchester) in 1854. The golden sandstone walls of its long elegant Italianate façade have been cleaned. Originally symmetrical the eight-bay central block had low end towers and a taller central clock tower, but with an off-centre canopy on cast brackets. Three-bay ranges linked to end pavilions

under hipped roofs; the left one was raised another storey to provide domestic accommodation. The platform side is built of brick with stone lintels and quoins, and now has a new glass-and-steel canopy on Y-shaped supports. This was Wakefield's first station, which was opened in 1840 by the Manchester & Leeds Railway, connecting the two cities via the North Midland Railway, which it joined at Normanton and ran through Kirkgate to Hebden Bridge. The completion of the Summit Tunnel the following year (1841) opened the line up to Littleborough, Rochdale and Manchester, which is still functioning nearly 200 years later.

39. Town Hall, Wood Street (1877–80)

The creation of municipal boroughs with mayors and elected councillors in around 1850 led to new town halls being built as a means of expressing civic pride: Leeds came first (1858), followed by Halifax (1863), which were both in a classical style with towers; Bradford came ten years later (1873), built in an Italianate style with

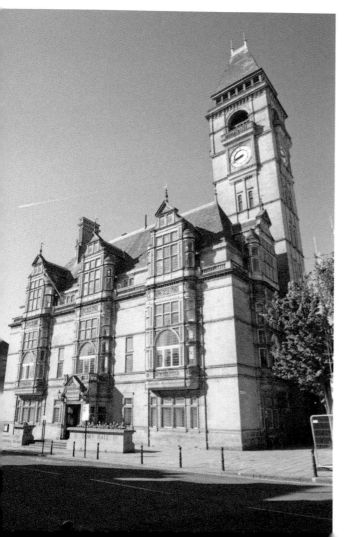

Wakefield Town Hall, Wood Street.

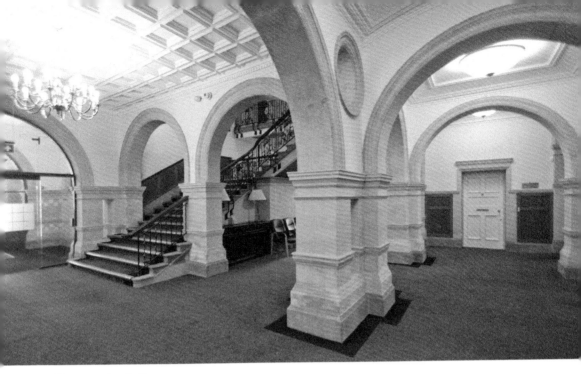

The reception hall.

a tall central tower; and then Wakefield's (1880) was built, which is considered the most original of the Yorkshire town hall designs. This competition-winning design by London architect Thomas Edward Collcutt broke the mould, and was chosen from thirty-five entries. Its tall 149-foot-high campanile clock tower was an instant landmark; placed asymmetrically at the rear, it adds to Wakefield's skyline. The relatively narrow but tall three-bay hipped roof building is squeezed between the Courthouse (1810) and the Mechanics' Institute (1823), contrasting with them and enlivening the street scene. Constructed of Spinkwell stone from Bradford, its symmetrical façade features three flamboyant projecting oriels that rise from the first floor to above the eaves line. It huge dramatic dormers terminate in tiny pediments. Echoing north European architecture, it is characteristic of the elaborate mullioned-window façades of England's Elizabethan mansions, such as Wollaton Hall (Nottingham). The entrance hall has a coffered ceiling and arcades of stone arches, with one framing the open-well stone cantilevered staircase that leads to the principal meeting rooms on the first floor. As the designer of the Savoy (London), Collcutt's reception hall feels a little like a hotel, and is much enhanced by its new lift. Now home to the Registry Office since reopening in 2016 after a refurbishment, its several meeting rooms are popular venues, especially for weddings. The impressive Kingswood Suite, which is 90 feet by 45 feet and lavishly half-panelled in American walnut, has a fine Jacobean-style plaster ceiling and frieze. This is lit on two sides by the large oriel windows with inner Venetian arches, and the fireplace has a tall pedimented overmantel. The Old Court Room served as the magistrates' court until recently, but now has a new open area in the centre, which is used for meetings and exhibitions. Its character is retained, the oak-panelled judges' dais and recessed jury area contrast with the utilitarian tiled public gallery.

40. Unity House, Nos 79–83 Westgate (1878–1908)

This large and impressive three-storey brick building owes it origins to the initiative of the prison officers of Wakefield Prison, who became shareholders in an enterprise to purchase food and goods at wholesale prices, forming the 'Wakefield Industrial Society Limited Central Stores' on Bank Street, dated 1878. Built to the designs of architects W. & D. Thornton in 1876 using a coarse russet-coloured brick, its Venetian Gothic façade has many tall narrow arched windows to its upper floors with linked stone lintels. It retains its original shopfronts (painted grey). Originally above the large shop windows were signs for different departments: 'Groceries & Provisions', 'Carpets', 'Drapery Department', and 'Central Stores' on the angle with Westgate, with 'Offices' over the central doorway and a carved-head lintel. The flagstone pavement and road laid with stone sets enhances its Victorian setting. It was massively enlarged between 1899 and 1902 by A. Hart, who added a three-bay range built on Westgate in a smoother brick with keyed-arched stone windows on the first floor. The ground floor retained its shopfronts and engraved facia, which still has 'Boots & Shoes' and 'Butchering'. This forms a link to a taller gable-fronted wing, which was similarly treated but with a large Gothic arched

Former shops on Bank Street.

tracery window lighting the upper storeys of Unity Hall. A carved stone plaque below is decorated with rural industries (a plough and a spinning wheel) and transport (a galleon and a steam-engine) with the symbolic hive of industry is at the centre. The return on Smyth Street has nine tall arched windows lighting the magnificent hammer-beam-roofed assembly hall. This was the venue for many memorable events in the past, including a talk by George Bernard Shaw.

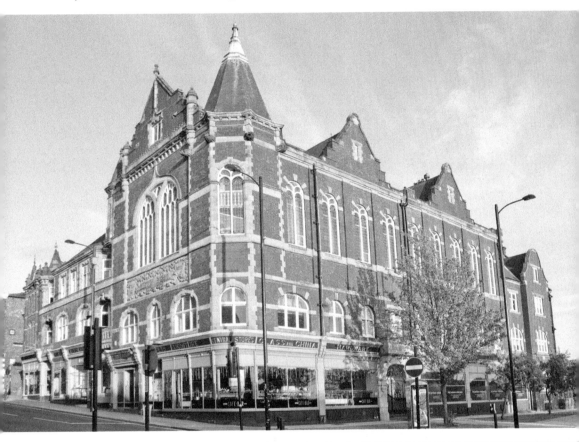

Above: Unity House at the junction of Westgate and Smyth Street.

Right: The Unity Hall with its hammer-beam roof.

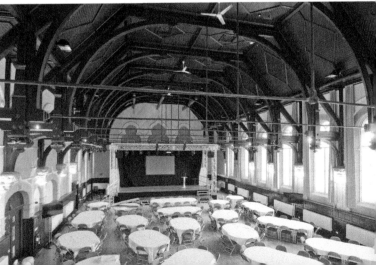

It temporarily closed in early 2018 before reopening for its first event, an award ceremony on 8 June 2018. Its stone-arched entrance has a carved-head keystone and fine wrought-iron gates in art nouveau style, which incorporated Wakefield's coat of arms, the fleur-de-lis. Following the decline of the Co-operative movement the property was bought by Wakefield Corporation in 1971. The former shops are now leased and its halls and meeting rooms are available for public hire.

41. Nos 57–59 Westgate, former Wakefield Building Society (1878)

This building embodies the Victorian concept that banks should be large and impressive tall edifices to help instil confidence in the public – common after a period when several went to the wall during the first half of the nineteenth century. Built in 1877–78 for the Wakefield & Barnsley Union Bank, described by Pevsner (in 1959) as 'the most ambitious High Victorian office building in the town', it was one of the last designs of the prodigious architectural practice of Bradford architects Lockwood & Mawson, shortly before the death of Henry Francis Lockwood in 1878. It is in essence a three-storey Italianate palazzo with a seven-bay symmetrical façade, except for the larger open doorway leading to Albion Court, built on one of the medieval burgage plots that runs downhill from Westgate behind the building. The stonework is reinforced by a cast-iron plate

Nos 57 and 59 Westgate.

Carved head keystone of William
Stewart.

to each side that perfectly matches the mouldings of the plinth. Built of ashlar
blocks, the stonework is rusticated. The ground-floor windows and doorways
have voussoirs with vermiculated stonework and carved head keystones showing
figures from classical antiquity: Mars, Minerva, Venus, Diana, Hebe and Mercury.
The central highly decorated doorframe with a segmental pediment has a plaque
inscribed with the conjoined letters of the original bank 'WBUB' and a keystone
featuring the carved bearded head of William Stewart, a local colliery owner and
later the deputy steward of the manor of Wakefield. The two doorways have
large formidable double doors. These are sufficient to withstand Wakefield's
night-time revellers – the building is now used as a nightclub. The upper-floor
windows have triangular pediments to the first-floor former boardroom, and
segmental pediments to the top floor. The central three bays are framed by giant
fluted attached Corinthian columns that support the slightly projecting deep frieze
below the decorated parapet with a central clock. The former bank was taken over
by Barclays in 1916, followed by the Wakefield Building Society in 1923 when it
was refurbished with a lift. The large banking hall has a fine plaster ceiling. This
former street of banks is now mostly occupied by bars and nightclubs.

42. Old Police Station and Fire Station, Cliff Parade (1879)

A new police station, which incorporated parts of Tammy Hall on Cliff Parade,
was built in ashlar stone (1877–79). It was linked by a high wall with an entrance
to a rear yard, and a new fire station on Gill Street, originally for hand- or
horse-drawn fire engines. On the opposite side the rendered long range contains
holding cells with a tunnel to the Town Hall and steps leading directly into the

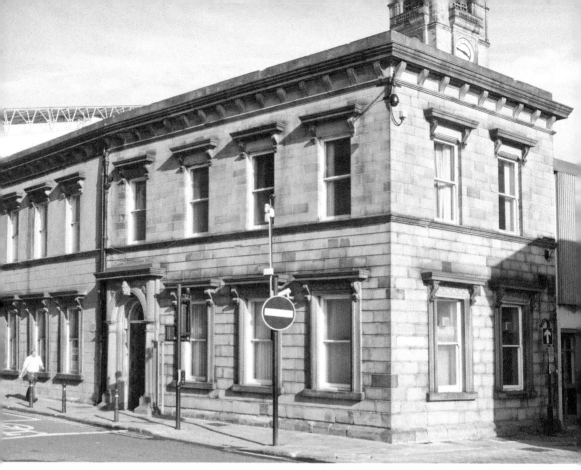

The former police station, later extended to the left of the door.

dock in the courtroom. Built in an Italianate style, it features interesting carvings: the keystone to the entrance of the police station features a 'bearded police officer of stern yet benign aspect wearing a traditional helmet' (listed building description), and hooded windows with console brackets, the frieze of which are carved with linked circles thought to represent handcuffs. The gabled façade of the fire station on Gill Street features delightful carvings of firemen with curling hoses set high up in its pediment. Its three-bay façade is dated 1878. Mechanised fire engines entered the building from one side and exited via a later extension with an arched entrance on King Street, where a pedimented doorcase features the Wakefield coat of arms, the fleur-de-lis, in its tympanum.

43. Qubana (former Barclays Bank), Nos 1–3 Wood Street (1881)

This landmark building, occupying a key site on the corner of Wood Street and Marygate, has much to commend it, both in the quality of its brickwork, terracotta and stone dressings constructed to a high specification by Bradford firm Beanlands. It was built shortly after the completion of the Town Hall to

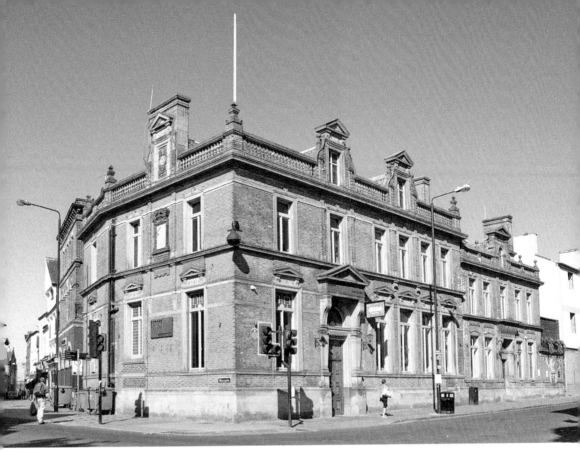

Nos 1–3 Wood Street, originally Leatham & Tew's Bank of 1881.

the designs of Archibald Neill (1856–1933) of James Neill & Son (Leeds) at a time of burgeoning civic pride. A deep ashlar plinth carries the pink brick walls. Thin ashlar banding articulates the six-bay façade at sill and lintel level, and the windows have eared architraves and pediments. A deep cornice is surmounted by a stone balustraded parapet with two pedimented dormers on the Wood Street elevation. The main entrance door in the second bay has an elaborate stone doorcase with an arched fanlight, consoles and a triangular pediment. To the right the lower five-bay symmetrical 'Bank House', originally constructed for the manager to live in, has similar details and features a terracotta hood above the door. The façade runs around the left side and has three bays of windows and a finely engraved sundial in a swan-necked pedimented terracotta frame between two first-floor windows. Rising above the parapet is a pedimented plaque with the dates '1809–1881' and a panel engraved with the letters 'L T & Co.', which stands for Leatham, Tew & Co. This records the date they came to Wakefield and the date this branch opened. In 1906 they merged with Barclays Bank, who made alterations including opening the banking hall up to the manager's house, and replacing the wall with an enormous steel beam with pop-rivets supported on fluted columns. They remained here for over 100 years before moving to Trinity Walk in 2012.

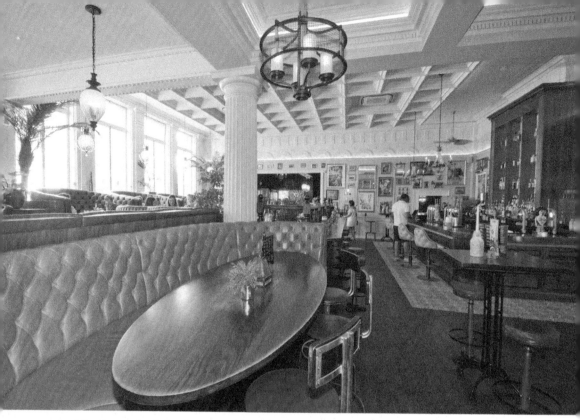

The former bank has been converted to a café bar.

Empty for a couple of years, it began to deteriorate and was sold at an auction in 2014. The new owners were careful to retain its original features, such as the fine coffered plaster ceiling above their new dining area in this restaurant conversion, which has a long bar, a rooftop bar and a remarkable private dining room inside the former strongroom.

44. County Hall, Bond Street, (1894–98)

Following the creation of the West Riding County Council, in 1892 Wakefield was chosen to host the new county council. An architectural competition was held in 1893 for a new building (opening in 1898); London architects Gibson & Russell won the first prize of £200. The original intention to build it in brick was amended and Derbyshire stone was used instead, but with brick lining the inner courtyard of its ingenious trapezoid plan. This placed the large Council Chamber with its domed ceiling (40 feet high) above a 50-foot square in the middle of the courtyard, which was built across the diagonal between Bond Street and Cliff Parade. At the junction with Wood Street they positioned a modest but highly decorated corner entrance, which is crowned by an octagonal turret with a domed cap and short spire – adding a significant note to the Wakefield skyline. Framing the corner are tall three-and-a-half-storey projecting Flemish

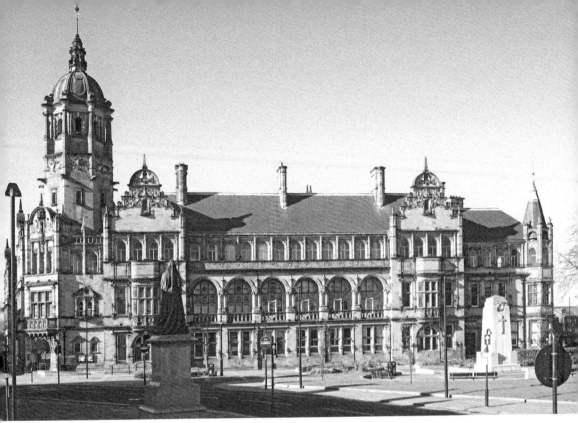

Above: County Hall. This long elevation contains first-floor committee rooms.

Right: The main open-well stair. The walls are decorated with murals.

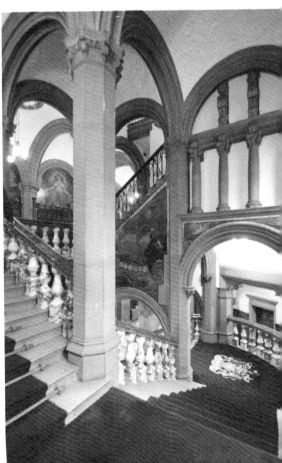

Colourful plaster frieze of Henry VII being offered the crown on Bosworth Field.

gabled wings that close off the two principal façades like bookends. The gables are similar but are treated differently: they were stepped or shaped with spiked finials piercing segmental pediments. This eclectic mix of Jacobean, classical Renaissance, and baroque satisfied the architectural brief set. What impresses is the quality of the carved stone decoration and sculpture by W. Birnie Rhind (Edinburgh), which, like other elements of the building, is of the highest quality, including the art nouveau light fittings and switches. The arched corner entrance below the Leader's office is key to the internal planning. The sumptuous entrance hall – more luxury hotel than municipal – has arcades of stone arches leading to an open-well stone stair, which is built with colourful marble balusters and handrail and lit by stained-glass windows. The walls are decorated with attractive murals. A short flight leads directly to the top-lit oak-panelled anteroom, which is decorated with plaster friezes recording events from the Wars of the Roses. The Committee Rooms fronting Burton Street retain original suites of chairs, stunning marble fireplaces and walls lavishly panelled in walnut. Following the demise of the WRCC in 1974, and its successor the WYCC in 1986, it is now Wakefield MDC's prestigious offices.

45. Theatre Royal Wakefield, Nos 92–100 Westgate (1894 and 1905)

James Bank's theatre of 1777 attracted performances by famous actors of the day, such as Mrs Siddons and Edmund Keen, and the theatre supported by a regular and fashionable clientele. In 1883 it was renovated by new owner Benjamin Sherwood, but was refused a licence in 1892 because of its 'many defects'. Sherwood decided to demolish it and build a new theatre on the site (opening in 1894), choosing London architect Frank Matcham (1854–1920) as his architect. Its striking gable front has a classical five-bay symmetrical

Right: The Theatre Royal on Westgate.

Below: The extension of 1905 on the corner of Drury Lane.

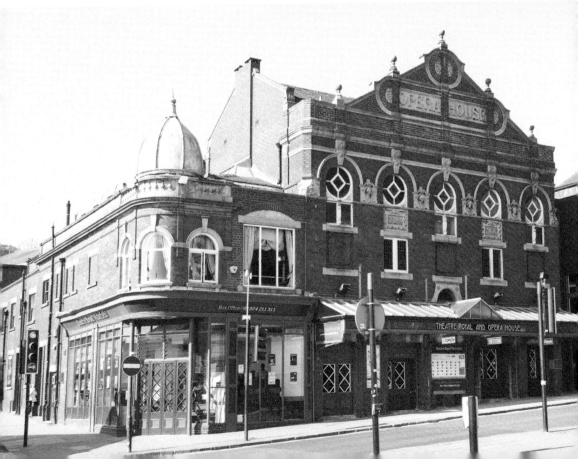

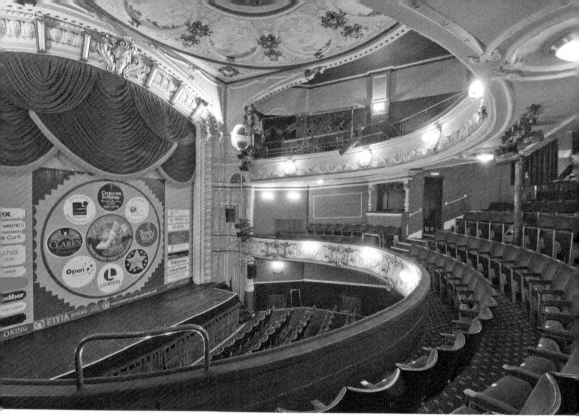

The sumptuous interior of the theatre with curved balconies and rich decoration.

brick façade with cast-concrete lintels and details. Circular windows light the top corridors, and these are set within recessed arches with hood moulds. The imposts are decorated with busts of Garret, Shakespeare, Beethoven and Mozart, with 'Drama' and 'Music' on plaques below. Flamboyant keystones rise up the gable framing 'Opera House', terminating in ball finials, typical of his Mannerist baroque style. On the corner of the street is a small extension of c. 1905 for a café and bar under a small spiked lead dome. A glazed canopy is carried over the pavement, which covers its separate entrances to the upper circle, dress circle, box office and stalls. Its name is emblazoned in white glass. The interior is a delight and is well preserved, even after suffering the indignity of being a cinema and bingo hall in the 1960s. Grade II* listed in 1979, it was eventually restored back to a theatre in 1985–86. This is Matcham's smallest surviving theatre, and its intimate auditorium is similar to the Lyric Hammersmith. It is a little jewel with horseshoe-shaped balconies for the dress circle and a gallery that uses his own patented system of cantilevers for balconies, slung between parallel walls. The fronts have wild rococo decoration using his own method of manufacturing fibrous plaster, used to good effect around the proscenium arch, which is crowned by the head of Bacchus, and on the circular ceiling with eight painted ovals. The overall effect is a sumptuous richness. The plush red comfortable seats, cream-and-gold-painted enrichments and draped red-velvet curtains to the stage emulate London's Royal Opera House.

46. The former Wakefield Library, Drury Lane (1906)

This is an early library built in 1905–06 with an £8,000 grant from the Carnegie Foundation. A competition for the design was held and attracted eighty-one entrants. It was won by Trimnell, Cox & Davison (Surrey), who initially designed a plain barn-like building that was modified to include some architectural elements. The arched windows and the tower-like entrance are in a neo-baroque style. It is built of a warm yellow-coloured sandstone from Crosland Moor (Huddersfield). It has a seven-bay symmetrical façade with keyed circular windows to each side of a pair of round-arched windows, which break the eaves line with segmental-arched hoods. They retain their original leaded lights in metal frames, giving it a distinctly Arts & Crafts feel. The central tower entrance has an inner hall decorated with Moorish tiles. The rather odd

An oblique view of the former Drury Lane Library.

The tiled
entrance hall.

tapering rusticated square columns give it an art nouveau flourish, and its Welsh
blue-slate roof is surmounted by a stylish wooden cupola. To the left a three-bay
addition (1939) for the Junior Library now forms the main entrance to the Art
House gallery and studios, with individual 'boxes' set under the still impressive
segmental barrel-vaulted plaster ceilings. A conversion in 2014 preserved some
oak bookcases and the dumb waiter lift to the reserve stack in the basement.
For many years the former caretaker's house at the rear was the entrance to the
John Goodchild Collection, which is now housed in the West Yorkshire History
Centre, Kirkgate (opened in 2017). The building was Grade II listed in 1990.

47. No. 3 West Parade, 1995

This outstanding office extension to premises then owned by building company
Leemeleg has an interesting conservation story. Occupying mews cottages at West
Parade in the 1980s, they first added a safe Georgian-style coach house extension
for their lorry and vans. When the MD of the company Terry Hodgkinson wanted
a new office extension in December 1993, he was encouraged by Wakefield
MDC's then conservation officer Bryan Sayer to seek a contemporary solution.
He enlisted the help of award-winning architect Ted Cullinan, the designer of
the Fountains Abbey Visitor Centre (1992), who produced a sketch scheme with
a steel wave-form roof, which gained planning approval in May 1994 and was
completed in 1995. Some twenty years later it still surprises, looking strikingly
modern and cutting edge. It is a tall white-painted concrete and steel-framed
part-cantilevered structure with an unusual curved roof. A glass box on its corner
is raised up on a tapering green foot so vehicles can park under it. A blue-painted
spiral stair lit by porthole windows leads from this lofty, inspirational office to
a boardroom in a gallery above. This inventive and sophisticated design by an
architect of international repute may one day become a listed building.

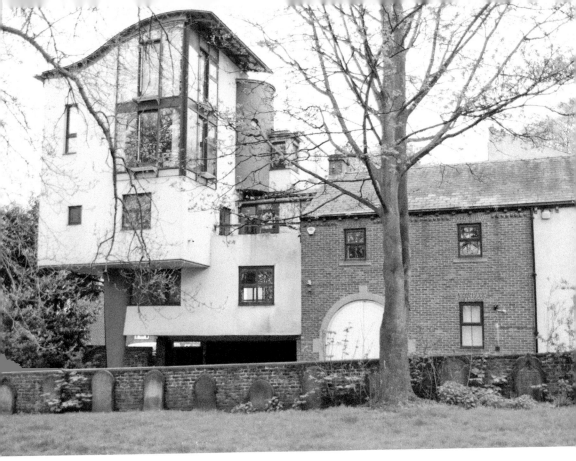

Above: This modern extension overlooks West Parade's former burial ground.

Right: The inspirational office interior used by a computer software designer.

48. The Hepworth Wakefield, off Doncaster Road (2011)

The catalyst for this iconic gallery was the offer in 1997 from the trustees of the Hepworth estate to Wakefield Council of Barbra Hepworth's original plaster sculptures, a unique collection of forty works found in her St Ive's studio after her death in 1975. *The Guardian*'s obituary described her as 'probably the most significant woman artist in the history of art to this day', a high accolade for a girl from Wakefield who, with Henry Moore, became the most significant British sculptors of the twentieth century. The gift was dependent on the sculptures being displayed in a suitable 'building of architectural distinction and museum quality'. From 1923 Wakefield Council had the foresight to collect the work of British artists including Hepworth, but these were inadequately displayed in a converted Victorian house on Wentworth Street. This was an opportunity too good to miss and gained sufficient political and financial support to encourage a feasibility study in 2000. A site on Wakefield's South Bank was secured for the new gallery. David Chiperfield Architects were the winners of the architectural competition held in 2003, carefully formulating spaces around the collection to be exhibited. This was conceived not as a single imposing building but more from inside-out, fulfilling his idea of 'purpose', explaining 'that both the interior space and exterior volume have always been conceived as an integrated idea … and how you walk through it … and experience it'. The Hepworth Wakefield is formed from ten individual galleries comprising of a series of interconnected volumes within differing cast-concrete boxes with mono-pitched roofs and concealed roof lights. The volumetrics of the solids and bulks was derived from the previous sheds

The Hepworth Wakefield on the edge of the River Calder.

Right: The Hepworth family gift at The Hepworth Wakefield. (© Marc Atkins for Art Fund)

Below: The approach from the footbridge over the river.

on the site and the mills and warehouses on its dramatic riverside location on the edge of the Calder. It has been an outstanding success, with 2 million people from all over the world visiting the gallery to date. At its opening on 21 May 2011 Sir Nicholas Serota described it as 'One of the most exciting and beautiful galleries in the United Kingdom'. The masterstroke is the footbridge over the river that gives it a unique sense of arrival.

49. Wakefield One (2011)

Wakefield's new £15 million Civic Offices are a key component of the Merchant Gate area. This competition design by architects Cartwright Pickard largely fulfils the council's brief for a multipurpose building to incorporate a one-stop shop for most council services with centralised offices for council staff in key areas such as planning, housing, rates etc. This contemporary and visually exciting building functions as a 'bottom, middle and top' structure in which the ground floor has a cafeteria close to its south entrance, together with the museum and part of the library, the main library and the one-stop enquiry desk on the middle floor, and offices for council staff occupying the upper floors. This five-storey reinforced cast-concrete-framed building is skilfully absorbed into its sloping site with a middle-level entrance on Burton Street. The striking entrances are set in wedge-shaped recesses cut into the overtly modern façades. Different sized windows are offset in an apparently random pattern, but with unusual coloured tiled inner frames. The colour palate is derived from a stained-glass window in County Hall. From a distance the walling looks like natural stone, but is actually variegated stone-coloured ceramic

Below left: The south entrance façade to Wakefield One.

Below right: The central top-lit atrium.

tiles. Its four façades are defined by the crisp dark shadow of it oversailing roof. Inside its impressive top-lit central atrium features a wide staircase that rises in three stages to the upper level. The stark fair-faced concrete walls are only relieved by the vertical timber boarding fronting the balconies of the upper three floors. The Create Café adds vibrancy: its ceiling is filled with colourful over-large lampshades, the colours of which is echoed in the seating. An imaginatively displayed museum on the ground floor has much to interest visitors including period-style room sets and the fascinating Waterton Collection, and has many weekly activities for children. Integrated with it is the Reference and Local Studies Library, an important resource for the study of Wakefield. The general library occupies 1,800 square metres within this flexible building, where walls are easily moved to suite different purposes. After its opening in 2011 it won ten regional and national awards including the prestigious OAS Award for the 'Best Development Outside London'.

5c. Wakefield Westgate and Multistorey Car Park (2013)

In 1856 a spur line from Kirkgate station formed a link to the Great Northern Railway's Leeds to Doncaster line, creating a new station on Westgate. This involved the construction of a ninety-five-arched viaduct, a major piece of engineering and still an impressive sight, but with a utilitarian bridge across the

The 1867 entrance to the station platform (now blocked).

street that ruined Westgate by severing one half from the other, and also involving much demolition including the Milnes family mansion, part of which was retained as the station. In 1867 a new station was built at a cost of £60,000 on the opposite side of Westgate, close to Pemberton House, which lost its gardens to a goods yard. The stone-arched former pedestrian entrance by the bridge gives some idea of the quality of its elegant frontage, which was designed by James Barlow Fraser (of Leeds) and his brother John Fraser, a civil engineer. It had a tall 97-foot tower – with clock faces added in 1880 – becoming a much loved local landmark. In 1967 the tower and station were mostly demolished by British Rail in a ruthless rationalisation exercise, replacing it with a bland station that proved increasingly inadequate for the needs of its business clientele on this main Leeds to London line. Planned improvements were made (2007) as part of Wakefield Council's Westgate Key Development Area that included Merchant Gate, the first phase being completed in 2010. Four years later the station was rebuilt again, moving it further north of the existing platforms. The up side was retained, but with a new enclosed footbridge and open-plan concourse. The single-storey entrance has a stylish, undulating, curving front with a fully glazed curtain wall, providing a wide foot plate with shops and cafés also lit by leaf-shaped top lights inset into its flat roof, first used in the Scottish Parliament Building, Edinburgh (2004). It is best observed from the upper floors of the highly regarded six-storey car park, which has a stunning façade, an original abstract design featuring black, grey and yellow panels, the design of which is based on a train passing at speed. Wakefield's new station (opened in 2014) provides a metropolitan gateway to the city, which is just two hours from London.

Wakefield's new railway station with fully glazed curtain walling.

Select Bibliography

Brears, P C. D., *Clarke Hall* (a guide) (Chorley & Pickersgill Ltd, Leeds, 1975)

Brears, P. C. D. (ed.) 'Clarke Hall, Wakefield: Architectural Innovations in 17th century West Yorkshire', *Post-Medieval Archaeology 12*, pp. 86–100 (1978)

Brook, Clifford, *George Gissing and Wakefield* (The Gissing Trust, Wakefield, 1982)

Dawson, Paul L., *Images of England: Wakefield Revisited* (The History Press Ltd, Stroud, 2003)

Dawson, Paul L., *Changing Wakefield* (Fonthill Media, 2013)

Dawson, Paul L., *Secret Wakefield* (Amberley Publishing, Stroud, 2015)

Fletcher, J. S., *A Picturesque History of Yorkshire, Part VII: The Calder from Castleford* (J. M. Dent & Co., London)

Giles, Colum, *Rural Houses of West Yorkshire 1400–1830* (RCHM(E), HMSO, 1986)

Goodchild, John, *Wakefield Town Trail* (1980)

Goodchild, John, *Wakefield Canal Trail* (Wakefield Historical Publications, Wakefield, 1985)

Goodchild, John, *Images of England: Wakefield* (1998)

Hall, Dr Ivan & Elisabeth, Heath, *An Architectural Description* (Muir & Mary Oddie, *c.* 1965)

Hall, Dr Ivan, *John Carr of York Architect: A Pictorial Survey* (Rickaro Books, Horbury, 2013)

Harman, Ruth & Nikolas Pevsner, *The Buildings of England: Yorkshire the West Riding: Sheffield and the South* (Yale University, London, 2017)

Johnson, Francis F., *Heath Hall, Wakefield* (Jowett & Sowry Ltd, 1964, reprinted 1973)

Johnstone, Christine, *Wakefield in Old Photographs* (Sutton Publishing, 1993)

Kerr, Nigel & Mary, *A Guide to Medieval Sites in Britain* (Paladin Books, 1992)

Linstrum, Derek, *West Yorkshire Architects and Architecture* (Lund Humphries Publishers Ltd, London, 1978)

Listed Buildings online, and British Listed Buildings website

Michelmore, David J. H. & Sugden, Jack, 'Horbury Hall, West Yorkshire', *Archaeological Journal 131*, pp. 40–43 (1980)

O'Regan, Mary, *The Medieval Manor Court of Wakefield* (Rosalba Press, Leeds, 1994)

Pevsner, Nikolaus, *The Buildings of England: Yorkshire the West Riding* (Published by Yale University Press, 2003)

Rochford, Michael J., *Wakefield Then & Now* (Pen & Sword, Barnsley, 2016)

Ryder, Peter, photographs by Paul Gwilliam, *Medieval Churches of West Yorkshire* (West Yorkshire Archaeology Service, 1993)

Taylor, Kate, *The Making of Wakefield: 1801–1900* (Wharncliffe Publishing, Barnsley, 2008)

Taylor, Kate, *Wakefield District Heritage Vol. 1* (1975) & *Vol. 11* (Architectural Heritage: Wakefield District Group, Wakefield MDC, 1979)

Taylor, Kate (ed.), *Worthies of Wakefield*, WHP 43 (Wakefield Historical Publications, Wakefield, 2004)

Taylor, Kate, *The Pious Undertaking Progresses: The Chantry Chapel of St. Mary the Virgin, Wakefield Bridge*, WHP 44 (Wakefield Historical Publications, Wakefield, 2011)

Taylor, Kate (ed.), *Wakefield Diocese: Celebrating 125 Years* (2012)

The Hepworth Wakefield: Art Spaces (Scala Publishers Ltd, London, 2012)

Tricket, Kevin, *Wood Street, the Heart of Wakefield* (Wakefield Civic Society, 2017)

Wakefield Civic Society publications: *City of Spires, Towers and Turrets Trail* (2010); *Blue Plaque Trail* (2011), *City of Sculpture and Public Art* (2011)

Walker, John. W., *Wakefield: Its History and People* (West Yorkshire Printing Co. Ltd, Wakefield (1st ed. 1934) (2nd ed. in two vols, 1939)

Warburton, Malcolm, *Wakefield Cathedral* (a guide) (Swallowtail Print, Norwich, 2016)

Wilkinson, John F, *For Grammar and Other Good Learning,* QEGS 400th Anniversary booklet (EIS Design & Advertising Ltd, 1991)

Wragg, Brian, (ed.) Worsley, Giles, *John Carr of York* (Oblong Creative Ltd. The Annexe, Wharfedale Business Centre, 2000)

Navigation

a newcomer's guide

Sara Hopkinson

Second edition

FERNHURST BOOKS

www.fernhurstbooks.com

Second edition © published in 2014 by Fernhurst Books Limited
62 Brandon Parade, Holly Walk, Leamington Spa, Warwickshire CV32 4JE
Tel: +44 (0) 1926 337488 | www.fernhurstbooks.com

First edition published in 2006 by Fernhurst Books
Reprinted and revised in 2009, 2010 and 2012 by John Wiley & Sons Ltd

British Library Cataloguing in Publication Data.
A catalogue record for this book is available from the British Library.

ISBN 978-1-909911-07-9

Artwork by Creative Byte.
Cover design by Balley Design / Rachel Atkins.
Further photographs, design & artwork by Simon Davison & Rachel Atkins.

Printed by Gomer Press Limited in Ceredigion, Wales.

Acknowledgements
The author would like to thank Roger Seymour, Robin Cole and Tim Scott-Douglas of Nunonavigator (www.nunonavigator.com) for their advice.

The publisher would like to thank RAYMARINE for their help in the preparation of this book. Also United Kingdom Hydrographic Office for their permission to reproduce charts. In addition: The Turkish Hydrographic Office (Seyir Hidrografi ve Osinografi) for permission to reproduce chart 1665; The Service Hydrographique et Oceanographique de la Marine for permission to reproduce chart SC5602.1; Tim Davison for photo page 79 and cover photos. Pages 76-7 contain an extract from a leaflet produced by the Maritime and Coastguard Agency, for which many thanks.

* RYA, YACHTMASTER, Coastal Skipper and Day Skipper are trademarks of the Royal Yachting Association.

Contents

Welcome to Navigation

**Navigation is something we all do:
it is simply finding the way around.**

We negotiate the motorways and rail systems using maps and signs. We have learnt to read the maps, follow the signs, look out for landmarks and study timetables. We estimate how long the journey will take, allowing for the distance and the average speed that we expect to travel, and then add on a bit because of possible delays. If it is somewhere we have not been before we read up about it and talk to friends for advice. This is navigation.

The aim of this book is to help transfer these skills of navigation from the land to the sea.

Someone once said to me that there are only two questions in navigation:

Where am I?
Where do I go now?

While I agree with this generally, there are other background details that need to be included to help answer these two basic questions.

To help make the book easy to use the different subjects are colour-coded and the details are built up gradually.

Navigation is fun and remember – it can't be that difficult because lots of people can do it!
Sara.

Some of the vast range of electronic navigation equipment available.

Looking at charts: 1
Types of chart

If you are interested in navigation at sea, start with a **chart**. Charts are the maps of the sea and are full of fascinating details (not of the land or of the sea really, but of the coast and what lies beneath the water). Data has been gathered over many centuries by navigators and explorers and satellite technology is now used to enhance the accuracy. Look for the **source data** on a chart to see the date of the surveys used to produce it.

A standard format chart

Source data.

Charts concentrate on the details that are of interest to navigators such as:

- The **depth** of the water.
- **Hazards**, like rocks and sandbanks.
- Conspicuous features on the **coastline**.
- **Points of navigational importance** like lighthouses and buoys.

Many details on the land are omitted as not relevant.

The best chart to start studying is one of an area that you have sailed in or know from the land.

Ordinary bookshops that sell maps do not generally sell charts, and most marina chandlers only stock a few charts of the local area, so for the best selection and advice search out a **chart agent**. Chart agents specialise in selling charts: they stock charts and navigation publications for the world.

There are a number of different types of charts.

Admiralty charts are produced by an agency of the government, the UK Hydrographic Office (UKHO), who produce charts and books for use throughout the world. The **standard format chart** is large - approximately 1m x 0.75m - which can be inconvenient to use or store with a small chart table, or no chart table at all. These charts can only be bought from Admiralty chart agents and are quite expensive, due to the chart being totally correct at the time of purchase. All charts become out-of-date quite quickly as depths change or buoys are moved, but a chart agent will hand-correct a chart every week if

necessary. After you have bought the chart, it is down to you to keep it up to date. Information can be found in 'Notices to Mariners' booklets, which can be bought from chart agents, downloaded from the Admiralty website on www.nmwebsearch.com or found in some boating magazines.

Additionally, the UKHO produces folios of leisure charts. These folios contain about 10 charts in A2 format and cover the most popular boating areas. It is important to note that these charts are not corrected once they have been printed, and so are cheaper and can be bought through chandlers. They are very good value and come in a strong plastic wallet, but you have no choice of chart or scale. Corrections can be made to the charts by referring to the Notices to Mariners.

For more information on any of the UKHO products go to www.ukho.gov.uk.

Folio of leisure charts

Imray Charts are produced by Imray, Laurie, Norie and Wilson. They are sold through chart agents and chandlers and cover the UK, Mediterranean and Caribbean. Their charts come singly or in folios and are on waterproof paper.

Imrays produce many pilot books of popular areas specially written for skippers of yachts and motor cruisers, whereas the Admiralty publications were originally intended for ship captains. Their website, www.imray.com, gives details of corrections too.

Electronic charts are becoming increasingly popular and can be used with a computer, or with a dedicated plotter with an electronic display. As well as the Admiralty, private companies produce these charts. More about these later, but remember these need updating too.

Foreign charts are quite similar in appearance to UK charts, and worth considering. The Dutch charts of their inland waterways, for example, are full of detail and so popular that they can be bought in chandlers in the UK.

Many of the symbols used on charts are easy to guess but others have to be learnt... it's best to do this a few at a time as there are hundreds!

The UKHO publishes a fantastic book: *Symbols and Abbreviations used on Admiralty Charts*. This is often called **5011** by old hands, as this is the old chart number dating from the time when the information was produced as a chart. This is a useful addition to every boat's library. The information is published for Admiralty charts, but the symbols are largely common to all chart producers.

Many of the **chart symbols** are easy to guess as they are simply very small pictures of the real object. Each picture obviously takes up much more space on the paper than the real thing so a small circle in the baseline shows the actual position. —o—

Many people starting their first navigation course immediately consider a new pair of glasses!

5011 / Symbols and Abbreviations used on Admiralty Charts, published by the UKHO.

"Understanding a Nautical Chart", published by Fernhurst Books, also contains all the chart symbols.

Colne Bar. Admiralty Vector Charts displayed using Nunonavigator.

**Here are a few of the common and
important symbols:**

A north cardinal buoy, unlit.

Red buoy, with light.

Rock awash at the level of
chart datum.

Green buoy, unlit.

Underwater rock over which
the exact depth is unknown
but which is considered
dangerous to surface
navigation.

Wreck, depth unknown, not
considered dangerous to
surface navigation.

Remains of a wreck, or
other obstruction, no
longer dangerous to surface
navigation, but to be avoided
by vessels anchoring,
trawling, etc.

Wreck, depth unknown, but
considered dangerous to
surface navigation.

Obstn Obstruction.

Wreck over which the
depth has been obtained by
sounding not by wire sweep.

Major light or lighthouse.

Wreck which has been swept
by wire to the depth shown.

Wreck over which the exact
depth is unknown but which
is considered to have a
safe clearance to the depth
shown.

Beacon, with light.

Wreck showing part of hull
or superstructure at the
level of chart datum.

Prohibited area.

Rock which covers and
uncovers, showing height
above chart datum where
known.

Overfalls.

Looking at charts: 2
Depths and heights

A non-metric chart.

A metric chart.

Most charts, but not all, are now **metric** and instantly recognisable because they are so colourful... and say 'DEPTHS IN METRES' on the white margins at the top and bottom of the chart! This means that the depths of water and the heights of bridges and lighthouses are given in metres. On **non-metric charts** the depths are in feet and fathoms (6 feet equals 1 fathom) and the heights in feet.
On comparison, the non-metric charts seem quite dull because the colours are mainly limited to black and white.

On Admiralty metric charts one of the main uses of colour is to make the different depths stand out vividly:

- **Yellow** is used to show the area above sea level - land!
- **Green** shows areas like beaches, rocks, mudflats and sandbanks which are sometimes covered by the water and sometimes not. These are known as drying areas.

- **Dark blue**, **light blue** and then **white** show increasing depth of water.

These areas are separated by **marine contour lines**. Follow a contour line and somewhere along it will be written the number of metres that it represents.

Don't expect to find the shallow areas only along the coastline. The sandbanks of the Thames Estuary are famous, or infamous! The banks fan out to form a complicated maze of channels as the River Thames flows out into the North Sea. It is possible for a boat to be aground in the Thames Estuary but unable to see land at all, and in bad weather boats have been smashed to pieces on these dangerous banks. Similarly the Bramble Bank in the Solent has caught out many sailors who go aground close to the main shipping channel to Southampton Docks.

All these banks are clearly marked on the chart but skippers need to navigate with

care and remember the old saying; "The nearest bit of land to you is usually the bit underneath the boat!"

Depth of water may be one of the most vital bits of information for navigators but it is not straightforward to show on a chart because the depth varies as the water goes up and down with the tide.

This problem is solved by relating the depths to **chart datum** as a theoretical level from which to start measuring.

Chart datum is usually defined as the **lowest astronomical tide** (astronomical since it is the positions of the sun and the moon that cause the movement of the water that we call tides). The level shown on the chart is therefore pessimistic - it shows the lowest level to which the water is expected to fall, except under extreme weather conditions or abnormal range of the tide. (The **range** of the tide is the amount the water has gone up or down between high water and low water.)

> ### Range = HW - LW

In other words, there is almost always some more water than is shown on the chart - at high water there is a lot more and at low water there is a little more. Showing the least depth ever expected increases the safety margin. The numbers written over the blue and white areas of the chart are the **charted depths** in meters, known as **soundings**. They are written without the use of a decimal point but show the figure for the decimal below the main number.

$1_7 = 1.7m$ $24_6 = 24.6m$

If it is necessary to know the actual **depth of water** at a particular spot then the **height of tide** would have to be added to the charted depth shown on the chart. (The height of tide is how much the water is above chart datum. For high water and

low water height of tide can be found in tide tables. Height of tide between high water and low water can be calculated if necessary. See Figure 1.)

> ### Height of tide + charted depth = depth of water

Height of tide + Charted depth = Depth of water

3.0m + 1.7m = 4.7m

Figure 1

Another feature associated with depth and shown by colour and figures is **drying height**. This is an area **above chart datum**, which therefore may 'dry out' or stick out above the water most of the time, some of the time or just occasionally. Drying heights are shown in **green with the figures underlined** showing the height in metres above chart datum (Figure 2).

$\underline{0}_5$ = **dries 0.5m** $\underline{1}_8$ = **dries 1.8m**
above chart datum

Figure 2

Height of tide – drying height = Depth of water
3.0m – 1.8m = 1.2m

From Figure 1:
Depth of water
3.0m + 1.7m = 4.7m

1.2m

1.8

Figure 3

These areas are found on the coast and where there are rocks or sandbanks, but again the height of the tide must be taken into account to calculate the real danger. **The height of tide must be applied to the drying height** that is shown on the chart, and may cancel it out completely. The chart is being pessimistic again to increase the safety margin. Remember there is almost always more water than is shown on the chart.

This is a good thing up to a point. The green areas are not always above the level of the water, even though they are above the level of chart datum. Skippers can see them on the chart but not always by eye - if they could maybe fewer people would hit them! Sometimes there is no water over a sandbank at all and the seals may be sunning themselves, sometimes there is enough water to sail right over the bank quite safely, and sometimes there is water over the bank so that it cannot be seen... but not enough! All of this depends on the height of the tide (Figure 3).

> **Height of tide - drying height = depth of water**

The colours and figures help the navigator to build up the 'three dimensional' image necessary to navigate in rivers, estuaries and coastal areas (Figure 3).

Is all information about heights given with reference to chart datum?

Well no, it is not. One exception is the height or elevation of a lighthouse. This is given with reference to **MHWS** (Mean High Water Springs) (Figure 4). MHWS is the height of the tide at the average, or mean, of the highest high tides, which are called spring tides. Spring tides occur all the year round, not just in spring! More about this later.

height

MHWS

Figure 4

height

MHWS

height of tide

Figure 5

Figure 6

Figure 7

Usually the height of the tide is lower than MHWS (Figure 5), so the lighthouse is in effect 'taller' than shown on the chart and so can be seen from further away (Figure 6). The second exception is the **vertical clearance** under a bridge or power-line. This is given with reference to **HAT** (highest astronomical tide) - the highest level to which the water is ever expected to rise under normal conditions. When the tide is lower the clearance will be greater (Figures 7 & 8).

The information given on the chart is again pessimistic, to increase the safety margin.

Figure 8

When taking a good look at a chart don't miss the information shown in the notices. Somewhere on the chart is a panel of information about the chart itself, with special details and warnings for the local area. This information will include:

- **The datum of the chart.** This is the measuring system that was used to produce the chart. Our charts used to be marked OSGB 36 for Ordnance Survey of Great Britain 1936 but UK charts are now all WGS84 meaning that they are based on the World Geodetic Survey of 1984.

 Do you need to know this? Yes, to some extent. If a satellite navigation system, such as GPS, is used on the boat it will need to be set to the same datum as the chart to prevent inaccuracies. It is necessary to go into the main menu system to do this, and maybe read the instruction book!

- **The buoyage system for the region.** There are only two systems - Region A and Region B. North America, and other countries nearby, use Region B but everywhere else uses Region A. This will be dealt with later in the book. It's not as confusing as it seems, but check up before that exotic charter or diving holiday!

- **Projection.** This is the method that was used to make the round world fit on a flat piece of paper. This has been a problem ever since the first charts were drawn and different solutions or projections are still used. All result in some distortions of scale.

- **Local safety notes and warnings.** It's a good idea to read these: if they were not important they would not have been put on the chart in the first place!

Giving a position: 1 Latitude and longitude

Having looked at a chart and understood some of the symbols and colours, the next thing to tackle is **position**. The position is a description of an **exact location** on the surface of the planet. I am going to cover this is two parts:

1. How to describe to another navigator where you are.
2. How to find out where you are.
 (*That's in the next section, from p18*).

The most well-known method of describing a position that can be plotted on a chart is by using **latitude and longitude**. These are lines that run round the world horizontally (latitude) and from pole to pole (longitude) to form a grid.

When latitude and longitude are used to name a position, **latitude is always given first.**

The grid is made up of **parallels of latitude** running north and south of the equator. The lines are not the same length, as they become shorter towards the poles, but they are parallel. The line 52° could be 52° N, close to Ipswich in Suffolk or 52° S, running south of Australia, so latitude must be marked N or S to make sense. The 52° is the angle from the centre of the earth (Figure 9).

Superimposed upon these lines are the **meridians of longitude**, measured east and west from Greenwich. These lines are all the same length, but obviously not parallel. The line 1° E runs close to Ipswich and should be written as 001° E to make it clearly different from 010° E or 100° E (see Figure 10). It's a bit like writing a cheque; *where* you put the zeros makes a lot of difference! Marking the longitude E or W is vital too. The 001° is the angle between that line of longitude and the prime meridian or 000°, which runs through The Royal Observatory at Greenwich, in London.

The position of 52° N 001° E for Ipswich is approximately correct but imprecise. For added detail **each degree is divided into 60 minutes, and each minute into tenths.**

Figure 9

52° N of Equator

52°

Equator

52° S of Equator

Figure 10

0°
Greenwich

001° E of Greenwich

Figure 11

Figure 12

Using this format, the position for Ipswich becomes: 52° 03'.5° N 001° 09'.5° E (see Figure 11). The placing of each zero, minute symbol and decimal point is vital to make the meaning correct, as is the use of N and E.

When this simple grid system is moved from the round world to a flat piece of paper:

- The latitude scale is found at either side of the chart.
- The longitude scale is at the top and the bottom.

Each minute is divided up depending on the scale of the chart, and the only way to know the value of each small subdivision is by counting (Figure 12).

How to measure latitude and longitude from the chart

An easy way of measuring the latitude and longitude is with the use of dividers. These are traditionally made of brass and shaped for single-handed use, so the navigator can hold on in a rough sea. Hopefully that won't be necessary too often!

Measure the distance relative to a line of latitude and then transfer that to the scale at either side of the chart. Count carefully because the appearance of the scale will differ from chart to chart.

Dividers

1. Hold the dividers like this.

2. Squeeze the curved parts to open the dividers.

3. Push the straight parts to close them.

Finding the latitude and longitude of a point on a chart

1. *Use the dividers to measure from the object to the nearest line of latitude, in this case the 50⁰ 15' line.*

2. *Move the dividers to the latitude scale and read off the exact latitude, 50⁰ 15'.90 N.*

3. *Now measure from the object to the nearest line of longitude, in this case the 004⁰ 40' line.*

4. *Now move the dividers to the longitude scale and read off the exact longitude, 004⁰ 39'.10 W.*

Repeat the exercise to measure the longitude, using the scale at the top or bottom of the chart, and remember that latitude is always given first (see panel above).

How to measure distances from the chart

Dividers are also used for measuring distances across the chart from place to place. On the chart the **distances** are measured using the **latitude scale** never, never the longitude scale. Although the appearance of each degree and minute of latitude will differ depending on whether the chart is covering a large or small area one fact is always true:

> **1 minute of latitude = 1 nautical mile**
> **1' latitude = 1 mile**

So to measure a distance, one point of the dividers is placed on each object and then that measurement is moved to the latitude scale to count the distance (see panel opposite).

This simple scale is not perfect because of the distortions between the round world and a flat chart. Chart makers have made adjustments to allow for this by using different projections, so on a chart covering a very large area it is possible to

How to measure distances from a chart

1. *Measuring a distance from the chart, in this case from the buoy to the circle (fix).*

2. *Open the dividers the required distance.*

measure a mile at the north of the chart and a mile at the south of the chart and find them different! This seems a bit surreal but is not so bad in practice. **Always use the part of the latitude scale that is nearest** to where you are plotting. This will avoid the problem, and it is convenient as well.

To measure a distance quickly and approximately, open the dividers to a convenient number, perhaps 5 or 10 miles, and then 'walk' them across the chart counting as the dividers are turned (Figure 13).

3. *Transfer to the nearby latitude scale and read off the distance (1' = 1M).*
In this case it is 4 miles.

Figure 13

Giving a position: 2
Range and bearing

Latitude and longitude are not the only way to tell someone your position, and in fact it may not even be the best way. It can be very accurate and easy to measure, especially if the boat has an electronic navigation system, like GPS, but it is not very 'user friendly' for the recipient of the information.

For example, if I told people that I lived approximately 52° 03'.50 N 001° 09'.50 E not many would have any idea where that was. On the other hand, if I said "I live north east of London, about 70 miles" they can imagine that immediately. To a local I can use a well-known landmark. I usually say "I live down the lane to the pub, about a quarter of a mile".

This method of giving a position is used at sea as well and is called a **range and bearing**. It is very easy for the person hearing the information to understand or to plot on the chart. They start at the well-known place and draw or imagine a line in that direction for the distance mentioned. (Despite being called a range

and bearing, the direction or **bearing from the named place is always given first**.)

To give the **direction** in navigation we no longer use the traditional 32 point compass with directions like 'north by north-north-west', but the 360 degrees of a circle instead. This is shown on the chart for reference on the compass rose. On most charts there are several compass roses.

A compass rose.

It is important to get a feel of these directions to make drawing and measuring lines on the chart easier. For example, north is referred to as 000° and south as 180°. Three digits are always used so east becomes 090°, with the 0 being said as "zero". Remember when drawing a line along a ruler it can go in either direction - up as well as down. The easiest mistake to make is to draw a line as a reciprocal, so always check against the compass rose until you have a feel for the directions.

I live north east of London, about 70 miles

Putting these together, the position of a boat two miles south of the Sunk Light-vessel off Harwich becomes '180° from Sunk Light Vessel 2 miles'.

To measure the direction from the chart various plotting instruments or rulers are available.

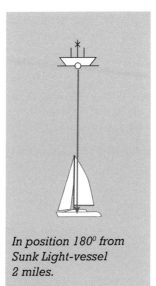

In position 180° from Sunk Light-vessel 2 miles.

Figure 14

Traditionally a **parallel ruler** was used on ships.

To use a parallel ruler place either the top or bottom edge along the direction to be measured and then carefully transfer it to the nearest compass rose by 'walking' the ruler across the chart (see panel below). When one edge is lined up through the centre of the compass rose read the answer from the outer ring. If the ruler slips then start again.

It only takes practice to use a parallel ruler quickly, but they can be very awkward on a small chart table where there is not really room to walk them across the chart.

Using a parallel ruler to measure the bearing of AB

1. *Lay the rule along the line.*

2. *'Walk' the rule towards the compass rose.*

3. *Continue 'walking' towards compass rose*

4. *Read off the angle, in this case 070°.*

The best plotting aid that I have found
and the one that I would recommend is
the **'Breton' type plotter**. A Breton type
plotter has a movable protractor disc
so there is no need to slide it across the
chart to the compass rose. This is much
more convenient on a small chart table.

How to use the plotter

The plotter can be used in two ways:

* To measure the direction from one
 position to another on the chart.
* To draw a line on the chart in a
 chosen direction.

How to measure directions from a chart

A 'Breton' type plotter

1. *Lay the edge of the plotter along the
direction to be measured (A-B).
Take care to point the large coloured arrow
on the plotter in the direction that you want
to measure.*

2. *Turn the protractor disc so that N is
pointing north and the grid on the disc is
lined up with a line of latitude or longitude
on the chart beneath.*

Answer
042°

3. *Read off the answer where the central
line of the plotter meets the protractor
(in this case 042°). Check the answer by
estimating, using the compass rose. Ask
yourself, "Does that seem about right?".
Always test measurements and calculations
against this common sense rule.*

How to draw a line on a chart

1. *Turn the protractor disc so the direction to be drawn is lined up with the central line of the plotter (e.g. 070°).*

2. *Place a pencil on the position on the chart that you are drawing from, and put the plotter against it.*

3. *Align the plotter so that the N is pointing north by sliding and rotating the plotter (using the pencil as a pivot) until the grid on the protractor is lined up with a line of latitude or longitude on the chart beneath.*

4. *Draw the line in the direction of the large coloured arrow on the plotter.*
Check the line by estimating against the compass rose. Remember, the easiest mistake to make is to draw a line as a reciprocal (that is, in exactly the opposite direction).

Finding your position: 1
GPS

Real navigation at last, **finding a position**, and the first chart plotting symbol used by navigators.

A position plotted by a navigator is marked with a circle and the time.

⊙ time

Keeping a sense of the boat's position is vital in the three-dimensional world of the sea. Unfortunately it is not as straightforward as on land. The sea has few features to recognise and no one to ask if you get lost, plus other problems too. Luckily there are instruments to help. As the boat travels forward the **steering compass** will show the direction that the boat is heading and the **log** will measure the distance travelled, but there are unseen forces acting on the boat:

- The **wind** may push the boat sideways causing **leeway**. This affects different-shaped boats to a greater or lesser extent, increases with the force of the wind and varies with the wind direction relative to the boat's heading. Leeway is difficult to measure and has to be estimated from the conditions at the time and the type of boat.

- The whole body of water may be moving too because of a **tidal stream**. This is the **horizontal movement** of the water caused by the ebb and flow of the tides. All vessels and other free-floating objects are affected to the same extent because it is the water that is moving. Tidal streams may increase or decrease the speed of the boat or push the vessel off the heading that the helmsman is steering. This does **not** show on the log and has to be calculated.

So checking the position regularly and **keeping a record in the logbook** is important.

There are lots of ways of checking the position, some quicker than others, some more reliable than others and it is best to use a variety of methods to avoid putting all your nautical eggs in one basket. Never just assume that a position is correct. Look for corroborating evidence and apply the common sense test:

- Does this make sense with what I can see and with the last known position?

Don't assume you are wrong either, in fact don't assume anything! Remember as well that by the time you have plotted the position on the chart you are not there any more! Even if the boat is travelling at only 6 knots, in 10 minutes it will have travelled a mile.

One of the biggest changes in navigation in recent years has been the introduction of electronic position fixing devices with ever-increasing accuracy. First Decca and Loran and now GPS have transformed the work of the navigator. GPS can find the position and then update it automatically every few seconds.

GPS
(Global Positioning System)
A GPS receiver uses information from several satellites to calculate its position. They are remarkably accurate, inexpensive and work world-wide.

The set needs an antenna that can 'see the sky', so many handheld sets will not work down below on the boat. With a fixed set the aerial should be mounted

low down to give the best results and remember to set the datum for the chart that you are using.

Most sets show the position as a latitude and longitude, sometimes to three places of decimals, which is perhaps a little misleading. The average calculated accuracy of a GPS set is within 5 metres 95% of the time. Some sets display the position on a chart image on a chart plotter or computer or the position can be fed into other equipment on the boat such as a VHF/DSC radio or a radar set.

Once the set knows the position it can then compute other very useful information, but to get the best of all these other extra features you will have to read the instruction book! Remember that whatever other information the set displays, **GPS is essentially a position-fixing device** and it knows nothing about depth of water or tidal streams. In fact most boats that go aground on sandbanks or hit rocks probably have GPS!

The GPS can display the position in different ways, such as:

- Latitude and longitude.
- Reference to a waypoint.

These will not give a different position. They cannot be used first one and then the other to check if the position is correct. It is the same information presented in a different way. GPS cannot check itself: new data from another source would need to be introduced to make a worthwhile check of a position.

The choice of display is personal to the skipper and for ease of plotting onto the chart. Using the position displayed with reference to a waypoint can make plotting much quicker and easier than using latitude and longitude.

Plotting the position from the latitude and longitude display

From the GPS the latitude and longitude information can be plotted onto the chart using dividers or plotter.

1. Start with the latitude and line the plotter up on the latitude scale, taking care to count the decimal places accurately. Make sure that the plotter is horizontal using the lines of latitude.

Draw a short line at approximately the correct longitude.

2. *Mark the longitude to complete the position.*

If the plotter is not long enough to line up and keep the lines level and perpendicular, use the dividers for both latitude and longitude.

Figure 15

On a small chart table when the chart has to be folded the latitude and longitude scales may be inaccessible so plotting the position with reference to a waypoint can be easier.

What exactly is a waypoint?

A waypoint is any navigation mark or point on the chart chosen by the navigator. The latitude and longitude of the waypoint are programmed into the GPS. The set will then display the **direction and distance to the waypoint**, updating as the boat moves.

The original idea behind this feature on a GPS set was that waypoints along a route could be selected and displayed during the passage. The directions shown could not be followed blindly, of course, because the GPS has no information about the wind and the tidal streams. Nevertheless, the route feature can be extremely useful, although accidents have occurred when:

- An unsafe waypoint has been chosen, for example, crossing shallow water or rocks.

- **The latitude and longitude of the waypoint has been put into the GPS incorrectly.**
- Boats have hit a buoy used as a waypoint.
- Many skippers have chosen the same waypoint.
- Skippers have not recorded information into the logbook and then suffered a failure of the set.
- Skippers have not checked their position, just followed the machine blindly.
- The GPS has not been set to the same datum as the chart.
- Navigators have not allowed for tidal streams and leeway.

GPS is really great, but use with care.

A waypoint is marked on the chart with a cross and a box.

Plotting a position with reference to a waypoint

You can use a waypoint to make plotting positions quicker and easier than latitude and longitude (see the panel on page 26). The waypoint does not have to be a place on the route, a buoy or anything real at all. It can be any point that is convenient and easy to see:

- The centre of the compass rose is simple for plotting because the compass is there (see opposite).
- A cross of latitude and longitude lines is quick to programme into the GPS.
- A buoy or convenient mark.

Remember the GPS will always show **direction and distance to the waypoint**, because *it thinks that you want to go there!*

Plotting using the compass rose as a waypoint

1. *In this case the direction to the waypoint is* **240°** *and the distance is* **3.6 miles.** *The waypoint is the centre of the compass rose.*

2. *Line up the plotter across the compass rose using the centre spot and 240° on the far side of the rose.*

3. *Draw a short line in the direction towards the centre of the rose.*

4. *Set the dividers to the distance shown, here 3.6 miles.*

5. *Measure the distance.*

6. *Mark the position. Then add a circle and the time, with an arrow pointing towards the waypoint.*

Plotting a position from a waypoint

1. In this case the direction to the waypoint is **030°** and the distance is **2.4 miles**. The waypoint has been chosen by the navigator.

2. On the plotter set the direction towards the waypoint by turning the protractor disc, here 030°

3. Put the pencil on the waypoint and the plotter against it. Slide and rotate the plotter (using the pencil as a pivot) until the grid on the protractor is lined up with the lines of latitude and longitude on the chart beneath, and the N is pointing north.

4. Draw a short line.

5. Measure the distance to the waypoint, here 2.4 miles.

6. Mark the position. Then add a circle and the time, with an arrow pointing towards the waypoint.

Finding your position: 2
A fix

Navigators often spend a great deal of time at the chart table, perhaps trying to calculate the boat's position, and sometimes miss easy opportunities to check the position visually. This is especially true in coastal navigation.

Finding or fixing a position, without the use of GPS, can be done by **observation**.

- If the boat is passing close to a buoy then this will give a **fix of position** (well almost a fix, as buoys do drift a little on their anchor chains).
- If a buoy or better still an object on the land can be seen clearly enough to be identified then a **bearing** can be taken with a hand-bearing compass. Plotted on the chart this bearing gives a position line, because we know that the boat is somewhere on that line. One **position line** will not give a fix of position, of course. Two bearings will give a cross, because the two lines are bound to cross somewhere, unless they are parallel or diverging, so three bearings are needed to give a **fix of position**. This is known as a three-point fix.

- If two objects that can be identified clearly and are marked on the chart are seen to **come into line** this will form a **transit** that can be drawn on the chart as a position line without the need to take a bearing. Again, one position line is not enough, but it can be combined with a bearing to give a **fix of position**. Just two lines is OK this time because the transit is so accurate.

Taking a fix of position using three bearings... a three-point fix.

1. Check on the chart and look around for suitable objects to use to take the bearings:
- Objects that you can see and identify clearly.
- Objects more than 30° apart so the lines cross at a good angle.
- Objects not 180° apart, or the lines will be parallel and not cross at all
- Objects not too far away because the longer the line the greater the inaccuracy.
- Objects on land are the most reliable

How to use a hand-bearing compass
Hold the compass to the eye and look over the compass card at the object. Allow the card to settle before taking the bearing.

as their position never moves.
2. Take the three bearings as quickly as possible, but allow time for the compass card to settle.
3. Take the bearing on the beam (the side of the boat) last, as it is changing most rapidly.
4. When the bearings have been written down note the **reading from the log** that shows how far the boat has moved and the time. It can sometimes be useful to note the depth reading on the echosounder too.

But, unfortunately, before these bearings can be plotted on the chart there is one small problem that must be dealt with.

Compass variation

Variation is caused by the way that the compass works. On small boats, most are magnetic compasses and show north by sensing the earth's magnetic field. Thus they point to **magnetic** north and not to **true** north, which unfortunately are not at the same place. True north is at the top of the world (where the stick comes out of a globe, where all the lines of longitude meet) but magnetic north is in northern Canada.

Variation:
- **Is the angular difference between true and magnetic north expressed in degrees.**
- Varies from place to place in the world.
- Can be E or W depending on the location.
- Affects both steering compasses and hand-bearing compasses.
- Affects all compasses in an area the same, so there is no point in buying a new one!
- Changes very, very slowly with time.
- Is shown on the compass rose.

On a compass rose it might say 3^0 10' **W**. 2000. (7' **E**). This means that when the chart was printed the variation was 3^0 10' **W**. This would be rounded to 3^0 W, the nearest degree, in all

Magnetic North True North

3^0

Variation

calculations (Figure 16). The (7' E) means that the variation is changing by 7 minutes every year. It takes 60' to make 1^0, so it will take over eight years for the variation to change by a whole degree. From one side of the chart to the other the variation may well be different by a few minutes.

To calculate the exact variation in this position:
- Multiply 7' x the number of years since 2000, add or subtract this figure from the 2000 variation. Then round to the nearest whole degree.

*For 2005 that is 7' x 5 = 35' **E**.*
*3^0 10'W - 35' **E** = 2^0 35'W, rounded to 3^0 **W***

In this example the change of 7' was E and **different** from the W variation of the chart, therefore it was **subtracted**. If the designation is the **same** then **add**.

Always correct for the variation to any compass reading before plotting it on a chart, because charts are printed based on true north.

Add or subtract the variation to the compass reading depending on whether the variation in the area is E or W.

To convert a **magnetic** reading from a compass to **true** to plot on the chart:
- **subtract a westerly variation**
- **add an easterly variation**

Friends will tell you rhymes to help you remember whether to add or subtract, which may or may not help. If necessary

write it on the top and bottom of the chart, write it on the plotter, or stick it up by the chart table. Most importantly; become familiar with how to apply variation in your local area. All variation in the UK is west for example, ranging from 5° W in the Irish Sea to 2° W in the North Sea.

My favourite mnemonic is:

C A D E T for Compass to True add E...

+E so -W
→

If the variation is W do the opposite

How to plot a three-point fix:
- Convert the magnetic bearings to true.
- On the plotter set the protractor to the true bearing.

- Place a pencil on the object from which the bearing was taken, with the arrow on the plotter pointing towards it and the N pointing north.
- Slide and rotate the plotter (using the pencil as a pivot) to line up the grid of the protractor with the latitude and longitude lines on the chart beneath.
- Draw in the bearing in approximately the right place. It is better not to draw the full length of the line to avoid clutter on the chart.
- Plot the other bearings.
- Mark each bearing with an arrowhead pointing away from the object. Mark the fix with a circle.
- Write the time beside the fix. The time of the fix is **when the bearings were taken**, because that is when you were there, not the time that the plot is finished.

Plotting a three point fix

1. *Plot the bearing of the headland.*

2. *Next, plot the bearing of the western end of the breakwater.*

3. *Finally, plot the bearing of the last object.*

4. *The resulting 'cocked hat'.*

Figure 17

Don't expect it to be perfect. Usually there is a small triangle called a 'cocked hat'. This is because the boat was moving forwards while the bearings were taken, and maybe up and down as well! If the cocked hat is huge then check the working. Forgetting to convert from magnetic to true will produce quite a large triangle.

Figure 18

Plotting a transit

Two objects that are seen to line up give a transit that can be plotted on the chart. No maths, just draw what you can see. One bearing, corrected for variation, gives a fix (Figure 18). Quick and accurate.

Transit bearing fix

1. *The breakwater and a buoy form a transit.*

2. *Add the bearing of the headland...*

3. *...to give a fix. Finally mark each line with an arrow.*

Finding your position: 3
A DR position

Away from land, especially without GPS, fixing the position can be much more difficult and navigators have to deduce their position using the instruments and written records, such as:

- A steering compass to measure the **direction** the boat is heading.
- A log to measure the **distance** travelled.
- A logbook to record this information at regular intervals.

In the early days the measurements were crude but modern instruments still need checking for accuracy. A **compass** may read inaccurately because of magnetic influences on the boat causing compass **deviation**. Wiring, mobile phones, loudspeakers, batteries, hand-held flares, the engine or even the keel can cause the compass to read inaccurately if they are too close. A **log** may under-read, or even stop, if the impeller is fouled by weed. Under-reading is especially dangerous as the boat may hit the hazard long before it was expected to be close. The instrument will often have a duel display showing the speed that the boat is travelling through the water and the total distance. Usually there is a 'trip' as well so that the distance can be set to zero at the beginning of each passage for easier maths.

Plotting the **direction** sailed and **distance** travelled will give an approximate position known as a **DR position**. DR is an abbreviation for 'Dead Reckoning', which does not seem to make much sense as a name until you know it was an abbreviation from the original expression 'Deduced Reckoning'. A basic DR is simple to use and

quick to plot, but does not give a fix of position with anything like the accuracy of GPS or a three-point fix because it ignores:

- Tidal streams which may be pushing the boat forwards, backwards or sideways.
- Leeway (wind effect) which may be pushing the boat sideways.

But it is better than nothing, and can be improved by allowing for tidal streams and leeway or by fixing the position by another method when it becomes possible.

Keeping a logbook

This is a vitally important record of the navigational details of the passage. The direction steered, alterations of course, log readings and GPS positions must all be written down. Many skippers also choose to record details of the wind strength and direction, depth shown on the echosounder, barometer readings, engine readings and even events like change of watches, change of sails or the sighting of dolphins. A ruled out notebook

From *Logbook for Cruising under Sail*, published by Fernhurst Books.

can be used but printed logbooks suitable for different kinds of boats are also available. They have the advantage of prompting the navigator to include all of the important and useful details.

How to plot a DR position

- Convert the **magnetic** heading that the helmsman has been steering to **true**.
- Set the true heading on the plotter.
- Place the pencil on the last position, and put the plotter against it.
- Slide and rotate the plotter, using the pencil as a pivot, until it is lined up with the chart beneath and the N is pointing north.
- Draw the line in the direction travelled, as shown by the arrow on the plotter, and mark the line with a **single arrowhead**.
- Mark off the distance that the boat has travelled using the difference since the last log reading.
- Mark the position with a line and write the time beside it.

Time	Log	Co. °T	
09.00	0	140° T	Leave mooring
10.00	4.3	120° T	Fix
11.00	9.7	120° T	DR position

DISTANCE
+
DIRECTION
= **DR**

Figure 19

It really is as simple as that. Taking a fix or plotting a GPS position can enhance the accuracy of the very basic DR position. Beware of using DR position after DR position after DR position, as the inaccuracies accumulate.

Plotting a DR position

1. *Set the heading in °T on the plotter.*

2. *Line up the plotter on the chart, from the last position.*

3. *Draw the course steered from the last position.*

4. *From the log, work out the distance travelled. Set the dividers to this distance, using the latitude scale.*

5. *Measure the distance along the course steered.*

6. *Mark the position with a line. Then write the time beside it.*

If the boat alters course at any time a record must be made in the logbook of:
- New heading.
- Time.
- The log reading so that the distance travelled since the last position can be calculated.

Time	Log	Co. ^0T	
09.00	0	140^0	
10.00	4.3	120^0	Fix
11.00	9.7	120^0	DR
11.30	12.6	120^0	alter course to 100^0
12.30	18.2	100^0	DR

Figure 20

Traditionally, information has been written in a logbook every hour, every few hours or on every alteration of course, and the position plotted on the chart at the same time.

What about leeway?

Leeway is the effect of the wind on the boat. It is expressed as how many degrees the boat has been pushed **away** from its intended heading, perhaps 5^0, 10^0 or more. It is difficult to measure and there are no tables where you can look it up.

It varies with:
- The shape of the boat below the waterline - a long keel helps to stop sideways movement.
- The shape of the boat above the waterline - the higher the superstructure the more leeway is made.
- The speed of the boat through the water - forward speed helps to diminish the effect.
- The direction of the boat relative to the wind.
- And for a sailing boat...
 ...how well it is being sailed!

This Dehler 37 is sailing forward nicely, but she is also making leeway towards the camera.

Northerly wind

Heading
130° T

Estimated
leeway 10°

So plot 140° T

130°

140° T

Southerly wind

Heading
130° T

120° T

Estimated
leeway 10°

So plot 120° T

130°

Figure 21

The skipper needs to estimate the amount of leeway that the boat is making and allow for this **before plotting on the chart**. Some people say that looking at the wake - that is watching the angle behind the boat that the wash is making - and maybe taking a bearing of it with a hand-bearing compass, helps in assessing the leeway... but I am not convinced.

Estimating seems to be largely based on experience and perhaps pessimism, although GPS can now help.

The important things to remember are:

- Add or subtract the estimated leeway before plotting on the chart.
- The wind has pushed the boat away from the intended heading so allow the leeway **downwind** - that is, away from the wind.

- **ADD / SUBTRACT LEEWAY BEFORE PLOTTING**
- **ALLOW FOR LEEWAY DOWNWIND**

Finding your position: 4
An estimated position

The DR position lacks accuracy because it does not take into account the **tidal stream** (TS). The tidal stream can be calculated and added to the diagram to give an **estimated position** (EP).

An EP is shown like this:

How to plot an EP

- Plot the DR position.
- From the DR position draw a line that represents the direction and rate of the tidal streams that have moved the boat away from the DR position.

Time	Log	Co. 0 T		TS
09.00	0	140^0 T	Leave mooring	170^0 T
10.00	4.3	120^0 T	Fix	1.0 knot
11.00	9.7	120^0 T	DR position	

Tidal stream information is always given in **^0T in the direction that it is going for each hour**. It means that the tidal stream

is taking the boat 170^0 T at a speed of 1.0 knot (Figure 22). **One knot equals one nautical mile per hour**.

If the EP were for 1030 then the skipper would plot the DR position as usual, but only half the rate for the tidal stream because it would have had only half the effect (Figure 23).

Figure 23

Always plot in that order: DR position, then tidal streams, to give an EP.

DR + TS = EP

An EP can be plotted after an hour or after several hours, if the boat is in open water.

It can be plotted if the boat has altered course, and even in the case of a yacht tacking. Plot the direction and distance sailed and then the tidal stream at the end. The important thing to remember is that the total tidal stream plotted must be in proportion to the time that the boat has been sailing. In most cases the direction and rate of the tidal stream will change from hour to hour. This is not a

Figure 22

problem, just plot them all at the end, but remember it is only safe to do this in open water. Skippers are recommended to check their position regularly - an EP is only an estimate of position.

Figure 24
Plotting an EP after 2 hours

Once the plot is on the chart it shows the result of sailing in one direction while the tidal streams have been moving the boat sideways. The plot reveals how much influence the tidal streams have had on the speed of the boat and the direction of travel.

The diagram can look very different depending on the direction of the tidal stream in relation to the heading of the boat (Figure 25).

Figure 25

Course over the ground (COG)
Did the boat pass to the north or south of the buoy (Figure 26)?

Figure 26

To the south, from the fix to the EP. The COG is shown here as a dotted line.

Speed over the ground (SOG)
Look at Figure 22 again. It shows that the boat was at the fix at 1000 and then at the EP at 1100. Although the log recorded a distance travelled of 5.4 miles the initial fix and the EP are more than 5.4 miles apart. This may look like a mistake but it is due to how the distance and speed are recorded by the log.

Most logs measure the speed and distance by means of a paddlewheel transducer mounted through the hull and show it on the display in knots (one knot equals one nautical mile per hour). As the paddlewheel spins the log measures the **speed through the water** but the log is not able to show the effect that the tidal stream is having. The tidal stream may increase or decrease the speed and the EP diagram demonstrates this (Figure 27). The diagram shows how quickly the boat is really covering the ground, it shows the **speed over the ground**, which the log is not able to do.

Figure 27

Without a diagram the speed over the ground is not always obvious but the difference it can make to a boat travelling at a slow speed is amazing.

This is yet another reason why it is so important for a skipper to know how the tidal streams are affecting the boat all the time: the tide's speed as well as its direction. This is especially true for skippers of relatively slow boats like yachts. On a passage along the coast, going with the tidal streams makes a huge difference for a yacht crew. Going against the tidal streams is like walking up a down escalator, it's not impossible to reach the top, but it's not quick and it's not clever.

Imagine two yachts sailing at 4 knots with a tidal stream of 2 knots. One is sailing up the coast and the other down the coast (Figure 28).

streams is still important. Planning to go **when the tidal stream is in the same direction as the wind** will give flatter water, higher cruising speed and better fuel efficiency.

A's speed through the water (from the log)	4.0 knots
TS	2.0 knots
speed over the ground	2.0 knots

SOG B's speed through the water (from the log)	4.0 knots
TS	2.0 knots
speed over the ground	6.0 knots

Figure 28

On both boats the speed through the water is 4 knots, the log shows 4 knots on both boats. Both boats feel as if they are making the same progress, but one crew will be in the showers and the bar way ahead of the other. So don't just get up, have breakfast and go, check the tidal streams and go at the best time.

All this means that it is possible for a yacht skipper to make a passage to a port 30 miles away but for the log to show that the boat has sailed only 25 miles through the water to get there. Conversely the crew on the boat where the skipper does not plan may have to sail further through the water than the total distance on the chart. A case of 'up the down escalator'.

For a fast motor cruiser lack of speed over the ground is not so much of an issue but knowing about the tidal

GPS is especially useful again because it has the ability to calculate speed over the ground (SOG) and show it on the display. It can do this so quickly and easily because it updates its position every few seconds.

GPS showing speed through the water and speed over the ground.

A, sailing <u>against</u> a 2kn tide.

B, sailing <u>with</u> a 2kn tide.

Looking at tides: 1
General introduction

Navigation would be so easy without tides. They cause vertical movement of the water producing changes in the **tidal height** and the horizontal movement of the water that we call **tidal streams**.

Without tides:
- An EP would be unnecessary, because a DR position would be accurate.
- Coastal passages could be made at any time.
- The direction to the next mark could be measured off the chart and steered, because the tidal streams would not push the boat off course.
- The depths over rocks and sandbanks would always be the same.
- The depth would always be as shown on the chart.
- The chart would show if there was enough water to get into a river or harbour.
- After anchoring the water level would not change. This would reduce the risk of the anchor dragging if too little anchor cable had been laid out

to allow for the rise of the tide.
- The boat could not go aground on a mooring, because the water level would not drop.

This list is enough to show that tides affect all aspects of boating.

What causes the tides?

The gravitational pull of the moon and the sun on the water causes the tides, and their relative positions in the sky produce the patterns in the behaviour of the tides.

As the earth spins throughout the 24 hours of the day we experience two high waters and two low waters, about 6 $1/4$ hours apart. The sun is sometimes pulling with the moon and sometimes against it, and this leads to some high waters being much higher than others (Figure 29). This pattern of larger tides occurs fortnightly and is called **spring tides**. A spring tide has a higher high water and a lower low water. Between the spring tides

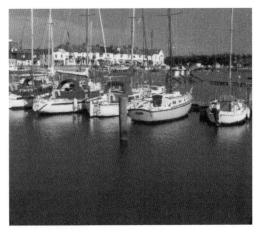

Arun Yacht Club at high water...

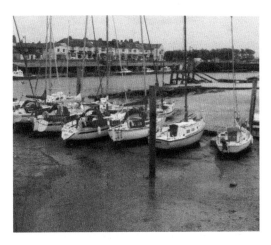

...and at low water.

Figure 29

are **neap tides** where the high water is less high and the low water less low. Spring and neap tides occur throughout the year about a week apart, but how extreme they are varies too. The most dramatic spring tides of the year occur in March and September, with the Equinox.

I have heard people say, "It is spring tides this week." This is as absurd as saying, "It is Monday this week." Tides move gradually from neaps to springs and then back again in a natural cycle. Each day the HW is likely to be a little higher until it reaches a peak and then declines again.

As soon as the subject of tides comes up there seem to be lots of new terms and it is useful to get their meanings sorted out straight away.

Range of the tide. The range of the tide is the difference in height between HW and LW. The range is the most reliable method of calculating if it is a spring or neap tide, by comparing it to the mean range for springs and neaps at the port.

Range = high water - low water

Spring tide. Spring tides occur about two days after full moon and new moon. The HW is very high and the LW very low, giving the greatest range. The tidal streams are also at their strongest, because there is more water to flow in and out but the same number of hours between high water and low water.

Figure 30

Figure 31

Neap tide. The HW and LW are less extreme when there is a neap tide so the range is smaller. The tidal streams are weaker too.

Chart datum. Chart datum (CD) is the reference level on charts from which depths and drying heights are measured. CD is the lowest level that the water is expected to fall, under normal conditions,

and is therefore the Lowest Astronomical Tide.

Drying height. A drying height is the amount a rock, mudflat or sandbank dries or sticks up above chart datum. Although it is above chart datum it is not always above the water. These are the areas on the chart shaded in green, where the numbers are underlined. Although they show so well on the chart they are not always visible to the navigator as sometimes the area will be covered by water.

Charted depth. The charted depth or **soundings** are the numbers written in black on the chart. The charted depth does not include the tide, so there is

Figure 32.
Tidal curve for Harwich shows mean (average) range of the tide for spring and neap tides.

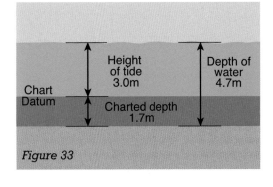

Figure 33

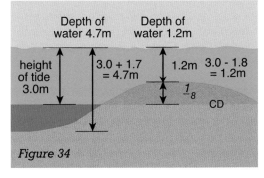

Figure 34

almost always more water than shown.

Height of tide. The height of tide is the amount of water above chart datum. The height of tide for HW and LW is shown in the tide tables. During the (approx.) 6 hours between HW and LW, the height of tide has to be calculated on a tidal curve graph (Figure 32).

Depth of water. The depth of water is the amount of water from the surface to the sea bed (see Figure 33). The depth of water can be calculated by:

> **Height of tide + chartered depth = depth of water**
>
> **OR**
>
> **Height of tide + drying height = depth of water**

For a drying height the depth is calculated as in Figure 34.

Rise of tide. The rise of the tide is the amount the tide has risen since low water.

Fall of tide. The fall of the tide is the amount the tide will fall until low water.

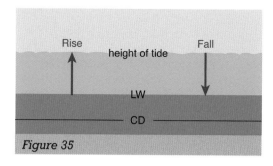

Figure 35

Chartered height.
This includes:
- the height or **elevation of a lighthouse** above MHWS.
- the **vertical clearance under a bridge** or other obstruchon above HAT (highest astronomical tide).

These levels are used to give a pessimistic answer.

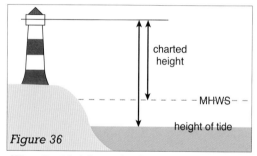

Figure 36

When the tide is lower the clearance will be greater.

Figure 37

On Figure 37 the elevation is shown:

$$\underline{3\,8}\qquad \text{meaning 38m.}$$

The height of a lighthouse is shown on the chart to give an indication of how far away it can be seen: the taller the lighthouse the further away it will be seen. When the tidal height is below MHWS (mean high water springs), the lighthouse will be higher above the water; therefore visible at a greater distance. The height of eye of the observer has to be taken into account too and in the almanac there is a table to do this.

MHWS. Mean high water springs is the average height of high water for all spring tides.
MHWN. Mean high water neaps is the average height of high water for all neap tides.
MLWS. Mean low water springs is the average height of low water for all spring tides.
MLWN. Mean low water neaps is the average height of low water for all neap tides.
HAT. Highest astronomical tide is the highest level the tide is ever expected to rise, under normal conditions.

Looking at tides: 2
Tide tables and tidal heights

Information about tides starts with tide tables, which are produced in many forms:

- Admiralty tide tables contain only tidal information. They include many national and international ports and are the size and weight of a telephone directory!
- Some marinas, chandlers and ports publish small booklets containing tide tables for their location. They are usually small enough to fit into a pocket and very useful, but do only cover a small area.
- Almanacs include tidal data for many ports and also an enormous amount of other information on ports, safety matters, weather forecasts and much, much more. They are pretty much an essential reference book on a boat.

Whatever source is used not all the ports can be included. Those listed are known as **standard ports** and HW and LW times and heights are shown for every day of the year. Don't forget that the height given is the **height of tide** - that is the amount of water above chart datum. Looking up the details for standard ports is straightforward.

To use the table:
- Check the port, month and date. Look twice, as it is easy to make mistakes.
- Note the HW and LW details.
- Consider the time zone, and add an hour for daylight saving time (DST), that is BST, when required.

UK tide tables are written in UT (Universal Time), which is the same as GMT, and so from March to October an hour needs to be added to convert to British Summer Time (BST).

The time zone for the table will be printed at the top of the page. For example the time zone for France, Belgium and Holland is **" –0100"**, meaning minus one hour. The " –1" time zone indicates than one hour needs to be **subtracted** throughout the year to convert the times in the table **back to UT**. That is how time zones are written.

In summer, of course, it is necessary to add an hour back on to convert to BST, and maybe another hour as well for local summer time. These calculations may seem complicated when planning at home but it is the same as adjusting your watch just before the plane lands.

While looking up the HW and LW in the almanac it is a good idea to take the opportunity to calculate whether the tides are on neaps, springs or somewhere in between. Some skippers guess whether

Figure 38

Figure 39

it is neaps or springs by scanning the list and spotting that the largest HW and then assuming that it is a spring tide. It is better to calculate, and not at all complicated.

How to decide if it is springs or neaps

- Look up the HW and LW height for the day.
- Calculate the range of the tide (HW - LW).
- Compare the range of the tide that day to the mean range for the port. The mean, or average, range for the port can be found in the almanac near the tidal curve diagram, which we will look at later. Here (Figure 39), the mean spring range is 3.6m and the neap range is 2.3m.

Using this method to calculate between neaps and springs is quick and accurate and shows the occasions when the tides come outside the average range, affecting the strength of the tidal streams. For example, if the range is 3.8m or 4.1m, we are on 'super springs' or a big spring tide.

Secondary Ports

Anywhere that does not have a full table in the almanac is known as a Secondary Port, irrespective of the size. For these ports simple calculations have to be made to work out the time and height of HW and LW. This converts the data for the Standard Port to the Secondary Port.

The principle is very simple:
- Ports that are near to each other often have tide times that are quite similar in a regular pattern, either a bit earlier or a bit later.
- If the difference between the time of the tide at the Standard Port and the time of the tide at the Secondary Port is known, then the latter can be calculated.

Looking this up in the pocket tide tables shows the simple logic of this.

Harwich is a standard port with its own pocket tide table. On a table the differences to add or subtract from the time of HW at Harwich are listed for many secondary ports up and down the

Ipswich ●

Pin Mill ●

HARWICH

Differences on Harwich
Pin Mill +10 mins
Ipswich +20 mins

HW Harwich 0756 UT.

So Pin Mill 0756 Ipswich 0756
 + 10 + 20
 + 1.00 + 1.00
 09.06 BST 09.16 BST

Figure 40

coast nearby.

For Ipswich, which is up the River Orwell from Harwich, the difference is listed as +20, meaning twenty minutes later.

For Pin Mill, the pretty riverside hamlet with the famous 'Butt and Oyster' Pub, which is half way up the river from Harwich to Ipswich, the difference is +10 or ten minutes later.

It's as simple as that, and usually quite accurate enough.

But...

There are more detailed tables in almanacs and the Admiralty tide tables that show that there is a little more to it than that.

- The adjustments shown in the pocket tables are the average of two differences given in the almanac.

- In the almanac the two differences are for springs and neaps. The pocket table might say +20 minutes when the almanac gave +15 and +25 minutes.

- When the differences vary a great deal, especially when it is not dead on springs or neaps, then it is necessary to look at the two figures and calculate or estimate how much to add or subtract between the two extremes (interpolate).

- In some places where the flow of water is complicated by the shape of the land, such as the Solent, the differences are complex too. This can mean that the two differences are hours apart. **Look for more information in local pilot books if the situation seems very hard to understand**. Many secondary ports that are both complex and popular publish their own pocket tide tables to save skippers complicated calculations.

How the Secondary Port table works

Standard Port Harwich	HW		LW		MHWS	MHWN	MLWN	MLWS
	0000	0600	0000	0600				
	1200	1800	1200	1800	4.0	3.4	1.1	0.4
Secondary Port Ipswich	+0015	+0025	0000	+0010	+0.2	0.0	-0.1	-0.4

If HW today at Harwich is **0000 UT** or **1200 UT** **ADD 15 mins**	If HW today at Harwich is **0600 UT** or **1800 UT** **ADD 25 mins**	If HW today at Harwich is 4.0 **ADD 0.2 for HW at Ipswich**	If HW today at Harwich is 3.4 **ADD 0.0 for HW at Ipswich**

BUT...

if between

0000 ⇄ 0600
1200 ⇄ 1800

ADD *between* 15 and 25 mins

if between

4.0 ⟶ 3.4

ADD *between* 0.2 and 0.0

For example...

HW at Harwich is at 0756 UT
- Call it 0800
- 0800 is between 0600 and 1200
 So add between 25 and 15 minutes
- 0800 is nearer 0600 than 1200
 So add nearer 25 minutes than 15

 0756 UT
+ 22 mins
= **0818 UT**

*Remember... you must take into account the **time zone**.*
*In this example, if it were currently BST, you would need to **add another hour**,*
*which would make the correct answer: **0918 BST**.*

To make things easier it is possible to download 7 days' worth of tidal data for both Standard and Secondary Ports from www.ukho.gov.uk/easytide and there are programs for PCs.

Looking at tides: 3
Tidal streams

In some ways tidal streams seem like a different subject to tidal heights, but obviously they are not, as they are caused by the rise and fall of the tides.

Tidal streams are the **horizontal movement** of the water and they are hugely important in navigation. Some people talk of currents when they mean tidal streams. Ocean currents, like the Gulf Stream or the Equatorial Current, generally flow in a constant direction, whereas a tidal stream **changes direction**, usually near high water and low water. On average, tidal streams flow for 6 hours in one direction and then for 6 hours in the other.

Generally:

- The direction of the tidal streams is along the coast.
- Tidal streams flow very strongly if the water is forced through a narrow gap between islands or at the mouth of a river.
- Tidal streams flow more strongly round headlands.
- On average the tidal streams are strongest during the 3rd and 4th hours of the 6 hour run and slackest at the turn of the tide.
- Tidal streams are less strong in the shallow water near the banks of a river or in a bay.
- Tidal streams are strongest during **spring** tides, when the range is at its greatest, because there is a greater volume of water but still just a 6 hour run.

How do navigators know what the tidal streams are doing?

In a river or when passing a fixed object like a buoy or moored boat it is often easy to **see the direction** of the tidal stream. A moored or anchored yacht will almost always lie to the tide because of its keel. If the wind is very strong and the tide very weak, or if the boat has no keel, then the direction it lies will be more influenced by the wind.

Sometimes the **strength** of the tide is dramatically obvious as well.

These anchored boats are all lying to the tide.

The 'bow wave' and wake of this buoy show the tide's direction and strength.

At sea these visual clues are rare and it is easier to forget the effect that the tidal stream is having on the boat. Ignoring the tidal stream influence when planning a passage can add hours to the journey, but more dangerous is not allowing for its effect when passing fixed objects, such as a navigation buoy, or navigating past sandbanks or rocks. Skippers need to keep tidal streams uppermost in their minds and calculate them using:

- **Tidal diamonds** shown on the **chart**.
- A **tidal atlas**, which is a **book** showing the tidal streams on maps of an area.

People ask which is better, but they are just different ways of showing the same information. The atlas displays the detail in a graphic way on maps and the tidal diamonds show the information in a table of figures on the chart. The figures may give the impression of greater accuracy but that is not so. Sometimes one is more suitable for what you are trying to find out than the other, but both involve some looking up and interpolation.

Tidal diamonds

Tidal diamonds, identified by letters, are spread around the chart and the information is given in a table.

Tidal Streams referred to HW at HARWICH

			Ⓐ		Four hours before HW:
Before High Water	6	273	0.8	0.5	
	5	263	1.2	0.8	254⁰ 1.1 0.7
	4	254	1.1	0.7	
	3	252	1.2	0.7	
	2	253	1.2	0.5	
	1	265	0.7	0.5	
HW		015	0.2	0.2	
After High Water	6				
	5				
	4				
	3				
	2				
	1				

At the top of the table is shown the **reference port** for the tidal stream information on the whole chart. As you continue on your passage the next chart may have a different reference port. This is a very easy way to get things wrong, so make it a habit to check the reference port for each new chart.

Each row of information in the table is valid for an hour before or after high water and the figures show the **direction and rate** of the tidal stream at the position of the diamond. That is the direction the tidal stream is **going** in degrees true, so there is no need to allow for variation before plotting it on the chart. The rate or speed of the tidal stream is in knots, (nautical miles per hour). The two different rates are for spring tides and neap tides, with the springs given first. This is easy to recognise as the rate at springs is stronger, because the range of the tide is greater. If the range is between spring and neap then **interpolate**.

The order of work is therefore:
- Look up the time of HW **at the reference port** for the chart, and convert to BST if necessary.
- Compare the range of the tide with the mean range to check if it is springs, neaps or in between.
- Calculate which hour to use.
- Look up the direction and rate of the tidal stream on the table.

Calculating which hour before or after HW to use is very important and needs to be done systematically. Just looking and guessing which hour to use, in my experience, does not produce accurate results. Obviously the tidal stream does not suddenly change direction, but the information is assumed to be the average for each hour. Each direction and rate from the table is valid for the hour, so if HW is 1215, then the hour of high water is from ¹/₂ hour before the actual time of HW to ¹/₂ hour after the actual time, i.e. 1145 to 1245. This follows for all the

other times too and is the standard way
of calculating which hour to use. It should
be followed pretty rigidly, only rounding
up or down the odd minutes. Again there
are several ways of writing this out but I
find a table successful, even if it does look
a little like writing out the times tables
from school!

Tidal stream atlas

The Hydrographic Office publishes atlases
showing tidal streams for different areas,
and smaller versions of the diagrams can
be found in almanacs and on some charts.
In the atlas are a series of 13 maps for the
same area with the tidal streams shown
as arrows and numbers to illustrate the
direction and rate of the tidal streams
for each hour. There is one map for each
hour before and after high water at the
reference port (Figure 41). The middle
of the sequence of maps shows the tidal
streams for the high water hour. The
maps give a good visual image of the tidal
stream direction, and this makes an atlas
especially good for **passage planning**
round the coast and for a quick picture
of the tidal streams while on passage.
They can also be used where there is no
convenient diamond.

The general **direction** of the tidal stream
is obvious and this may be sufficient for
a passage plan. If a precise direction is
required for navigation then use a plotter
to measure the direction from the best-
placed arrow, on the correct page of the
atlas (see photo opposite).

Figure 41

The numbers printed beside the arrows
show the **rate** of the tidal streams. The
two figures are the rate for spring tides
and neap tides, strangely with the neaps
given first this time. If you forget this it is
easy to guess, as the neap rate is almost
always less.

Measuring the direction of the tidal stream from a tidal stream atlas.

The numbers look a little weird as they are written without the use of a decimal point so **14, 25 means 1.4 knots at neaps and 2.5 knots at springs**, and not 14 and 25 knots! The appearance of the arrow also indicates the strength of the stream, with stronger tidal streams being shown by the darker thicker lines.

The order of work is therefore:

- Look up HW **at the reference port for the atlas** and convert to BST if necessary.
- Compare the range of the tide with the mean range to check if it is springs, neaps or in between.
- Mark up the tidal atlas, that is write on the HW page the time of HW for the reference port and then by adding and subtracting write the time on all the other pages.

Remember that **each page is valid for an hour**. That is $1/2$ hour before to $1/2$ after the exact time that you have written. Some skippers find it more convenient to write the hour that is covered on the page, rather than the exact time, to remind them of this.

Looking at tides: 4
Using tidal heights

In *Looking at tides 2* and *3* we have covered looking up the times and heights of HW and LW at standard ports and at how to convert these to secondary ports. These figures can be used with other tables or maps to calculate the tidal stream, or applied to the chart depths shown on the chart to give the depth of water:

- Height of tide + chartered depth
 = depth of water
- Height of tide – drying height
 = depth of water

But... there is more. Perhaps the plan is to go into a small harbour on a particular summer afternoon.

The chart shows that the charted depth is 0.5m. At 1506 BST, at LW, there will be only 1.4m depth of water in the entrance to the harbour - too little water to go in. At 2137, at HW, the depth of water will be 3.9m, which is plenty of water but perhaps rather late in the day for showers and dinner ashore. But, if there is too little depth of water at LW and plenty at HW, it must be possible to go in at some time between LW and HW as the water rises.

What time can we go in?
The answer to this question is going to be when there is the amount of water that we need. So the first thing to work out is how much water (or height of tide) we require.

Consider:

- The **draught** of the boat.
- The **clearance** that you want beneath the keel. This is an individual decision and may be based on the nature of the seabed, how rough the conditions are likely to be and whether the tide is rising or falling (Figures 41 and 42).
- The **information on the chart**. The charted depth or drying height.

Draught:		1.8m
Clearance:	+	0.7m
Depth needed:	=	2.5m
Charted depth:	–	0.5m
Height of tide required: =		2.0m

Once the height of tide required has been calculated then the **tidal curve diagram** needs to be set up (Figure 43).

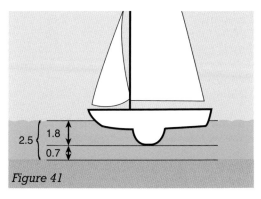

Figure 41

Depth needed = draft + clearance

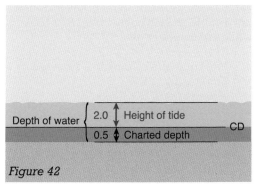

Figure 42

Height of tide required =
depth need - chartered depth

From the tide table the following
information is needed:
* Time of HW. Add the hour for BST if
 necessary.
* Height of HW.
* Height of LW.
* Spring or neap tide. This is necessary
 because in some places on the curve
 there is a different line for springs
 and neaps.

On the diagram:
1. Mark on HW and LW on the left of
 the diagram, and join them with a
 diagonal line.
2. Write the time of HW in the HW
 box on the right, beneath the curve
 showing the height of tide rising and
 falling, and fill in the other boxes as
 necessary (2137, 2037 etc).
3. Find the height of tide required, 2.0m
 in this case; draw a line vertically
 down to the diagonal line; draw
 the line horizontally to the curve,
 then down to find the time. Use the
 neap curve or the spring curve or in
 between depending on the range.
4. Read off the time: 1737 + 20 minutes;
 1757 (about 6-ish) is the earliest the
 boat can go in.

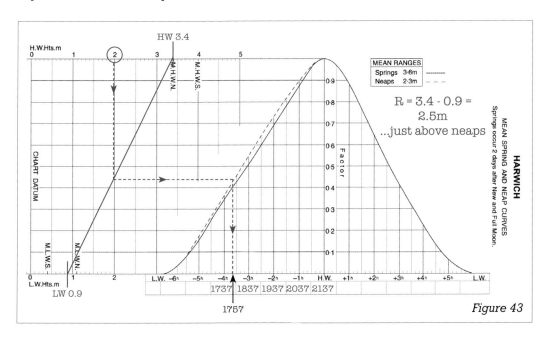

Figure 43

Or perhaps another boat might meet this situation:

Draught:		1.5m
Clearance:	+	0.5m
Depth needed:	=	2.0m
Drying height:	+	1.1m
Height of tide required	=	3.1m

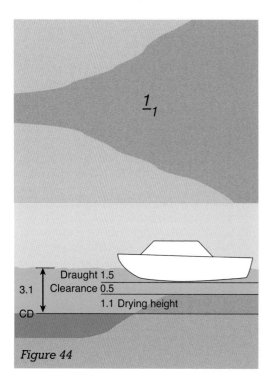

The tidal curve can also be used to answer another type of question:

What is the height of tide at a specific time?

This, in a way, is the same as the last question but the other way round! The tidal curve diagram is set up in the same way using the same information as before, but using the morning HW. The things to consider are:

- The time of HW, in BST if relevant.
- The height of HW.
- The height of LW.
- Springs or neaps.

What is the height of tide at 1030 BST?

1. Mark on the HW and LW and draw in the diagonal line.

Figure 44

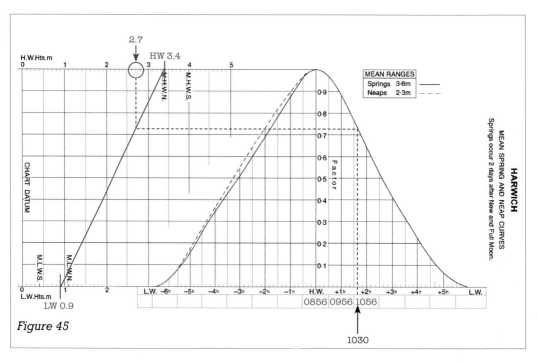

Figure 45

2. Write the time of HW in the HW box beneath the curve and fill in the other boxes as necessary

3. Find the time required -1030 in this case - beneath the curve; draw a line up to the curve; draw horizontally to the line; and then up to find the height of tide. Use the neap curve, the spring curve or in between depending on the range.

4. Read off the height of tide: 2.7m in this case.

This type of calculation can be used when planning to anchor or moor, especially on a falling tide.

What is the minimum depth to anchor, or for mooring?

The things to consider are:

• The **draught** of the boat.
• The **clearance** required under the keel at LW.
• The **fall of the tide** between the time of anchoring or mooring and the next LW. This is extremely easy to work out because the tide will fall from the height of tide at the time of anchoring to the level of low water. Once it is LW the tide will stop falling...
...that's why it is called low water!

> **Draught + clearance + fall
> = minimum depth to anchor**

The skipper decides to anchor at 1030 and realises that the tide will be falling while the boat is at anchor. It's important not to anchor in too shallow water even though this may give good shelter or keep the boat clear of other vessels, in case the vessel goes aground.

So the way to work this out is:

1. Calculate the height of tide at the time when they plan to anchor.
2. Work out how much the tide will fall while the boat is there. It will fall from its present height to the height of low water.

> **Height of tide - low water
> = the fall of the tide
> 2.7m - 0.9m = 1.8m**

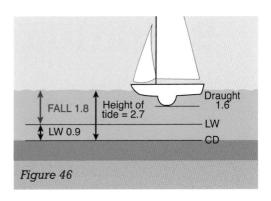

Figure 46

3. The minimum depth to anchor in at 1030 will then be:

> **Draught + clearance required at LW
> + the fall of the tide
> 1.6m + 1.0m + 1.8m = 4.4m min. depth**

OR... You have picked up the only mooring available in a very popular, pretty spot but it is in quite shallow water. Will there be enough water at LW or will the boat go aground?

• Check the depth of water on the echo sounder
• Calculate the height of tide now
• Work out the fall of the tide. (Height of tide – LW)
• Don't forget the draught of the boat.

> **Depth of water - fall - draught
> = clearance at LW**

If the place is a **secondary port**, first convert the standard port times and heights to the secondary port and then do the calculation. Use the tidal curve for the standard port if it is necessary to do a 'height of tide' calculation.

Sierra on a passage ...Pin Mill towards Brightlingsea

Sierra is preparing for the passage from Pin Mill towards Brightlingsea

Don't overload the dinghy and wear a lifejacket.

Check safety equipment and brief crew

- Lifejacket and harness
- Lifebelts/liferaft
- Flares
- Use of VHF/DSC
- Gas and fire extinguishers
- MOB procedure
- First aid kit

Checklist before departure

1. Charts and navigation plan
2. Engine checks
3. Sail cover off / sails ready to go
4. Weather forecast
5. Fuel/water/gas
6. All hatches shut
7. All gear stowed
8. Crew ready, waterproofs/boots/ lifejackets as necessary
9. Food prepared
10. Radar reflector up
11. Details left ashore
12. Instruments on

Follow the channel down the river

Marina

In harbour
Look out for shipping,
and monitor the VHF.

Avoid big ship channels when possible.

Out to sea

Sierra leaves the harbour on passage, **but the first buoy on the route is dead upwind... what do we do?**

Sail to the best course to windward.
Make a log entry.
Put the buoy in as a waypoint.

Check the position.
'Go about' and make a log entry.

Check the position. Look for the buoy.

FIX

At the buoy make a log entry.
"Where now skipper?" asks
the crew... to be continued.

Course to steer: 1
The basic plot

From the chartwork point of view, calculating and understanding a course to steer is perhaps the most important and most regularly used part of navigation. A course to steer is vital, to make navigation safe and efficient.

Although at first glance the diagram may look a little similar to an EP, the purpose of the calculation is completely different. An EP is one of a range of methods of checking the boat's position, to answer the first question in navigation "Where am I?" GPS is used more frequently than an EP (or any other method) to check the position, because it is quick and generally reliable, but there is only one way to answer the second question, "Where should I go now?", and that is the **course to steer**.

A course to steer is unique because it involves **predicting** the course that will take the boat to a chosen position. It takes into account:
- The tidal stream that will be experienced.
- The estimated speed of the boat.
- Any leeway.

A course to steer is calculated in advance; it is a form of **pre-planning**, adjusting the way the boat is heading before setting off to prevent the tidal streams and the leeway from pushing the boat off the desired track. **A basic GPS set cannot do this**. If the destination is put into the GPS as a waypoint the set will calculate the direction towards it and keep updating that as the boat moves, but it will not take into account the tidal streams, because the set does not have that information. The boat may be pushed away from the track, possibly into a dangerous

situation. Remember that GPS is a great aid to navigation but essentially it is a position-fixing device. After the skipper has calculated a course to steer the GPS can be invaluable for checking that everything is going well while the course is sailed. In fact, without GPS, if there is nothing on which to take a bearing, it can be impossible to check a course to steer. The skipper may only know that they are wrong when the buoy fails to appear!

The principal of a course to steer is easy to see when a boat is steering into the entrance of a marina where there is a strong cross-tide. The experienced helmsman can see and feel that the boat is being pushed sideways by the tidal stream, and will instinctively head up into the tidal stream to compensate (Figure 47).

Tidal stream

Figure 47

If they can see that altering the heading alone is not sufficient the experienced helmsman will increase the speed. The speed of the boat is obviously significant, especially a lack of speed when the sideways effect of the tidal stream will be felt more strongly. These adjustments

How to work out a course to steer:

Figure 48

1

1. Plot the course over the ground on the chart. This is the line that the boat will follow, so take care that it does not cross any hazards like shallows or rocks. Always extend the line beyond the destination to avoid mistakes in plotting at a later stage. Mark this line with two arrowheads.

2 About 1 hour, at average boatspeed

2. Estimate how long it will take to get there. This does not have to be precise, just measure the distance to travel and use the average boatspeed, working to the nearest convenient hour or half hour.

3

	Ⓐ		
-6	180°	0.7	0.3
-5	170°	1.0	0.6
-4	000°	1.8	1.0

3. Calculate the tidal streams that the boat will experience during that time. This is pre-planning don't forget, so it must be future tidal streams.

170°
1.0 mile

4

4. Plot the tidal streams from the initial position. Plot the tidal streams in the direction they are going and mark the line with three arrowheads.

5. Now the effect of the speed must be considered. Use the average speed of the boat through the water from the log. If this is a one hour diagram set the dividers to one hour of boatspeed and mark this distance from the end of the tidal stream to the point it crosses the course over ground (COG). Draw a line from the end of the tidal stream to this point. This last line is the **course to steer**. The course to steer from the chart will be in °T so adjust for variation before telling the helmsman. Do NOT just draw the line from the end of the tidal stream straight to the destination; although neat, it is wrong.

5

course to steer

6. Consider leeway. How much the wind may push the boat off the COG needs to be allowed for before telling the helmsman the course to steer... more of this later.

This order of working is reliable and, with a bit of practice, quite easy.

to the heading and speed are often made by eye, or by following markers put up to form a **transit**.

A course to steer is really just the same but, without the posts and the narrow entrance ahead, the effect of tidal stream cannot be seen and the allowance made by eye. The tidal stream must be calculated using the tidal diamonds on the chart or the tidal stream atlas and **the speed of the boat must be taken into account**.

The basic method of calculating a course to steer is very straightforward and needs to be worked out in good time, before the boat arrives at the position where the skipper intends to alter course. Once at that position the crew will ask,

"What's the next course, skipper?" and the skipper needs to be ready with an answer. "Er, well I'm not sure" will not inspire them with confidence. I heard a skipper say once, "Sail round the buoy while I work it out." Not a good idea! (See Figure 48, p59)

Additionally, just a quick look at the finished diagram should be enough to see approximately when the boat will arrive. A rough estimated time of arrival (ETA) is quite good enough usually, and useful too. It avoids skippers worrying when they cannot see the next buoy ages before it will be visible and allows time for a cup of coffee! (See Figures 49 and 50.)

Many skippers plan their trip using the buoys as marks along the route. This is

One hour diagram

TS 170 ⁰ 1.0 knot
Boat speed
6 knots

COG

CTS

About how long will it take to get there?
Just under an hour

Figure 49

One hour diagram
What if your boat speed is only 5 knots?

TS 170 ⁰ 1.0 knot
Boat speed
5 knots

COG

CTS

About how long will it take to get there?
Just over an hour

Figure 50

fine, but remember that buoys can be
a little off their charted position. Also,
although using a buoy is convenient
because it is easy to know when you have
found it, and the buoy gives the skipper
a fix of position, be cautious. In poor
visibility or in the dark the boat could
come dangerously close to a very solid
object. Motor cruiser skippers often set
the waypoint near, but not dead on, the
buoy because of their speed.

OK, so plotting a course to steer is easy;
follow the steps and you cannot go wrong.
So... what has gone wrong with these
diagrams (Figures 51 and 52)?

080⁰ 1.5 knots
Boat speed
10 knots

It went wrong at the last minute...
Do not join up the tidal stream to the target.

Figure 51

275⁰ 2.0 knots
Boat speed
6 knots

The second step went wrong...
It will take far longer than an hour to reach the target,
so allow for that initially by plotting a 2 hour diagram.
(See the next section!)

Figure 52

Revision of chart plotting symbols

Heading / water track		Fix		⊙
Course over the ground (COG)		DR position		
		EP		
Tidal stream		Waypoint		⌗

Course to steer: 2 ...so much more

With a bit of practice calculating a simple course to steer becomes quite straightforward, but it is worth looking at the basic diagram again to see what else it shows.

Figure 53

From Figure 53 it is easy to see about how long it will take to get there (a bit under an hour) and the crew can look out for the buoy. Don't expect to see it until it's within a couple of miles and even then what looked like a cardinal buoy can turn out to be a yacht with tan sails as you get closer!

When the buoy is first sighted the crew may say, "I can see the buoy, skipper. It's way over there", pointing perhaps 20° or 30° off the bow (their tone of voice implying that they think that there is something wrong). "Shall I just aim at the buoy?" the helmsman may ask, trying to be helpful.

To agree could be a mistake. When looking for the next buoy in a river or at sea there seems to be a natural tendency to look dead ahead, to expect what we are looking for to turn up straight in front. In a cross-tide situation this will never be the case. The point of calculating the course to steer in advance is to allow for the tidal stream that will push the boat away from the desired course over

Figure 54. Buoy seen off starboard bow.

the ground. When the course to steer is followed, the boat is therefore crabbing sideways along the COG. Taking another look at the diagram will make it clear whether to expect the buoy to be on the port bow or the starboard bow.

Just as no skipper should jump to the conclusion that the course to steer is wrong because the buoy is not dead ahead, they should not assume they are right either. In fact don't assume anything; **check**. There are several ways of confirming that all is well:

- If the course to steer has been calculated from a buoy, it should remain visible for at least 15 to 20 minutes to a yacht skipper, and a back bearing can be taken of it (Figure 55) with a hand-bearing compass. The advantage of using the buoy the boat has just left is the positive identification. The single bearing will not give a fix of position of course, but it should be a reciprocal of the course over the ground that the boat is trying to achieve. If the tidal stream is not as predicted, or if something else is pushing the boat off the COG, the back bearing will show if the boat is to the right or left of the COG.

GPS showing direction and distance to waypoint.

but it will display the direction and distance to the waypoint, updating every few seconds.

The direction shown **will not** be the same as the calculated course to steer but **will** be the same as the course over the ground and should remain reasonably constant, thus providing an excellent check.

Figure 55. Taking a back bearing.

- GPS sets have an additional feature that can help here too. This is known as the **cross track error**, often abbreviated to XTE, which shows how much the boat has been swept off the original direction to the waypoint given by the GPS. XTE is displayed as tenths of a mile away from the original direction. If the course is working perfectly the XTE will be zero, but perhaps it is more realistic to expect it to be extremely small if all is well (see Figure 56, page 64).

- Once the buoy is sighted and positively identified, it is easy to check that the course is going to work out. Take a bearing of the buoy with the hand-bearing compass and (once adjusted for variation) this should be the same as the course over the ground. Alternatively, take several bearings of the buoy. If they remain constant the boat is going towards the buoy.

- The north cardinal buoy ahead can be put into the GPS as a waypoint as a check, taking great care to measure the latitude and longitude and enter them correctly into the GPS. Mistakes at this point are some of the easiest to make! The GPS **cannot** work out the course to steer to allow for the tidal stream or leeway

How cross track error works

Figure 56

*At position **A** the GPS shows a cross track error of 0.10 miles - we need to turn to port. But we are swept further off course and at position **B** the XTE is 0.50 miles.*

Leeway

If the courses are not working out well the boat may be making **leeway**. In the case of a course to steer the leeway does not appear in the diagram on the chart at all. **After** the course has been calculated, assess the strength of the wind and the likely amount of leeway. Then the helmsman should '**head up**' into the wind the extra 5°, 10°, or more (as necessary) to prevent the wind pushing the boat off the desired course over the ground (Figure 57).

Figure 57

Figure 58

ETA (Estimated Time of Arrival)

In the first section we saw that it was easy to look at the diagram and predict whether it would take more or less than an hour to get to the buoy. If the skipper needs a more precise answer then it is possible to calculate that too, both from the diagram and from the GPS if the destination has been put in as a waypoint.

* On the diagram (Figure 58) measure the distance to travel and the speed over the ground.

$$\frac{\text{Distance to travel}}{\text{Speed over ground}} \times 60 = \frac{\text{Time to}}{\text{destination}}$$

$$\frac{\text{DTT}}{\text{SOG}} \times 60 = \text{ETA}$$

* The GPS will calculate the TTG (time to go) to the waypoint. As the GPS recalculates its position every few seconds, it will update the TTG so the GPS will never be wrong!

Course to steer
for more or less than an hour

If, at the first stage of planning a course

to steer, it is obvious that it will not take about an hour to get there then adapt the diagram accordingly. In a fast boat it may be more convenient to draw a half hour diagram instead, using half the speed of the tidal stream and half the boat-speed. In the case of a diagram for less than an hour, the answer will remain the same as long as the correct proportion is maintained between the speed of the tidal stream and the speed of the vessel. (See Figure 59)

Figure 59. For a half hour diagram ¹/₂ the TS and ¹/₂ the boat speed.

If it will take much longer than an hour to get to the destination **plot all the tidal stream at the beginning** (Figure 60). Look in the tidal atlas to see which tidal streams to use along the course over the ground. It is more efficient to plot all the tidal streams at the beginning because the boat will travel a shorter distance than if the boat keeps changing course. But the boat will be pushed off the COG so it is important that skippers check that this will be safe.

3 hours of TS

3x boat speed

Figure 60

Pilotage: 1
The buoyage system

Everyone onboard needs to be familiar with the local buoyage system. The chart will show whether the area is IALA Region A or Region B. IALA, the International Association of Lighthouse Authorities, sets the world-wide systems and standards. The USA, and countries nearby, are region B, and everywhere else is Region A.

Buoys are shown on the chart as very small pictures of themselves, major lights and lighthouses are shown as stars and beacons as a combination of the two.

lateral buoys

a pillar buoy, north cardinal

major light or lighthouse

beacon

Figure 61

The magenta shaped teardrop beside the image shows that the buoy is lit. No teardrop means no light. The direction that the teardrop points is insignificant. Beside each lit buoy, beacon and lighthouse are the abbreviations giving the details of the light's pattern.

The details are shown in order:

- Pattern of flashing.
- The number of flashes.
- The colour. If no colour is shown, then the light is white.
- The time period for the total pattern of the light, i.e. the time for one cycle.
- Height of the light in meters above MHWS for beacons and lighthouses.
- The nominal range in miles. This does not mean that it can be seen at the distance shown from the flybridge or the cockpit. How far a light can be seen depends on the height and brightness of the light, the height of eye of the observer and the weather conditions at the time. The nominal range is to indicate the brightness of a light.

The list of possible **light patterns** is quite long:

F... for a fixed (non-flashing) light. These are most commonly used on the ends of piers and jetties e.g. **2FR (vert)** or **2FG (vert)**, meaning 2 fixed lights in red or green displayed vertically. It is important to recognise these as different from the flashing light seen on a buoy or beacon. Often it is a good idea for a small vessel to pass the 'wrong' side of a navigation buoy in a busy shipping area, if there is sufficient water, to keep out of the way of commercial ships. It is obviously unsafe

to pass the other side of a feature marked with fixed lights because the light is attached to the land!

Fl... for flashing e.g. Fl (2), with the number of flashes always shown in brackets.

LFl... for long flash.

Q... for quick flash or VQ for very quick flash.

Iso... for isophase, meaning equal periods with the light on and the light off.

Oc... for occulting. This is similar in a way to flashing, but the other way around. With a flashing light the light is basically off and then comes on for short periods. Occulting is the opposite with the light being on and then going off for short periods. It was once described to me as "flashing darkness", which made sense to me!

Mo... for a Morse flashing light, as in **Mo (A) or Mo (U)**

Colour is shown with easily-guessed abbreviations:

R... for red
G... for green
Y... for yellow

These are the most common, but **Bu** and **Or** are also used for blue and orange.

The same letters are used below the buoy or beacon to show the colour of the structure.

This all fits together in a set order with the total time period in seconds at the end, for example 5s or 10s. Remember that this is the period before the sequence is repeated, not the period of darkness.

Here are a few to practise decoding. (The answers are at the end of the section.)
a) Fl (2) 20s 12m 24M on a light vessel
b) VQ (6) + LFL 10s
c) Mo (U) 15s 2m 3M on a beacon
d) Fl. Y 2.5s
e) Iso. 10s
f) Oc. (2) WR 15s 10m 18M on a lighthouse where the sector of visibility of the red and white light is shown on the chart. The sector is the area, or areas, where the light is visible. The sectors are marked on the chart and help to guide vessels into a narrow harbour or protect them from hazards like rocks. (See Figure 62)

A sequence that cannot be decoded can be found in the book 5011, Symbols and Abbreviations used on Admiralty Charts. (See page 8)

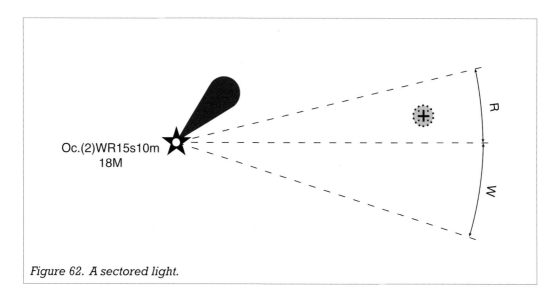

Oc.(2)WR15s10m
18M

R

W

Figure 62. A sectored light.

Types of buoys and beacons
Generally these fall into three types:

- **Lateral marks** which are red or green
- **Cardinal marks**, which are black and yellow.
- **Other marks** which are used as necessary. These include: **special marks** which are yellow; **safe water marks** which are red and white; **isolated danger marks** which are red and black.

Lateral Marks
These mark the channel and show where the deepest water is located, but do not necessarily mean that it is deep enough for the boat at all states of the tide.

Large shipping channels may be so deep that there is room to navigate just outside the channel. In some ports small boats are required to do this under local regulations. Details will be found in the almanac. Lateral marks are often called port hand and starboard hand buoys, but there is more to it than that. Whether the skipper should leave them to port or starboard depends on whether the boat is going into or out of the river, and if the plan is to follow just inside or just outside the channel. So maybe it is easier to call them red and green buoys or beacons.

For IALA Region A, if coming in from the sea then red buoys should be left to port and green buoys to starboard to be in the marked channel (Figure 63).

The light characteristics of red and green buoys are straightforward. All red buoys flash red and all green buoys flash green, if they are lit.

Some very small channels are marked by withies, which are willow sticks driven into the mud or sand, or by small buoys placed by yacht clubs.

Cardinal buoys and beacons
The common diagram of the four cardinal buoys around the danger gives the impression that every hazard is surrounded with buoys, but in reality this is not the case. A sandbank several miles long may only have a buoy every few miles. Good navigation, not buoyage, is the secret to avoiding hidden hazards.

The cardinal buoys were devised more recently so to learn them look for the logic in the shape, the colours and the light patterns.

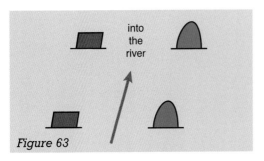

Figure 63

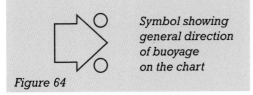

Symbol showing general direction of buoyage on the chart

Figure 64

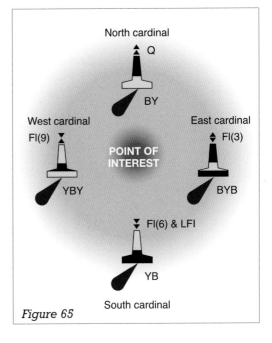

Figure 65

The buoys are labelled north, south, east and west to guide the helmsman which way to pass them. **So pass north of a north cardinal, south of a south cardinal**, etc. The shape of the topmark on each buoy is the easiest part to learn for most people, especially with north pointing up and south pointing down, and with the east and west described as looking like an egg and a wine glass perhaps. Unfortunately the topmarks may be easy to learn but they are not that easy to see at a distance so learn the colour scheme of the buoys as well. This is simpler if you notice the pattern: the black on the buoy follows the points on the cones. For example, the cones point up on the north cardinal and the black on the buoy is on the top. This works with them all, even the east and the west.

Then there are the lights to learn. The colour is easy when you know that **all red buoys have red lights, all green buoys have green lights, all yellow buoys have yellow lights, and all the rest have white**. The number of flashes shown applies to all cardinal buoys and they can be counted going round as on a clock face, with north doing a continual flash, east flashing three times, south flashing six times (with an additional long flash) and the west flashing nine times.

Other buoys

Special marks.

The **special mark** is yellow and has no navigational significance. Special marks may be racing buoys, or be used to indicate waterski areas, anchorages, or for other general purposes. The shape can vary but the light is always yellow, if the buoy is lit.

Safe water marks.

The **safe water mark** is used to mark the beginning of a buoyed channel and has red and white vertical stripes. The characteristic of the light can be LFl, Oc, Iso or Mo (A) and it is always white.

The **isolated danger mark** shows a hazard with safe water all around. The colour is red and black in horizontal stripes and the white light is Fl (2). The characteristic of the light is easy to remember: just look at the topmark.

Isolated danger mark.

Answers:
a) Flashing twice within 20 seconds. The light is 12 meters above MHWS and has a nominal range of 24 miles.
b) This is a south cardinal buoy. It is flashing a white light very quickly 6 times followed by a long flash. The cycle is 10 seconds.
c) A white light flashing the morse letter U (. . -) every 15 seconds. The beacon is 2 meters above MHWS and has a nominal range of 3 miles.
d) A yellow buoy flashing a yellow light every 2.5 seconds.
e) A white light showing isophase every 10 seconds, then is on for 5 seconds and then off for 5 seconds.
f) A red or white light, depending on the sector from which it is viewed, which is on and then goes off twice within 15 seconds. The light is 10 meters above MHWS and has a nominal range of 18 miles.

Pilotage: 2
The plan

Pilotage is quite different from navigation because it is largely visual. In rivers and other areas that we know well it is relaxing and enjoyable; we know where we are and appreciate the hazards, in fact they aren't hazards because we are aware of them. When exploring a new area never underestimate the difficulties of the pilotage, especially at night. It's like turning off the motorway into a town you have never been to before: too many signs, too many side turnings, too many decisions... and instantly you're lost!

It is the part of the passage when the boat is in a confined area, the water may be shallow or there may be dangerous rocks close by. Decisions have to be made quickly and it may come at the end of a long and tiring day. Detailed navigation down below at the chart table is just too slow and takes the skipper away from the deck. It is vital to be on deck, not steering but monitoring the progress of the vessel and everything that is happening round it. There is no time to plot the GPS position or take a fix, no time even to look at the chart for more than a few moments at a time, so the skipper needs to prepare a **pilotage plan**.

A few things to consider:
- The more people on board who can identify the different buoys, by light as well as shape and colour, the easier it will be. At night, with background lights, buoys can be difficult to spot so **get everyone to help**.
- Make sure you have a **detailed chart**, with up-to-date buoyage.
- It may be necessary to give the helmsman a **heading** to the next buoy if it is difficult to see, so have this information in your plan. Tell

them which side of a buoy they should pass and what effect the tidal stream is having on the boat. At night tell them how far away it is too, but don't tell them about the next two or three buoys ahead. It's hard to remember lots of details, especially if you haven't seen the chart.
- Keep things simple and, in a yacht, use the **engine**.
- The **almanac** will usually give the most up-to-date information because they are reprinted annually, including local regulations and port entry signals.
- Monitor the harbour **VHF** channel for information on shipping movements. Check if you need to get permission over the VHF to enter the harbour.
- The local **pilot guide** will give advice on marinas, moorings and anchorages, sometimes including pictures or aerial photographs of the features described.
- Consider the **depth of water**. It may not be possible to enter the river, harbour or marina at all states of the tide.
- Have a contingency plan in case you arrive too early or too late, or if it is too dark or too rough to go in.
- Are there enough **lit buoys** to make it a safe area to navigate in the dark? Remember that unlit buoys, or 'blind buoys' as they are called, could be a hazard.
- Monitor the **speed** over the ground. During the day this is quite easy by general observation, at night the GPS is especially useful for this. In the dark it is easy to forget the effect that the tidal streams are having on the boat. The boat may be travelling much faster than indicated on the log.

But if you're going too slowly the boat will be more affected by any cross-tide.

- Know what the **tidal stream** is doing. Besides increasing or decreasing the speed over the ground it may be having a sideways effect on the boat, pushing it towards shallow water.
- Have a **hand-bearing compass** ready and use back bearings and clearing lines to check that the boat is in a safe position.
- The **echosounder** and its **alarms** can be very useful for shallow and deep water. Use them because it is impossible to watch the display all the time. If you are following a buoyed channel, especially at night, set the shallow water alarm as high as possible so that it just does not go off. This will then give an early warning if the boat begins to drift out of the channel, rather like the rumble strips beside the motorway. They warn the driver that the vehicle is drifting onto the hard shoulder, not that they are just about to go into the ditch. Don't set the alarm for 2.0m, that could be too late, set it high to give a warning in good time.
- The deep water alarm can be used to warn that the vessel is drifting into the deep water channel. In a busy commercial harbour it may be best to keep out of this channel (if possible) and it may even be a local regulation.
- **Pre-plan the route**. Draw a plan that works for you, including the buoys and lights to look out for and choose a good **starting point**. Some ports have a safe water mark in the approach as a good starting point, if not pick your own; you need to know where you are when you start.
- It is OK to follow the buoys but take one at a time, like stepping stones, and don't assume the one in the distance is the one you are looking for. Know the direction from one to the next and take care not to miss one out and cut a corner by mistake.
- At night be cautious using extra

lights as they will ruin your **night vision**. The instruments on deck and the chart table light need to be usable, but not dazzling.

- A small **torch** may be necessary to read the plan on deck. Remind the crew not to use other lights down below.
- Only use a spotlight on deck if it is essential, because they are so dazzling.

There are one or two quick navigation techniques that are particularly useful for pilotage, with its need for simplicity and speed.

Transits and leading lines

Some small rivers and harbours have up posts, other marks or lights to act as transits and show a leading line. These will be shown on the chart or described in the pilot book. The pilot book may even include a picture of what to look for. If the two objects or lights are kept in line, ahead or astern, then the boat is on the leading line.

Leading lines

Turn to port to line them up.

Keep in line.

Figure 66

It is possible to use the same method by looking at an object, perhaps the next buoy, in relation to the background behind it. Heading the boat to keep the background behind it stationary forms a transit and will work the same way (see Figure 67).

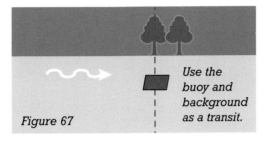

Figure 67

Use the buoy and background as a transit.

Back bearings

A back bearing works very well in pilotage, especially if there is a cross-tide. It shows if the boat is on track, or off-track to the right or left. Calculate in advance which way to turn if the back bearing shows that the boat is off-track.

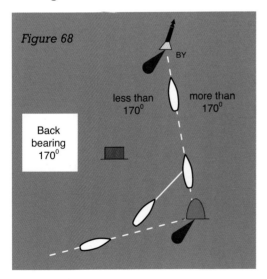

Figure 68

BY

less than 170⁰ more than 170⁰

Back bearing 170⁰

Problem:

The route into the harbour is easy in daylight, but at night there are two hazards:

1. Being dangerously close to the green buoy, the turning point for the harbour.
2. Turning to avoid the green buoy too

soon and hitting the red unlit buoy which is close to the COG.

Solution:

Turn early to avoid the green buoy. Take bearings on it to check that the boat is safe. When the bearing is 170⁰ turn onto the new heading. Keep checking the back bearing: if it becomes more than 170⁰ turn to port; if less than 170⁰, turn to starboard.

GPS waypoint

Placing a GPS waypoint in a river entrance and monitoring the Cross Track Error can be used in a similar way. Draw in the track, distance and XTE like a ladder (Figure 69). In this case there does not need to be a charted object on which to take the bearing.

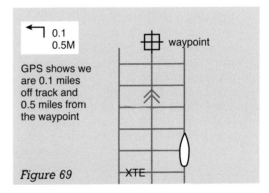

0.1
0.5M waypoint

GPS shows we are 0.1 miles off track and 0.5 miles from the waypoint

Figure 69 XTE

Waypoint web

This pattern takes a little time to draw on the chart but it shows immediately the approximate position (Figure 70). This is useful for navigating at speed using a laminated chart on deck.

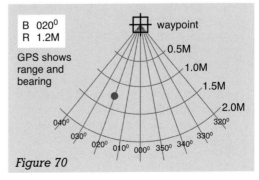

B 020⁰
R 1.2M waypoint

GPS shows range and bearing

0.5M
1.0M
1.5M
2.0M
040⁰ 320⁰
030⁰ 330⁰
020⁰ 010⁰ 000⁰ 350⁰ 340⁰

Figure 70

Clearing lines

One or two clearing lines can be used to keep the boat clear of hazards that cannot be seen. The line is drawn to mark the safe side or safe sector and by checking the bearings the skipper will know that the boat has not crossed those lines.

To be in the safe sector the bearing on the red buoy must be:

- Not more than 020°
- Not less than 340°

(See Figure 71)

Figure 71

020° 340°

The Plan

This can be in the form of a list, an 'AA style' route map or an artistic sketch as suits the situation and the skipper best. I've seen them all work successfully. In the case of the sketch map, take care with scale and direction so as not to build in false impressions.

Figure 72

Passage planning: 1
The regulations

Thankfully, when we go boating there are not many regulations that we need to know about, but there are a few:

- If you have a VHF/DSC or any VHF radio on the boat then a **Ship's Radio Licence** is required. To get this contact Ofcom via their website www.ofcom.gov.uk. The licence must list all of the transmitting equipment on the boat. With this licence, the boat will be given an international call-sign and an MMSI number to be programmed into the VHF/DSC set.

- In addition, at least one member of the crew must hold the appropriate certificate which is either the old VHF licence in the case of a basic VHF set or the SRC (Short Range Certificate) if the set is VHF/DSC. In reality it makes sense for all the crew to be competent to use the radio for both routine and emergency communications. To help with this an emergency radio procedure card can be fixed up by the set. To learn radio procedures and take the simple test for the SRC certificate contact the RYA* on 0845 345 0400 or visit www.rya.org.uk for details of a sea school or college offering courses in your area.

- **SOLAS V regulations** came into force in July 2002 and affect us all, whatever the size of the cruising boat. These regulations are part of Chapter V of the International Convention for the Safety of Life at Sea, most of which applies to large commercial vessels.

The regulations affect passage planning and safety.

1 Passage planning

The rules state that all trips should be pre-planned. This does **not** have to be written down and then submitted to the authorities, but skippers are recommended to consider the following before departing:

The weather

Check the forecast before you go and get regular updates during a longer passage. For local trips over a day or weekend this is quite easy. Television, radio and the internet give good information, and many marinas pin up the local inshore forecast on a notice-board. Easiest of all is to listen to the Maritime Safety Information Broadcasts made by the Coastguard. These are announced on VHF channel 16 and then read on a working channel. The times and channels used are published in the almanac (see page 42). For forecasts covering a wider area, the shipping forecast is available on BBC radio or via a

Reading *VHF Afloat* will help as well!

navtex receiver.

The tides
Plan the trip to fit the tides. This means taking into account the tidal heights for going into and out of marinas and harbours, and when the tidal streams will be most favourable.

The limitations of the vessel
The boat and its equipment must be suitable for the planned voyage. How rough the passage is going to be is determined by the strength of the wind, the distance from the sheltered shore, the length of time the wind has been blowing in the same direction and the depth of the water. Consider how the conditions will affect *your* boat in particular. A Force 4 or 5 will be a very different experience on an 18 foot as opposed to a 45 foot boat. The shape and type of the craft and the direction of travel in relation to the wind will all make a huge difference too.

The ability of the crew... and skipper
The plans need to be realistic for the skipper and the crew. They need to enjoy the trip, not just survive it. Passages that are too long or where the crew become ill will reduce their enthusiasm for the next trip! They need to be well prepared with warm, waterproof clothes or sun cream and hats as necessary. There needs to be lots of food easily available, and suitable for the conditions. Never lie to your crew. If it might be a bit rough then say so, explain how long it will last and the measures that you have taken to make it safe and exciting.

Don't just consider if the crew are up to the passage, but yourself as well if you are the skipper. Be honest with yourself and don't be pushed into making the trip because you said you would. If you don't fancy the forecast or you don't feel ready for the passage, then don't go. Or maybe prepare well, go and have a look, and if the conditions at sea are not nice, turn round and have a relaxing evening somewhere else. Don't forget that with a weekend trip everyone will probably need to get back the next day, so check the outlook in the weather forecast as well.

The navigation dangers in the area
Make sure that in the plan potential hazards have been taken into account. These could include rocks and sandbanks, large ships, fishing vessels and fishing pots, areas of rough water or overfalls, naval activity from a firing range or submarine exercise area or a major shipping lane.

A back-up plan
Always have a contingency plan. What to do and where to go if the conditions deteriorate or the crew becomes too tired, cold or seasick to want to go on, or when you arrive at the marina or river and it is too late, too dark, too rough or too shallow to go in. It may be possible to divert to another port, it may be necessary to turn back or anchor.

Leaving details ashore
Let someone know where you are going and when you will be back and join the Coastguard Voluntary Safety Identification Scheme (often called the CG66). To join, contact the local Coastguard station or log on to www.mcga.gov.uk.

All this is extremely good common sense and should not be considered a burden. With experience and for short trips much of this planning will become automatic and could be done in the skipper's head, but a few written notes are a good idea so the crew can get involved.

2 Radar reflectors
All vessels are required to fit a radar reflector, if practicable, as high as possible. Large ships rely heavily on radar and without a radar reflector small boats may not be seen. The radar reflector is a passive device that does exactly as it says - it reflects the radar signals of other vessels to make the boat more visible on their screen.

Life-saving signals

There should be a table of life-saving signals on the boat to show the signals used by ships, aircraft or persons in distress to communicate with rescuers. The table is often in the almanac and the signals are in addition to the normal red rockets, flares and orange smoke signals. An illustrated table of these signals is shown below. Any sightings should be reported to the Coastguard.

3 Assistance to other craft

If the skipper or crew see a hazard to navigation, such as a damaged or unlit buoy, or if a distress signal is sighted, or a life-belt found, a report should be made to the Coastguard as soon as possible. If another vessel requires assistance it must be provided, if it is safe and reasonable to do so.

This table contains public sector information licensed under the Open Government Licence v1.0.

LIFE SAVING SIGNALS

To be used by Ships, Aircraft or Persons in Distress, when communicating with life-saving stations, maritime rescue units and aircraft engaged in search and rescue operations.

Search and Rescue Unit Replies

You have been seen, assistance will be given as soon as possible.

Orange smoke flare.

Three white star signals or three light and sound rockets fired at approximately 1 minute intervals.

Surface to Air Signals

Message	ICAO/IMO Visual Signals
Require assistance	V
Require medical assistance	X
No or negative	N
Yes or affirmative	Y
Proceeding in this direction	↑

Note: Use International Code of Signal by means of lights or flags or by laying out the symbol on the deck or ground with items which have a high contrast to the background.

Air to Surface Direction Signals

Sequence of 3 manoeuvres meaning proceed to this direction.

1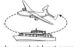

Circle vessel at least once.

2

Cross low, ahead a vessel rocking wings.

3

Overfly vessel and head in required direction.

Your assistance is no longer required.

Cross low, astern of vessel rocking wings.

Note: As a non preferred alternative to rocking wings, varying engine tone or volume may be used.

4 Misuse of distress flares

It is illegal and irresponsible to let off distress signals if you are not in distress, even at a bonfire party. All sightings of flares that are reported to the Coastguard by radio or phone are investigated, so resources could be diverted from a genuine emergency. Once flares pass their expiry date they can be handed in to a Coastguard station for safe disposal. Do not throw old flares over the side, throw them out with the rubbish or bury them in the garden!

If you are planning a **foreign trip** then it is important to check local regulations, which tend to be far more complicated and restrictive. For RYA* members there are excellent booklets and abundant advice available from the Cruising Department. For some countries the skipper or all the helmsmen may need the International Certificate of Competence (ICC). This is not difficult and not too expensive to sort out. Again contact the RYA*, this time the Training Division, or a local sea school for advice.

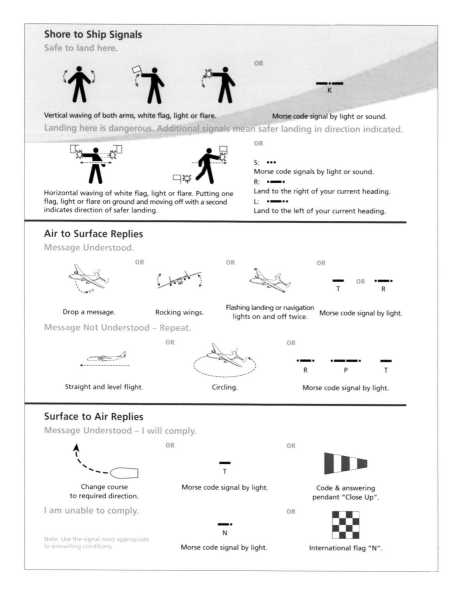

Shore to Ship Signals

Safe to land here.

OR

Vertical waving of both arms, white flag, light or flare.

K
Morse code signal by light or sound.

Landing here is dangerous. Additional signals mean safer landing in direction indicated.

OR

Horizontal waving of white flag, light or flare. Putting one flag, light or flare on ground and moving off with a second indicates direction of safer landing.

S: •••
Morse code signals by light or sound.
R: •—•
Land to the right of your current heading.
L: •—••
Land to the left of your current heading.

Air to Surface Replies

Message Understood.

OR OR OR

Drop a message. Rocking wings. Flashing landing or navigation lights on and off twice.

T OR R
Morse code signal by light.

Message Not Understood – Repeat.

OR OR

Straight and level flight. Circling.

R P T
Morse code signal by light.

Surface to Air Replies

Message Understood – I will comply.

OR OR

Change course to required direction.

T
Morse code signal by light.

Code & answering pendant "Close Up".

I am unable to comply. OR

Note: Use the signal most appropriate to prevailing conditions.

N
Morse code signal by light.

International flag "N".

Passage planning: 2
The navigation plan

Passage planning is quite fun, rather like poring over holiday brochures deciding on your next trip. With a day sail from your own marina or mooring, the plan may consist of checking the tides, looking at the forecast and saying to the family, "Let's go, the weather and the tides are right. We can be there in time to have a picnic lunch and be back before dark. I have told Grandma we will call in on the way home at about 8 o'clock. If it gets late we'll motor back."

That is a passage plan because it considers some of the most important aspects including:

- Is the weather OK?
- Are the tides right?
- Will there be enough water to get into the river or marina?
- Will the tidal streams help or hinder the trip?
- Is the trip suitable for the boat and the crew?
- What is the contingency plan if it gets dark, the weather deteriorates or something else goes wrong?
- Does someone else know of our plan?

For a more complicated passage more detailed planning is necessary because of the regulations and for an enjoyable trip.

Look at the three different phases of the trip when you start the plan:

| PHASE ONE Getting out | PHASE TWO Getting there | PHASE THREE Getting in |

People often ask which of the three phases is the most important and which will determine when we go, but that is hard to say initially. In some cases, *when* the boat arrives is so critical that the passage will be planned back from that, but make no firm decisions too quickly. Look at all three phases, then firm up the plan.

Getting out / getting in
The first and last phases of the journey have many similar potential problems:

- What is the **charted depth**? If there is not enough water to get in and out at all states of the tide then calculate the **earliest** and the **latest** time that you will be able to leave and arrive. It is ideal to be crossing shallow areas on a rising tide, if possible.
- Is it possible to enter or leave in the **dark**? Are there enough lit buoys to do this, and are you comfortable with the idea? If you have never been to the port before, making the first entry at night could be very stressful. Check sunrise or sunset times in the almanac.
- Will a strong **tidal stream** in a narrow channel make entering or leaving difficult, or even impossible?
- Plan the **pilotage** into and out of rivers and harbours. Check in the almanac for the opening times of any **lock** or **bridge**.
- Check the local **regulations** and practices for traffic signals, calling for permission to leave or enter on VHF, monitoring VHF for shipping movements, use of the engine, and hours when the office or water taxi will be manned.
- What **hazards** can you expect? It

may be necessary to look out for commercial shipping, fishing boats, fishing pots, areas of moorings or unlit buoys.

- For motor cruisers, the skipper needs to check on the availablity of **fuel** for the outward and return passages.
- At the end of the journey there needs to be a **'what if'** plan built in. What if we arrive early or late so that it is too dark or too shallow to get into the planned marina or harbour? Calculate the latest time that the boat will be able to go in and then plan what to do if you're late. It may mean going to another port altogether, picking up a mooring, anchoring or just waiting for more light or more height of tide.

This planning may show up problems, but it may be possible to work round them.

Here are three examples of how potential problems can be overcome:

1. The best time to leave to catch the tidal stream down the coast does not fit in with the opening of a lock gate. So exit the lock, pick up a mooring, or anchor and wait for the tidal stream to be favourable. This will avoid the problem of being with the tidal stream for an hour through the lock and down the river, then against it for the rest of the day.

2. It may be necessary to leave the river during daylight when the tidal streams are wrong for the passage. So come out of the river the day before, stop overnight at the nearest convenient anchorage or mooring, then make the passage.

3. The time to go into the shallow harbour does not fit with the tidal stream down the coast to get there. So make best use of the tidal streams and check the chart for somewhere to moor and wait to go in.

Getting there

The middle phase of the planning usually takes longer, and may seem more complicated as it will often be necessary to use several charts. When on passage it is important to use detailed charts, especially near the coast or other hazards, but for the initial plan a chart which shows the whole route is useful too.

Look in detail at the following:

- **How far** is it and, at the average speed of the boat, about **how long** should it take to get there? The first ETA will always be very approximate. The tidal streams hopefully can be with the boat on a coastal passage and therefore increase the speed over the ground. With a yacht there can be a problem with **wind direction** on the day. A yacht tacking, that is sailing against the wind, but with the tidal stream, will have to sail about half as far again to get to the destination. Bad, but not as bad as sailing against the tidal stream and against the wind - when the boat would have to sail about twice as far. This means that to achieve 10 miles towards the destination, the boat would have to sail approximately 20 miles. This can be very demoralising for all on board and is best avoided!

- **Tidal streams**. When will they be favourable? For a coastal passage this may be the most important factor in the plan and may make when to leave as obvious as looking up a train timetable. Make up the tidal stream atlas in real time for the day, then it is easy to see when the tidal streams become favourable and, just as important, when they turn against the boat. Tidal streams tend to flow along the coast so their influence will be much more important at the planning stage if the passage is up or down the coast, especially for a yacht. On a yacht where the average speed

is 5 or 6 knots it makes sense to **sail with the tidal steams**, as the speed over the ground will be greater and the journey time reduced. It may be possible to add up the average speeds of the tidal streams for each hour, and so estimate the time saving, to improve the initial ETA. For a planing motor cruiser a more important factor may be **sea state**. The sea will be smoother when the wind and tidal stream are in the same direction. Smooth conditions make it possible to maintain the optimum cruising speed for fuel efficiency and a pleasant trip.

- **Plan the route**. It is useful to have a chart that shows the whole journey as on that scale the general direction and distance can be seen. If this is not possible then draw a sketch map and write the details of distances and directions on that. Check the route on the detailed charts to be used on the passage, to be sure that it is safe. Drawing the route gives the opportunity to select the waypoints and measure the distances and directions between them. If these waypoints are going to be used as a route in the GPS it is vital that the distances and directions measured from the chart are checked against those calculated by the GPS. Putting waypoints into the GPS incorrectly is extremely easy to do, and can be very dangerous. Skippers of fast boats often place the waypoints near the buoys rather than on them!

- What **hazards** are there to avoid along the route, such as sandbanks, rocks, traffic separation schemes or areas busy with commercial shipping or fishing boats?

- Look on the route for any **tidal gates**. These are points on the route where the tidal stream is particularly critical. Round a headland the tidal streams can be exceptionally strong, making it important not to be late.

Look at the plan as a whole:
Look at all three phases of the passage to find the best way of fitting them together.

Remember that if the arrival time is critical but the wind is very light the skipper and crew of a sailing boat may have to use the engine to arrive on time or not go at all. A passage is a journey like any other and once the timetable has been planned it must be adhered to, or the destination changed.

THE ROUTE PLAN

Pin Mill ●

Pilotage out
of the river

170⁰
4M

● Brightlingsea

Pilotage into
the river

235⁰
12M

Not to be used
for navigation!

Figure 73

Looking at electronics: 1
The basics

When you buy or charter a boat it will probably come stuffed with electronic gadgets. They are a great boon, but if you are buying your own there are lots to choose from and expert advice is a good idea. Even better is the opportunity to try them out afloat on a friend's boat, a sailing school boat or a charter trip. Things to consider are not just the immediate benefits and the initial costs but the ease of operation, the size of screen, the updating requirements and whether the use can be extended to make the equipment multifunctional.

The navigator's most basic tool after the steering compass is the **log**, which measures the distance travelled and the speed through the water. Most logs these days use a paddlewheel transducer mounted through the hull. The display needs to be easy to read and the information available to the navigator and the helmsman.

The paddlewheel of the log transducer projects below the hull.

It can be withdrawn for cleaning.

A multi display.
The log shows we have sailed 287 miles.
Speed is currently 5.9 knots.

The **log transducer** is vulnerable to fouling by weed, but can easily be cleaned by withdrawing it through the hull. This is quite safe, even when the boat is in the water, as the opening will be protected by a flap valve or with a screw cover, which will be provided. If the boat has

The depth is 197.9 metres.

Set the shallow water alarm to something you are comfortable with e.g. 5.5 metres.

neither of these, a hand over the opening will stop the water coming in but makes the maintenance job very difficult! I have found a large sponge pushed well into the hole works well, but this is only very temporary and obviously needs to be watched carefully. If the paddlewheel is not clean the log will probably under-read, which will be confusing and perhaps dangerous. The accuracy can be checked over a measured distance and then the instrument calibrated to read correctly. Don't forget about the tidal streams if you try this and use slack water if possible or do two runs, one with the tide and one against. If a second-hand instrument is persistently giving trouble, even when the transducer is clean, it is probably best to have the installation checked professionally, as any replacement transducer needs to be compatible with the instrument. Alternatively, the GPS can be used to help calibrate the log.

The modern digital **echosounder** is easy to read and will include features such as shallow water and deep water alarms, which can be very useful in pilotage situations. Some people think that the purpose of an echosounder is to stop a boat going aground. This is obviously not so, as boats seem to go aground all over the place. Clever use of

the shallow water alarm helps. Set it so it gives a genuine warning that the boat is out of a channel, not so that there is a split second warning before the bump. The deep water alarm can be useful in avoiding a big ship channel. Usually the instrument can be set up to read depth below the transducer, depth beneath the keel or depth of the water. Decide which you think is best and if you go on other boats it is useful to know how it has been set up too.

Once the log and the echosounder are set up and working well, the next most important instrument is the **VHF/DSC** - not exactly for navigation, but an

Fixed and portable VHF sets.

essential part of the electronic kit on a boat nevertheless. A handheld set has the advantage of being portable if you sail on lots of different boats, but the low aerial, low power transmission and lack of DSC capability reduce its appeal for the owner of a boat. In the almanac you can find the VHF channels to monitor or use (if necessary) in harbour areas and the times of the Maritime Safety Information Broadcasts made by HM Coastguard. These broadcasts include weather forecasts and navigation warnings. While at sea skippers are advised to monitor channel 16. (Avoid transmitting on channel 16, except in an emergency.)

The next instrument most navigators want is a **GPS**, in fact many buy a hand-held GPS before owning a boat because they are such a valuable aid to navigation. The basic sets, no bigger than a mobile phone, have an internal aerial and work off batteries so can be taken and used anywhere. Even these sets have many features beyond the position display, such as the ability to store waypoints, build a route, show directions as true or magnetic, change datum and many more. When first switched on in a new location the set has to work quite hard to calculate where in the world it is and therefore which satellites to look for,

A GPS set giving you latitude and longitude.

but after this it can work out the position very quickly. If the set is taken on a flotilla holiday or a Caribbean charter it will take time to orientate itself again. It is important to go into the menu system and set the **datum** to that of the chart, WGS84 in most cases. This information is found on the title panel of the chart.

For the boat owner there are advantages in having a bigger built-in set connected to the boat's power supply and with a fixed external aerial. The position from this set can be interfaced via an NMEA connection to the VHF/DSC set, and to other equipment such as an electronic chart plotter, Yeoman plotter or radar set. The GPS needs an aerial that can 'see the sky' and it should be mounted low down on the boat for the best signal quality.

The **Yeoman plotter** is another aid to consider. This British invention has been around for a few years, but continual developments during that time mean that it has a lot to offer at a relatively low price. It provides **a link between the paper chart and the GPS** to eliminate the most common mistakes. Any chart can be used with the active mat on the chart table, with the A2 folio charts from the Admiralty or Imray fitting perfectly. The chart can be held in place and protected by a soft plastic cover. All the plotting can be done on this cover with the chart seen perfectly through it. The link to the GPS and the active mat is made by a special sort of computer mouse, called a puck. Every time the chart is changed it has to be referenced to the plotter, and then the position from the GPS can be transferred to the chart in seconds, error free. A waypoint can be stored in the GPS at the press of a button, with no possibility of a mistake.

The puck can be used to measure distances and directions, and with practice any of the plotting normally done with a Breton-type plotter can be done with it. The Yeoman is robust,

protects the paper chart, and can be updated by buying a new folio of paper charts - but best of all it helps to prevent the most common plotting errors, mistakes transferring latitude and longitude from the chart to the GPS and the GPS to the chart. The Yeoman is quick and easy to use with very little practise, and its usefulness seems to grow the longer you have it on the boat.

Where there is no chart table on the boat a portable version can be used which includes a rigid board and cover.

Find more information from:
www.precisionnavigation.co.uk.

Yeoman plotter.

Looking at electronics: 2 Chartplotters

Chartplotters are very common nowadays. They are not a substitute for understanding navigation and the ability to navigate at sea, just a different way of doing it. They use a screen to display the electronic chart and are combined or interfaced with a GPS set to show the boat's position on the screen, which is updated as it moves. Things are changing very rapidly with this technology and it is potentially very expensive, so get advice from experts as there are several options to choose from. Some plotters have stored tidal data and can do course calculations as well so they form a complete navigation system. Some can be integrated with other aids, such as

Radar and **AIS**. AIS is an automatic tracking system which ships are required to have. Information on identity, position and course is transmitted via a VHF signal. It is used by port authorities and Coastguards to monitor shipping movements, and by other vessels as an aid to collision avoidance.

The basic requirements of the system for electronic navigation are:

- A **screen** on which to display the electronic charts. This can be a computer screen, which means taking a laptop afloat, fitting a rugged panel PC or buying a dedicated chart

plotter. The plotter will have a much smaller screen, indeed some are very small but, unlike the computer, it will have been manufactured for the marine environment by marine specialists. (The laptop approach allows the option of planning passages away from the boat more easily).

- The **software** to make the charts work. The plotter will include the software but a computer will require additional software before it can run the charts. The computer software tends to be more complex to operate, but once in place on the boat it can be used for many additional tasks such as connecting to the internet, long range communications and obtaining meteorological information. A computer driven system is popular with skippers doing extended cruising and the charts and software can be restored to a replacement computer anywhere in the world. A good system will also allow more than one user for back-up or for practice.

- The **electronic charts** themselves have to be bought to use on the computer screen or plotter. The charts come in two different types, **raster** and **vector**. The way the chart image is produced on the screen is different, giving the charts different characteristics in use. The other important considerations are the source of the data used to compile the charts, the updating facility and the cost. Remember that the UKHO, an agency of the government, publish chart corrections weekly to an international standard for paper charts but that will not be true for all producers of electronic charts. Charts can become out of date very quickly.

The **raster chart**, or raster scan chart to give its full name, is a **scanned** version of a paper chart, so it looks exactly the same. The UKHO produce ARCS charts, the Admiralty Raster Chart System, on CDs for displaying on computer screens with the use of additional software. The UKHO provides a weekly correction service for this online, just as it does for paper charts, and it is included in the cost.

The scanned charts produce a picture on the screen that is very familiar, in fact it is exactly the same information as on the paper chart. The picture is built up on the screen by illuminating pixels, like an LCD screen, and these produce a very distorted picture if zoomed beyond their natural scale. Changing scale should be done by changing chart rather than by zooming in or out and hazard alarms must be set by the navigator rather than automatically by the system.

Vector charts are produced by a completely different system. The picture is built up from **layers of information**, so the image on the screen can be changed to suit the circumstances. The software to run the chart can be run on a PC or on a dedicated plotter and it can manipulate the image to different scales, to omit some data or to interrogate a feature (such as a buoy) for more information. Another possibility with the set may be automatic alarms to warn of hazards and shallow water.

Chartplotter or PC?

The menu systems of plotters tend to be less complicated and the controls easier to use at sea than a computer. The unit will also be waterproof, robust and fixed in position, unlike a computer used on board occasionally. Additionally, if there is a problem with the plotter, then there is one manufacturer to deal with, not possibly three in the case of a computer manufacturer, software company and chart producer. On the other hand, a modern wireless, touchscreen PC can provide a more flexible multi-use and portable system.

A UKHO set of raster and vector charts of all UK waters, or part of the set, is available from a number of companies, packaged with navigational software. These can be installed on a PC with GPS, and even AIS, connected via a USB cable, or on a dedicated chart plotter. They are updated quarterly.

From 2013 worldwide official Electronic Navigation Charts (ENCs), known as S57 vector charts, have been available very economically in small numbers for periods of 3 to 12 months at a time. They can be ordered online and downloaded onto a PC or some chart plotters. Admiralty ENCs from the UKHO are updated every week, and corrections can be applied automatically whenever it is possible to connect to the internet - free of charge. They are cumulative too – miss a couple of weeks or even the whole winter, and the system will sort it out for you. Brilliant!

The source of the data for vector charts may be commercial companies not government agencies so check how to update the charts and the cost before buying into any system.

No chart plotting system can be seen as a single purchase. Paper charts get damaged with use and wear so we have to buy more, while those on a screen remain pristine.

But don't be fooled – they require updating too. Out of date charts, or those produced with low quality data, will lead to uncertainty and possibly to danger.

Even with good quality, up to date electronic charts on board and the ability to use them, **carry the relevant paper charts, write up the ship's log regularly and practise plotting skills** because electronics or their power supply do occasionally fail. Anyway, navigation is fun so get the crew to compare the navigation on the paper chart with the chartplotter or let the children have a go with a back-up laptop on a longer voyage!

Brightlingsea (top) and Languard Point.
Admiralty Vector Charts displayed using Nunonavigator.

Zooming in on a vector chart for more detail.

Sierra
...the passage continued

Sierra needs to calculate a course to steer to the next buoy.
It is about 12 miles. The speed is 5 knots but with a favourable tidal stream it should take about 2 hours.

Plot 2 hours of TS at the beginning and use twice the boat speed.

CTS

Monitor the position using landmarks and GPS.

FIX

Keep monitoring the position.
Identify all buoys carefully.

**At the Bar Buoy start the engine
and lower the sails.**
Then follow the pilotage plan.

**Use a back bearing to avoid
shallow areas.**

Tidal streams

shallow area

160⁰

shallow area

Once the next buoy is visible ahead, line it up with the background to form a transit and keep on track.

Follow the buoyed channel.

Check the depth before entry:
Height of tide + chartered depth = depth of water.

Too early?
Anchor and have a cup of tea.

Too late?
What was the contingency plan?

Prepare the boat for mooring with warps and fenders on <u>both</u> sides.
Follow the buoyage and leading marks.

Call the harbour master for berthing instructions.
Keep a good lookout for other boats, moored or under way.

Moor up. Tidy the boat, then put the kettle on and relax... and plan your next voyage!

Navigation
...to sum up

How to find out where you are

1 GPS a) latitude and longitude
 b) with reference to a waypoint

2 Fix

3 DR

4 EP

Where am I ?

How to find the place you want to get to

1 CTS

How do I get to the next point?

That is all there is to it!

Glossary

COG. The Course Over the Ground, also sometimes called the *ground track*. Shown on the chart with 2 arrows. It is the path over the seabed that the boat has travelled or will travel along.

Chart datum. Chart datum is the level used on the charts to show the charted depth. It is approximately the Lowest Astronomical Tide.

CTS. A course to steer is a course calculated in advance to allow for the predicted tidal streams and the estimated leeway.

Depth of water. The depth of water is a combination of the height of tide and the charted depth or drying height shown on the chart.

Deviation. This is caused by the boat's magnetic field, and affects each compass differently, depending on its position on the boat. It also varies with the boat's heading.

DR. A position based only on the distance and direction sailed through the water. Leeway may be allowed for. A very basic position.

EP. An estimated position is a DR position with the tidal stream taken into account and plotted.

Height of tide. The height of tide is the amount of water above chart datum. The figures in tide tables are the height of tide at HW and LW. In between HW and LW height of tide can be calculated using the tidal curve diagram.

Interpolate. Insert a number in a series so it fits the sequence. E.g. a number one-sixth of the way between 12 and 24 is 14.

SOG. The speed over the ground is not shown on the log. SOG is the combination of the speed through the water (shown on the log) and the tidal stream. It can be shown on a GPS.

TTG. Time to go. When added to the current time, gives the ETA.

Variation. Variation applies to both steering and hand-bearing compasses and is caused by the world's magnetic field. It is the difference between the magnetic reading on the compass and the chart (the chart is drawn to true north). Variation is different in different places in the world and the information for a location is found on the compass rose.

Waypoint. A waypoint is a point on the chart chosen by the navigator. It can be any point or a buoy used as part of a route. If the latitude and longitude of this waypoint are put into the GPS, the set will display the direction and distance to the waypoint, updating as the boat moves. The original purpose of the waypoint feature was as part of a route, but it can also be used to make plotting your position quicker and easier than using latitude and longitude.

XTE. Cross Track Error. When a waypoint is put into the GPS the set will show the direction and distance to the waypoint, updating as the boat moves. The XTE is the distance, in tenths of a mile, that the boat has been pushed off the original direction given by the GPS.

Websites
www.fernhurstbooks.com
www.mcga.gov.uk
www.nunonavigator.com
www.pinmillcruising.co.uk
www.raymarine.com
www.rya.org.uk
www.ukho.gov.uk